WEDDING PHOTOGRAPHY
ART, BUSINESS, AND STYLE

STEVE SINT

SILVER
PIXEL
PRESS®

Rochester, New York

Wedding Photography: Art, Business, and Style

Published in the United States of America by
Silver Pixel Press®
A Tiffen® Company
21 Jet View Drive
Rochester, NY 14624
Fax: (716) 328-5078

Photographs ©Steve Sint, unless otherwise noted.
Cover photo ©Franklin Square Photographers, Ltd.
Design: Windsor Street Design Associates
Printed in Belgium by die Keure n.v.

®All product names are trademarks of their respective owners.

Library of Congress Cataloging-in-Publication Data

Sint, Steve, 1947-
 Wedding photography : art, business, and style / by Steve Sint.
 p. cm.
 ISBN 1-883403-36-7
 1. Wedding photography. I. Title.
TR819.S56 1998
778.9′93925--dc21 98-7007
 CIP

Dedication

For three Js and an M

Acknowledgements

Without the help of these fine studios, photographers, and wedding suppliers,
this book would not have been possible. I would like to thank the following friends:

Phil Cantor Photography, Montclair, New Jersey
Classic Color Labs, Brooklyn, New York
Franklin Square Photographers, Franklin Square, New York
Glenmar Photographers, Inc., Lodi, New Jersey
Great Expectations, Dance Studio, Staten Island, New York
H & H Photographers, Riverdale, New York
In-Sync Limited, Summit, New Jersey
Sarah Kiss Leichtung, Makeup Artist, Lawrence, New York
The Jerry Meyer Studio, Flushing, New York
Jan Press Photomedia, Livingston, New Jersey
Vincent Segalla Studios, Brooklyn, New York
Stefan's Flowers, Cedarhurst, New York
Three Star Photography, Brooklyn, New York
BT, A good ear
All manufacturers who supplied product photographs for this book

CONTENTS

WORKING WITH FLASH

EQUIPMENT

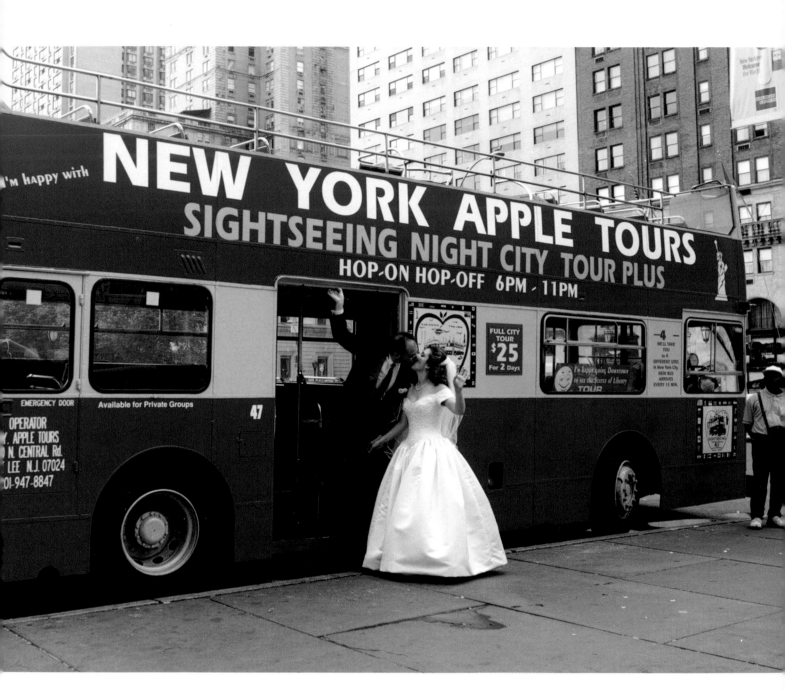

When I was a young man I wanted to be a professional photographer in the worst way. I devoured books on photography (as many of you do), lusted after the latest lens (as you probably do), shot tons of what I thought were meaningful images (as you, no doubt, do), and couldn't make a living at my craft. As luck would have it, through a friend of a friend of a friend, I met the head photographer at CBS. He was "The Man"—UPI Press Photographer of the Year, Nixon's campaign photographer—The Man! He looked at my meaningful images and asked "How are you planning to make a living?" Luckily, I understood that this was precisely the problem, so he let me in on his big secret. He told me that 30 years ago he started his career by shooting weddings.

INTRODUCTION

This was not what I wanted to hear. I wanted to roam the globe, shoot for *LIFE*, be a fly on the wall recording meetings that shaped history. The Man slowed me down. He told me that shooting weddings could give me the four things I needed to roam the globe.

First, it would give me a chance to expose a lot of film. Second, it would make my camera an extension of my hand and eye, which would help when I became the fly on the wall. Third, he told me that shooting weddings would teach me to finish a job no matter how bad it was. This would give me the patience I needed to sit around waiting for the meeting that would shape history. Finally, he explained that wedding photography was regular work, and by doing it I could get the equipment I lusted after, and I would not have to eat gruel as I waited.

About ten years later, on a Saturday night, my assistant and I loaded my camera cases into a cab to go shoot a wedding in New York City. This was not just any wedding, mind you, but a wedding in the Grand Ballroom of the Plaza Hotel. Please understand what this means: Any wedding held in New York's Plaza Hotel is one of the biggest parties happening in New York. And that means there was a good possibility that I was covering the biggest party in the world on that particular night.

The cabbie looked over the seat at my cases and our tuxedos and asked what we were doing at the Plaza. I told him that I was a photographer and that we were going to shoot an assignment. He asked me what kind of assignment, and I replied that it was a wedding. At the next traffic light he looked over into the back seat again and told me that he was a photographer too, but that he could never lower himself to shoot a wedding! I thought for a second and told him that I understood, but I could never lower myself to drive a cab. To this day, I remember that cabbie, and I'm glad I shoot weddings.

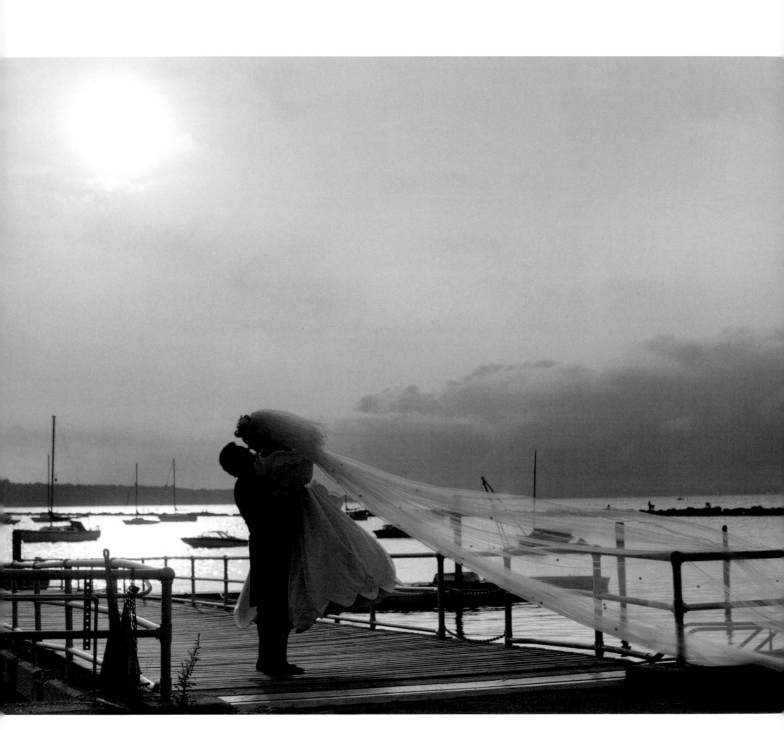

GETTING STARTED

The white-gloved waiter was serving lamb chops from a silver tray...little paper booties on every succulent morsel. I was setting up a picture of an adjacent table. I backed up for my shot...right into the lamb chop serving waiter. His tray fell, sliding down between a guest's back and his chair. I turned and saw the guest, in an outdated, light blue dinner jacket, with a lamb chop resting delicately on one shoulder. I wanted to laugh, but Colonel Lambchop was furious, and after apologizing profusely I went back to shooting my table pictures...wondering why the tray always lands on the guy in the light blue jacket.

Many people consider wedding photography an art, but I disagree. Although there are moments when it may be elevated to an art form, I prefer to call it a craft. Once learned, a craft is something you always have. In fact, it can be argued that a wedding photographer can go to any major city in the world and, with a minimum of equipment and a nice suit of clothes, make a living. This being the case, there are two different scenarios in which you can make it as a wedding photographer. Both are worth considering.

SCENARIO #1: OPEN A WEDDING STUDIO

The first way to make money at the wedding game is to contract with couples to produce their wedding photos. While this may seem to be the obvious way to go about it, it is a very laborious process.

First you must *find* the bride and groom. Then you must show samples of your work to the couple (and often to the parents), draw up and sign a contract with them, get a deposit, buy the film, shoot the job, process the film, deliver the proofs, go over the proofs with the customer, take the order, order the prints, send the prints for retouching, send the retouched prints to a bindery or assemble the album yourself, place extra prints in folders, check the job over, deliver the finished product, and finally, collect the money. As you can see, there are many more steps in the process than just shooting the assignment! In fact, many successful wedding studios say that shooting the assignment is probably one of the least important parts of the whole process!

Selling the photographs is the name of the game. While it is very important to sell the couple on the idea of you shooting their wedding, stiff competition in most regions demands that a studio offers its customers a competitive price with only a very small profit built in. In this kind of environment, if you want your studio to be successful, you have to create the desire in your customers to buy extras after they see the proofs. These include extra prints for the albums, loose prints for family and friends, album style upgrades, or even frames and plaques for displaying the pictures. The key to success is *selling*, both before you've been hired and after the proofs have been delivered.

Many wedding studios offer their prospective customers a package that includes the basics that most newlyweds want. An example of this might be: one 24-photograph 8 x 10 bridal album, two 12-photograph 5 x 7 parent albums, an 11 x 14 portrait, a dozen wallet-sized photos, and 50 or 100 photo thank-you cards. Some studios think it is smart to offer three or four different starter packages that offer variations in the number of photographs in each of the three albums or possibly a package that doesn't include any parent albums.

However, if you are going to offer an inexpensive starter package of photographs, you must remember that you will be locking yourself into an assignment on that particular day that might not be as profitable as another wedding in which the customers might order a larger package. It pays to consider this if a couple wants to book you at your minimum rate for a Saturday night in June (prime wedding season).

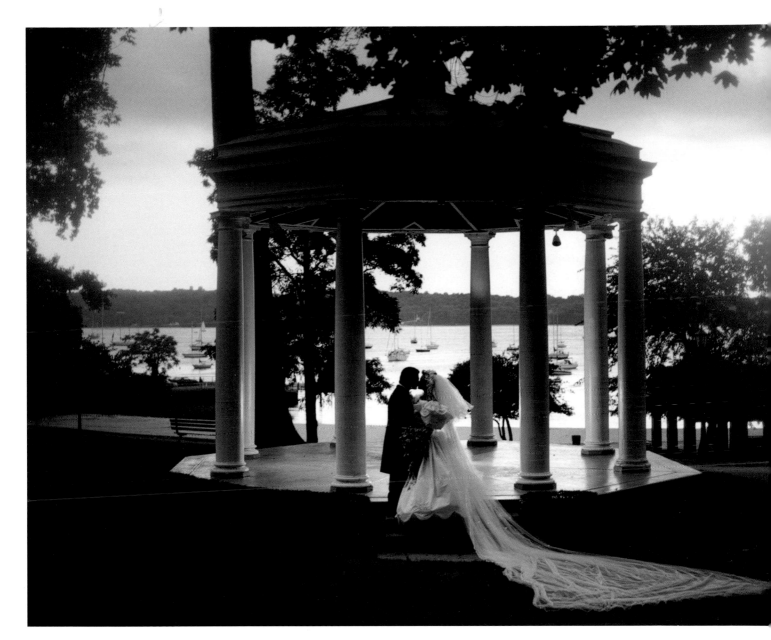

Brides and grooms are looking to you for ideas to make their day idyllic. Suggesting scenic locations for their pictures can increase your sales. Become familiar with the scenic spots in your area; rock outcroppings, willow-rimmed ponds, lovely architecture, and public gardens can all make picturesque backgrounds for formal portraits. Photo © Franklin Square Photographers, Ltd.

Understanding that wedding work is seasonal comes with experience. In the northeastern United States you will be riding high in June (and also in April, May, August, September, and October), but you might find that the pickings are slim in February.

Selling your work as a package, whether large or small, has its advantages and pitfalls. On the positive side, packages give you an idea about how much profit can be made on the assignment before you commit your dollars to film and processing costs. This lets you make economical choices right from the start. For example, if a couple contracts for a 50, or better yet, a 75-photograph bridal album instead of your minimum of 24 prints, you can afford to take more photographs, because the profit built into the higher package price will pay for the extra film and proofing. On the negative

side, large starting packages can often make customers resistant to purchasing extras. For instance, very often when a couple decides on a more elaborate package of photography from the start, their budget is carefully considered, and "building the order up" during the proof viewing session may be more difficult. So, larger, more elaborate starter packages usually mean few, if any, spur-of-the-moment additions later on.

Some studios don't offer wedding packages at all. These operations usually cater to the "carriage trade," where the customer is relatively well-heeled and less encumbered by budgetary considerations. These studios very often start with a minimum order, which by most standards can be quite high. Then they sell their customers all the extras (from parent albums to portraits) on an à-la-carte basis. These studios cater to the whims of their more affluent customers, and very often their next assignment is obtained because of whom they shot previously.

In this same vein are wedding studios that specialize in shooting for a specific ethnic group or community. They, too, often get their next assignment from referrals within that community. This can be very lucrative, and if the community is large (or affluent) enough, there may be work within this specialized area to keep a studio going for generations.

SCENARIO #2: BECOME A "CANDIDMAN"

If you live in a medium-to-large metropolitan area, there is another way to make money at the wedding game. If you own a camera and strobe equipment, you can rent out your services to wedding studios on a per-job basis. When a photographer does this, he or she becomes a "candidman," and playing the wedding game this way has both advantages and disadvantages.

Let's digress with a quick history lesson. The term "candidman" started in the 1940s with the advent of portable flash units. Before this invention, couples went to a photographic studio to have a wedding portrait made. If the couple could entice the rest of the family to come along, then more photographs (with different combinations of people) were taken.

Once portable lighting joined forces with smaller, more portable cameras (the venerable Speed Graphic, for example), a new type of wedding photography—candid wedding coverage—was born. This new style turned out to be a brilliant marketing ploy because it opened the door to

Weddings are steeped in tradition. Traditional poses such as this are almost always chosen for the album. Though couples often desire creativity, they also want a flawless visual record of their special day. Photo © Three Star Photography

Photographs can be confrontational or non-confrontational—the subjects either seem aware or unaware of the photographer's presence. Although this photograph is posed, the fact that neither subject seems aware of the photographer gives it a candid air. Good wedding photographers mix the two styles throughout the assignment to add variety to their coverage.
Photo © Corel Corporation

selling entire albums. Simply put, photographers could sell a lot more pictures by filling an album than filling a single picture frame!

What followed was a need for photographers: wedding photographers. While one studio photographer could handle many portrait sessions in a single day, the brave new world of candid wedding coverage required that many photographers be hired on a single day, one for each wedding. A new breed of photographer developed, aptly named the "candidman" ("man" because at that time men predominated in the profession). The candidman, armed with a Speed Graphic and some flashbulbs in the trunk of the car, was a "gun" for hire, and to this day good candidmen are in high demand.

While wedding studios must do all the work involved in selling and producing the final product, a candidman just has to show up on the day of the wedding, shoot the film supplied by the contracting studio, and deliver the exposed film to the studio after the job is completed. Depending on the size, length, and

importance of the job and the level of expertise required, a good candidman can earn between $150 and $600 per assignment. It's simple really—get the film and the details about the job from the studio, shoot in the studio's style, return the exposed film, and get paid.

Good candidmen often shoot for more than one studio. In large cities a candidman can shoot for many different studios without ever encountering a conflict of interest. Many candidmen (myself included) change their style or repertoire when they shoot for different studios so that the pictures they produce match the style of the samples the studio has shown to the customer. Some studios show very formal portraits to prospective customers, while others present photos shot in a more candid, relaxed style. Some studios expect (or their customers want) to see creative double exposures, available-light photographs, or soft-focus effects. A good candidman can switch from style to style to satisfy his or her customer, namely, the wedding studio itself.

Like fashions, wedding photography styles go through cycles. Men's ties narrow and widen, hem lines go up and down, and wedding pictures switch from traditional to avant-garde. Soon after color photography was first introduced you couldn't give away black-and-white photographs, but once color photos became the standard, many couples began asking for more "daring" black-and-whites. Successful wedding photographers can shoot beautiful compositions in both media. Photo © In-Sync Ltd.

Being a candidman is a good way to supplement a regular job, and for that it is terrific! A good candidman is always in demand, and he or she can find work on a regular basis. But some candidmen can make a good living at it full time. These include the very top candidmen who are guaranteed a specific number of assignments per year from one big studio or those who are so complete as photographers (i.e., they are gifted at shooting a broad range of subjects and applying a wide range of techniques) that they can shoot for many different studios. Candidmen in this position are capable of becoming studio owners if they choose.

While the life of a candidman may seem perfect because there is no selling or album-producing involved in the job, it does have some disadvantages. First, candidmen don't build a clientele like wedding studios do. This means that at the end of their career there is no business to sell or pass on to a child. The candidman's eyes, hands, voice, and equipment (although by the end of a long and fruitful career, most of the used equipment is usually in pretty rough shape) are the only assets of the business.

However, for some photographers the first step towards opening their own wedding studio is to become a candidman.

Established studios (especially in larger cities) have many assignments that a good candidman can pick up while building a sufficient reputation to support his or her own studio.

Many owners of small studios switch hats and shoot as candidmen to supplement their studio's income. While this supplemental income can be helpful, many established studios are wary of hiring a candidman who is also a studio owner. Plainly put, an established wedding studio is not in business to further the reputation of one of its freelance employees' studios. Why help the competition? With this thought in mind, it is easy to understand that it is a big "no-no" to give out one's own studio's business cards while shooting as a candidman for another. Photographers who do this usually find that assignments from other wedding studios will be few and far between.

However, in densely populated areas it is possible for a studio owner to have his or her own clientele and shoot as a candidman for studios that cover an entirely different segment of the population. Examples of this can be found most readily in areas where there is a great deal of ethnic diversity. For example, if your studio mostly handles Christian weddings, you can shoot as a candidman for studios that cater to an Orthodox Jewish clientele with little chance of running into a conflict of interest. Or, if your studio is on Long Island (a New York suburb), for instance, you could shoot as a candidman for a studio in New Jersey. Once again, this scenario is really only possible in large metropolitan areas.

Regardless of which career path you choose, success in wedding photography, like in real estate, is a matter of location, location, location! Smaller cities and towns with only one photo studio and one catering hall limit your possibilities. Big cities, on the other hand, offer an incredible variety of options and opportunities.

While some may think that being a great candidman requires superhuman photographic skill, this is really not the case. While the list of required skills and equipment is long, it is not unobtainable. Here's what I think you'll need to play at the top of the game (i.e., elegant, big-contract weddings) in any big city:

1. An easygoing, engaging personality.

2. Good communication skills.

3. You must care about what you produce—have an intense desire to treat any assignment as if you were shooting a center spread for *LIFE* magazine.

4. The ability to keep your cool and your wits about you.

5. Good to very good (notice I didn't say "great") photographic skills.

6. The ability to make studio owners confident that you are as interested in the quality their customers receive as they are.

7. A complete roll-film camera system with at least two camera bodies and backups of all other major camera equipment: meters, sync cords, lenses, etc.

8. At least two battery-powered strobes with extra batteries and spares (flash tubes, battery charger, brackets, remote triggers, radios, batteries for radio remote slaves). However, for a big-contract, elaborate wedding, four strobes would be better.

9. At least two AC strobe generators (three would be better) and three to four strobe heads.

10. Light stands and supporting accessories (barndoors, clips to attach barndoors, umbrellas, bank lights, boom arm) for the lighting system.

11. A tuxedo or equivalent formal attire and a neat, clean appearance.

12. A reliable car.

13. Liability and theft insurance.

14. A date book for keeping you organized.

While some may think the equipment required is unobtainable, let me point out that its acquisition can be spread out over a long period of time. Also, please note that I list photographic skills as fifth in importance. Your friendly personality and a caring attitude are more noteworthy assets.

With all the effort required, it might pay to establish your own studio. Many top candidmen do! On the other hand, in a densely populated area, it's possible to make a comfortable living just being a top candidman without the hassles and responsibility of owning a studio. Just remember, getting to the top is not an easy proposition. Being a top candidman requires commitment and a solid reputation for reliability that can only be built over time.

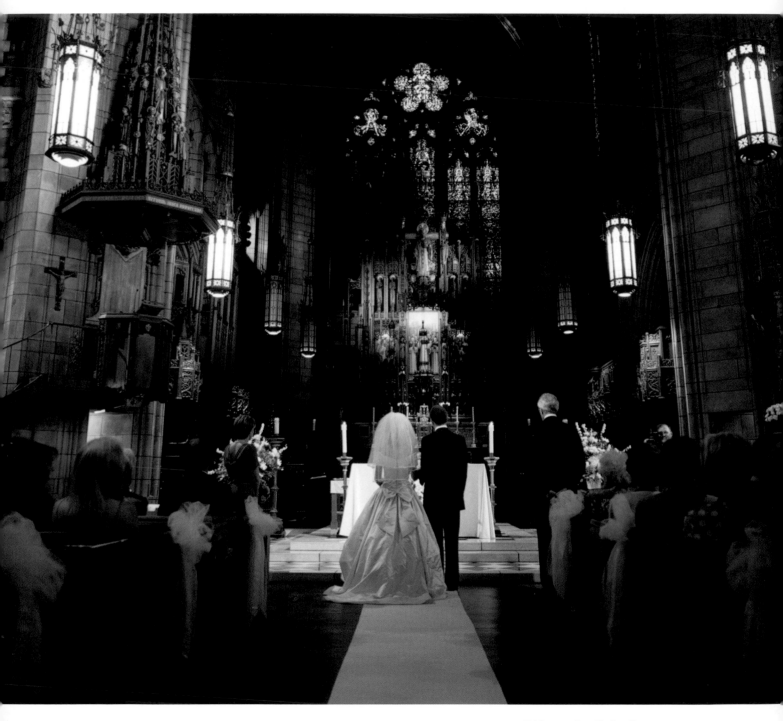

THE WEDDING REPERTOIRE

It's a crisp, autumn evening wedding with centerpieces of dried flowers and leaves surrounded by votive candles on the tables. I go for a table shot, asking four people to remain seated. The guy at the far left says, "Hey...you can't see me. I'm behind the flowers!" Flipping my pointer finger between us I smile and say, "If you can see me, I can see you. It works that way!" He thinks for a moment and then pushes the centerpiece aside anyway...right over a votive candle. The dried flowers and leaves become the burning bush. I push the button.

I once shot a wedding for one of America's great families. I worked all day, into the night, shooting 500 pictures. I charged them a lot of money. Within a week I received a check for the entire amount called for in my contract, but when the proofs were returned, the customer wanted only three 8 x 10 portraits. I called to find out what was wrong with the rest of the pictures and was told (by a secretary) that my clients loved the pictures, but they needed only one print for the bride and groom and one print for each set of parents. I had sold three 8 x 10s for $1,000 each!

Years later, as I toured the mansions of America's aristocracy in Newport, Rhode Island, I realized what had happened. For the "beautiful" people—those who will never know the pleasures of having a boss; those with a mansion in New York, a house on the Seine, a villa on the Riviera, or a horse farm in Kentucky; and those with a chauffeur on the house staff—a wedding is just one more nice day in a life filled with nice days. All the pomp and circumstance surrounding a wedding is just that: pomp and circumstance.

But for every one of these people there are millions of others for whom a wedding is the most special event of their lives, a once-in-a-lifetime occurrence. To these people, every nuance of the traditional wedding is something to be savored and remembered—and photographed. A repertoire, as used in the context of this book, is a list of all the photo opportunities that record those nuances and traditions.

BUILDING YOUR OWN REPERTOIRE

This repertoire contains all the pictures I feel are necessary to cover a Christian wedding assignment and produce an album that will tell a story about the day. If you go through it carefully, you'll notice that, although the shots are listed, exactly how they are produced is not always mentioned. This is where your individual creativity comes into play.

A repertoire is a living, breathing thing. You can use this one, but the best repertoires are filled with individuality. So use this one as the basis for creating your own. Feel free to add, subtract, and combine it with your ideas and those of other photographers. But always remember...the best repertoire for you is YOURS!

For the novice, having a repertoire is almost essential. Very often when new wedding warriors go on their first assignments, they draw a blank when it comes time to start taking pictures. By memorizing a list of pictures and going down that list, you always have something to fall back on. This is not to say that a wedding photographer shouldn't be constantly trying to build on and improve his or her repertoire. That is one way to keep assignments fresh over a long period of time. Finally, if a new wedding photographer can capture 95% of the photographs on this list, he or she will be able to produce a traditional wedding album that tells a story *and* has great sales potential.

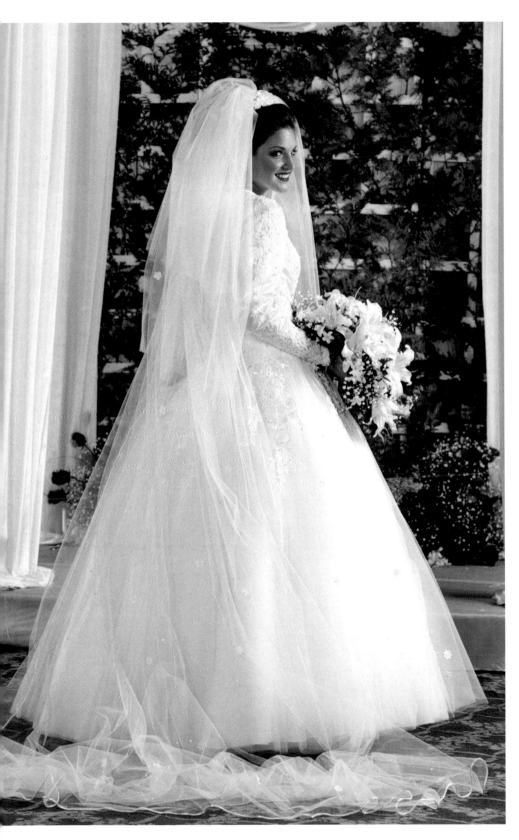

Looking at wedding photography through the eyes of a pro can be an enlightening experience. Every wedding (both the ceremony and reception) has specific events that occur. Realistically, after you've shot 100 (or 500, or 1,000,...) weddings in your area, you should start to see which things happen regularly. As your experience grows, you'll find that brides and grooms are constantly explaining to you how unique their wedding will be, and in reality you've seen the same "bridal cake on the plastic volcano" at the local catering hall a hundred times. No matter what, *do not* diminish or deflate the excitement they show. *It will sell photographs for you!* Just smile to yourself and remember that the volcano photograph is paying for your new car.

There is a growing feeling today that brides and grooms want nontraditional wedding photographs, and I see this happening to a very small extent. The words "reportage style" are often bandied about. I've heard some current shooters tell their customers that their shooting style "goes with the flow,"..."is a photojournalistic style,"..."follows a nonintrusive approach," ...etc. It is best to remember that this is a sales tool used on customers. To shoot an

A picture that displays the back of the dress and veil can add variety to your repertoire. Examine this pose. Arranging the full-length veil close to the dress gives the veil body and texture and compresses the composition so the image of the bride can be larger in the frame. Two lights were used in this shot—the stronger main light was placed to the right, while the camera-mounted light acted as fill. Photo © Jerry Meyer Studio

assignment competently—any kind of assignment—all pros have some idea of what they are going to shoot. Whether you call it a shot list or a repertoire doesn't matter. For shooters who think that reportage is the wave of the future, I still think a repertoire is a good idea. If you decide to shoot in a nonintrusive, totally candid atmosphere, the list of combinations that I'm proposing should still be covered, even if the photographs are very casual.

Personally, I don't subscribe to the reportage style of photography. I like a more traditional approach, with posed portraits of certain people and a totally candid style in situations where the photographer is just an observer (though not a casual one!). While some think that candid style I snapped a picture and, as if by magic, the bride's mother became sweetness and light. She told me later that the boutonniere shot was in her wedding album, and she had been wondering when (and if) I was going to get it.

A repertoire is based on the first pro axiom: Plan Ahead. This doesn't mean you don't have to be prepared for the unexpected. You may go to an assignment knowing you want to do a formal portrait of the bride and her sister because it's in your repertoire. You want formal, but they want to throw their arms around each other and hug. The photographers with the best people skills can get both, but even if you get only the hugging shot, you're still working from a repertoire.

can figure out how much film you'll need to complete the job and the cost of film and processing (OK, OK...only approximately!). This type of information is very important because, although you want to be the "harbinger of happiness" to the bridal couple, you still want to have a profitable business.

Another advantage of shooting to a repertoire is that you, as a wedding studio, can book more than one job on a beautiful Saturday in June. After all, if you're selling a specific content and style of photography, then you can teach that to other photographers you hire. This freelance addition to a staff is called a candidman. Candidmen populate every city, but good ones can be hard to find. These photographers can look at a studio's set of proofs and copy the assignment. And the best candidmen can bring creativity to the situation while still emulating a studio's style.

The repertoire I present here is based on a few assumptions. First, I'm assuming that the photographer will arrive at the place where the bride is dressing 1-1/2 hours before the ceremony and has at least 1 hour in which to work with the bride, her parents, her siblings, and the bridal attendants. While some might feel that the hour spent at the bride's home shortchanges the groom's side, it pays to note that many people consider a wedding to be the bride's day, and from a photographer's point of view, more can be done with a beautiful gown, headpiece, and bouquet than a tuxedo! So much for equality of the sexes! If the customer insists on photographs of the groom's preparations, that is the perfect time to sell the idea of hiring a second photographer to them. Each of the photographers can start at the two principals' homes, shoot parallel pictures, and meet at the church. (If that is the game plan, note that the order of the repertoire changes with regards to when you shoot the groom's family pictures.) Like many extras in the wedding photo game, this can be a situation that allows you to make extra profit.

Getting Your Sea Legs

For the beginner, it might pay to go to the ceremony's rehearsal before the real thing to get a feel for how things happen, but remember that your time is worth money. One mistake green photographers often make is to minimize the value of their own labor. After all is said and done, the most expensive part of creating any photographic product is the time (i.e., labor) involved.

nontraditional is where it's at, I might point out that weddings by their very nature are steeped in tradition and custom. It is a time when families dress up and come together—it's like shooting fish in a barrel! Most of the couples getting married (by a large majority) want the traditions and, more important for us, they want pictures of them.

One time I was 45 minutes late to a bride's home because the wedding I had covered that morning had run late. I shot a minimalist repertoire at the bride's house, and all afternoon and into the evening I picked up my missing photos in bits and snatches. Because of my tardiness the bride's mother was not very enthralled with me, and try as I might I couldn't turn her around. My people skills just weren't working. As we walked into the country club, I asked the bride to adjust her father's boutonniere. In a

Like many things, this list is not engraved in stone. Very often a photographer will suggest where to start, and the bride will make a face signifying she doesn't like the idea. At that moment it's time to modify your repertoire (or at least that small section of it). It's equally true that sometimes you might take a photograph that I would place into one of the five basic segments of the coverage (the bride's home, the ceremony, the formals, the family pictures, and the reception) and move it somewhere different from where I might have put it in the scheme of things. That's OK...there are no hard-and-fast rules dictating the order in which you *must* take the pictures!

There is, however, safety in working to a plan. Not only do you not want to lose a sale, you do not want to be responsible for missing a memory. By having a specific idea of what you're going to shoot, you

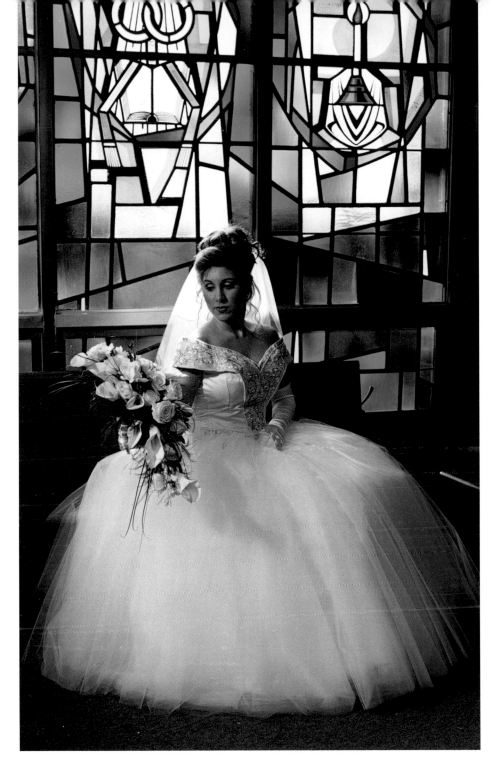

A well thought-out plan regarding the order in which pictures are taken can also expand time. You, the photographer, can build a group picture in such a way that you keep adding people to a pose, taking pictures as you build the scene. For example, you can start with the bride and groom and pick a pose for them that can be built upon, such as the bride with her back to the groom's front. You can then add a set of parents with the mother facing the bride and the father behind the mother. After taking that picture, a crafty photographer can add all the siblings, shoot that picture, and then add the grandparents. After that, instead of letting the pose dissolve, the photographer can remove the parents and grandparents and be left with a pose of all the siblings together—a perfect picture for the album or, better yet, the parents' living room wall!

I designed this repertoire to include most of the basic combinations. Whoa, Steve. What is a combination? Well, I guess some definitions are in order. I think of people placed together in wedding photographs as combinations. Furthermore, I refer to a one-person picture as a single, a two-person picture as a two-up, and a three-person picture as a three-up, etc. A work-up, such as "the groom's family work-up," refers to all the pictures of a family treated as a group.

Second, between the ceremony and the reception the photographer has about one or two hours in which to take formal and family photographs. This can be spent at a park (weather permitting), a backyard, or even at a photo studio or reception hall. The time can be broken down further by taking the bride, groom, and bridal party to a park and then shooting the family photographs once the bridal party gets to the reception hall.

In any event, if the photographer's time is limited, either by subjects not being ready, the scheduling of events, or the traveling time required to get from location to location, he or she must start to prune the repertoire. In that case it's best to concentrate on photos of the bride and groom, the parents, and larger groups. Taking a picture of the bride and each of her six sisters will take six times as long as taking one photograph of all the sisters together.

A STANDARD REPERTOIRE

THE BRIDE'S HOME

Become an Insider

The photographer is the first in a long line of people who will direct a couple through their wedding day. The priest or minister will tell them where to stand, the maître d' or caterer will tell them when to eat, the band leader will tell them when to dance, and you, the photographer, will pose them, even if only by suggestion. While the others may direct, I *suggest*.

You have a terrific advantage in being the first of these authority figures to see the bride on this day. You can use your first-in-line position to your advantage. While I can (and do) shoot 48 different pictures in one hour at a bride's home, I also use this time to become an insider—a friend.

Insiders have privileges—their counsel is heeded. This is just what I (and you!) want in order to do a better job and generate recommendations. During my first hour with a bride I ask questions. Even these are a repertoire, because at every wedding I'm really interested in the same sort of information. How long has she known the groom? Who is her maid of honor? How close is she to her sisters and brothers? If the bride confides in me that, for example, she's close to her sister or doesn't like her future mother-in-law, I'm on my way to being an insider. Every question I ask, every bit of information I get, is absorbed for later use. Where are they going on their honeymoon? This can be used sometime later when the groom

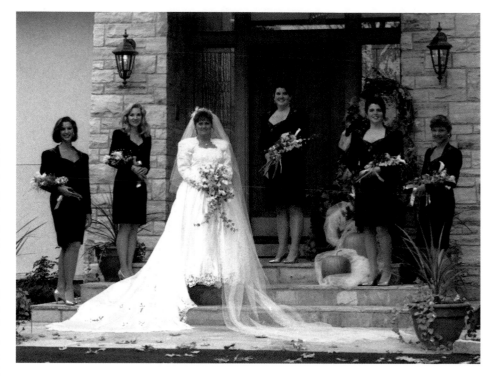

has a hard time smiling. I can say, "Think of you and (bride's name) on the beach in Malibu (or wherever)."

I ask questions about the ceremony: How well do they know the cleric? Is the person performing the ceremony a friend of the family? If so, a picture of him (or her) with the couple is in order. And if the cleric married the parents too (!) you might want to take a shot of him with the parents and the couple. As important as it is to ask questions, it is more important to listen to the answers. On the job a good candidman should be in a high state of concentration. Even though a photographer who is new to the game might know his or her first subjects intimately (because they're probably friends), it still pays to ask questions.

If the front of the bride's house offers an expansive porch or a broad set of stairs, you can use it to create a relaxed, multi-level grouping of the bride and her bridesmaids. This picture makes a nice transition in the album between the pictures taken at the house and at the church. Photo © Corel Corporation

Equipment Concerns

Logistically, once you get to the bride's house, it pays to create a base of operations—a safe place where you can put your equipment. I often choose the kitchen table, but what you need is any flat surface that's not in the areas in which you'll be shooting. I usually lay out a longish normal and a wide-angle lens, some filters, a few film magazines (I shoot roll film), and so on. I also test-fire my flash equipment a few times. This is called checking the sync (synchronization).

There is nothing that puts a flash photographer's mind at ease more than knowing that the flash and camera are on the same page of the play book. I shoot with a leaf shutter camera. These cameras let you check the flash sync relatively easily. At every wedding I check my sync before I start shooting and at breaks in the action just to be sure. I also check it each time I mount a lens.

Check Your Sync Again and Again

Always check your flash sync before you load your camera! And check the sync before every segment of the repertoire, too (if not more often), just to be safe. That way, if your sync goes out sometime on the job, at least you'll know which photos you have to retake...which is another good reason to follow a repertoire!

In truth, it's one of the first things that should be taught to a green assistant. Before you teach your assistant however, have a little fun. Tell him (or her) to check the sync, and when he asks how, tell him to go into the kitchen and make sure the faucets work. Ha, ha, very funny. The point of this rite of passage is that very few assistants ever forget how (or how often) to check the sync. Just for the record, I thought I'd explain the procedure for checking a leaf shutter camera here...and you don't even have to go into the kitchen.

Attach the flash unit and the sync cord to the camera. With the camera empty and its back open, aim it at a light-colored wall. As you release the shutter, look through the camera from the back (where the film goes). If you see a circle of light when the shutter and flash fire, you are indeed in sync. As long as you're back there, you might fire off a few more blank exposures at different apertures to check that the camera's auto-diaphragm system works. With a smaller f/stop you should see a smaller opening, and with larger f/stops you should see a larger opening. Consider changing the shutter speeds a bit as well so you can be sure your leaf shutter is syncing at every speed.

Finally, after my flash, the most important accessory I carry is my tripod. More than half the pictures I take at any wedding are taken with my camera mounted on a tripod. In fact, any time my shutter speed drops below 1/60 second, my camera is mounted on my tripod. There are times, for example, during the church processional or on the reception hall dance floor, when a tripod is impossible to use, but in general my tripod is my constant companion. Not only will it free up your hands for holding filters in front of the lens and sharpen your available-light pictures, but it also adds a presence to your camera and smacks of professionalism.

Now we're finally ready to make pictures.

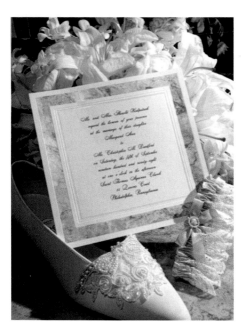

The Bride's Home List

The Dressing Room

Doing pictures of the bride's reflection in the mirror over the dresser in the master bedroom might seem a bit like an old-fashioned cliché...and it is. However, very often the bride can remember those very same photographs in her mom's album. Remember, traditions can be nice. More importantly, it can give you a few moments alone with the bride that can help you establish rapport with her. To get some privacy you can always point out to onlookers that you can see their reflection in the mirror—you usually can—and once you point this out, ordinarily they scatter. While you're at this, notice exactly what the reflections in the mirror reveal. It isn't attractive to have a beautiful bride and her bouquet reflected in the mirror if the reflection also includes dad's dirty socks lying next to the bed! Finally, if you're going to take photographs of reflections in the mirror, remember to straighten up the bureau top. Maybe you can decorate the scene by laying the bridal bouquet (and possibly the bridesmaids' bouquets) at the base of the mirror.

A photo of the invitation just begs to be accessorized. In this instance the bride's garter and beaded shoe play supporting roles in personalizing the image. Remember to save the invitation for the information it contains.

1. The Invitation and Possibly the Ring Bearer's Pillow with the Bridal Bouquet

If you don't have a ring bearer's pillow, you might use the bride's engagement ring and/or her garter (if she's wearing one) as accessories for this invitation photograph. Bridal props are all around you on the wedding day. Don't overlook shoes, rings, champagne glasses, parasols, beaded gloves, sun hats, and bouquets as possible props.

This photo is very important for two reasons: 1) A photograph of the invitation is a great beginning to the album. You can always sell this idea at the proof review, so even if you don't shoot it here, shoot it sometime during the day; 2) After you shoot the invitation, put it in your camera case so that you know the address and name of the church!

While some of you may laugh at this (what kind of photographer doesn't know where the church is?), if you're in a new neighborhood or lose the limousines that you're trying to follow to the church, the invitation (complete with the church's name and address printed on it) can be your salvation! Since you have it, you might even invest a second frame or two of film and shoot a photograph of the invitation propped on the wedding cake or with two champagne glasses later on at the reception...it's worth it for a sure-selling image!

2. Mirror Photos

If you're doing these photographs in the traditional "candidman" style with flash on-camera, you might consider using bounce lighting to even out the illumination between the bride and her reflection. If you use direct flash, you'll find that the bride is much closer to the camera than the reflected image is, and she will therefore be hopelessly overexposed compared

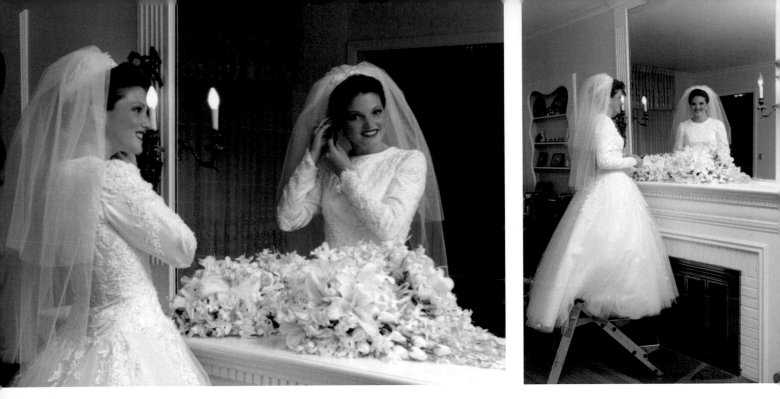

There is almost always a suitable setting for taking a mirror portrait. This house didn't have any traditional dressers with mirrors, but it did have a mirror over the fireplace. The photographer's stepladder was used to raise the bride up to a natural looking height, and looking at the finished photograph, no one is the wiser!

to her reflection. The flash unit may be only 1-1/2 to 2 feet (0.5 to 0.6 meter) from the bride herself, but to illuminate her reflection the light has to travel from the flash to the mirror and then back to her face—a total distance of about 6 to 8 feet (1.8 to 2.4 meters)! In this instance, mirror photographs and bounce lighting work together to make salable images. If the dressing room has a dark ceiling, however, bounce lighting won't work, so in that case try to shoot only the bride's reflection to avoid the problem of lighting both the subject and reflection.

➤ *Bride Using Comb or Brush*

➤ *Bride with Compact*

➤ *Bride Applying Lipstick*

➤ *Bride's Hands Holding Parents' Wedding Photo, with Her Reflection in the Mirror Behind*

This and the next two photos are modifications of the more traditional "mirror poses," and they make use of the reflection in the mirror and a foreground item

in front of the reflection. They're interesting and different from the run-of-the-mill dressing room photos, so it's worth taking one or two. In addition, if you include one of the parents' wedding photos, you can often sell the same image for the parents' album.

➤ *Bride's Hands Holding Invitation, with Her Reflection in the Mirror Behind*

➤ *Bride's Hand Holding Engagement Ring, with Her Reflection in the Mirror Behind*

➤ *Bride and Mirror Together (only if the bride can position her body close to or actually touching the mirror)*

This type of photograph is not really a traditional dressing room photograph and can be done anywhere. It is an especially convenient pose to use in catering halls with mirrored walls, and although it is a simple picture, the results look special. Remember it when you're up against the (mirrored) wall! Try shooting the bride's face and its reflection, either with her looking at her ring or at the bouquet.

3. Mom Adjusting Bride's Veil

4. Bride and Maid of Honor

As an aside, for this picture you might want to do something really corny with the maid of honor such as having her adjust the bride's garter. If you decide to go this route, consider including the flower girl and getting her to cover her eyes as the bride lifts her dress to reveal her garter.

The Living Room or Yard

In colder climates, bad weather, or houses without beautiful yards you'll find yourself taking photographs of the bride, her family, and her attendants in the living room or family room. If the room has a white ceiling, once again, bounce lighting is the way to go.

Shooting indoors has some limitations. Groupings require a wide-angle lens, and between changing lenses and putting down your camera and flash to arrange each picture, things proceed more slowly than outdoors.

Find an attractive couch, sit the bride down, ask the maid of honor to adjust the garter and wink, and you'll have a very cute picture that will probably be included in the album if the couple does a bouquet and garter toss at the reception.

By using a short telephoto lens and placing a bit of distance between the subject and the background, even cluttered, distracting settings can be transformed into soft, pleasant blurs of color. This bride is actually surrounded by a confusing background of splotchily lit houses and a section of dirty sidewalk. By zeroing in on just a segment of the scene and throwing the background out of focus, you can turn the setting into a fairyland. If you keep this in mind, one-up and two-up portraits can be taken almost anywhere.

Shooting outdoors proceeds much faster, especially if your camera is tripod-mounted and you're shooting under natural light. If you decide on the outdoor route, here are a few hints: Look for open shade so you don't have to use flash fill. Open shade makes complexions smooth, which is just the effect you're after. When you're looking for a portrait location in open shade, imagine what the backgrounds will look like. If the backgrounds are lit by direct sunlight and your subject is in open shade, you'll find that the backgrounds are overexposed and will generally detract from your primary subject. As with all rules, though, this one begs to be broken, but if you decide to break it, do so only occasionally. It won't work as a steady diet!

I find that some of the best backgrounds are out-of-focus green smudges created by such things as high shrubs or low trees. While the smudged background really isolates the subject, it too is a rule ripe for breaking. Even the bride's house can be an effective, if busy, background. Some might say that if you can include in the background the place where the bride grew up, so much the better.

Sometimes you'll have an embarrassment of riches, and both the front and back yards will be photogenic. In this instance try to use both locations, because the variety of backgrounds can increase your sales. When I first arrive at the bride's home, I spend five minutes looking for backgrounds and deciding which sections of my repertoire I'll shoot where. It's time well spent. Don't overlook little nooks and crannies that might be good for single or two-up portraits. A porch or corner of the yard might be great for a small photograph. Equally true, look for stairs and banisters that might help arrange larger groups in an interesting composition.

1. Bride and Dad: Formal

2. Bride and Dad: Kissing Him on the Cheek or Hugging Him

This picture may appear to be a relaxed version of the previous "Bride and Dad" shot, but you can have two possible sales if you change the background and the pose enough to make the photos different.

Shoot Matched Sets

Here is an important point that I will mention more than once: Think about selling and producing album pages in twos, as a spread. That way you might convince the bride to use a formal spread that includes the bride and her mom next to a photo of the bride and her dad. Somewhere later (or earlier) in the album you might be able to sell another "bride and individual parent spread" if you have two more casual, different images to put together.

3. Bride and Her Parents: Two Frames

You'll notice that this and some other photos are designated to be shot twice. That's because this photo is a specific "bread-and-butter" picture that's in every album. It would be a pity to have one of the three principal subjects blink and for that to be the only image available.

➤ *Bride and Her Parents: Selective Focus*
The idea of this photo is to focus on the bride with her parents in the background, slightly out of focus. This different approach to a bride-with-parents photograph is a perfect candidate for selling the two-page spread idea, but to pull it off you must shoot the same picture later with the groom and his parents (see

page 54). The great wedding shooters even take this spread idea one step further and reverse the pose for the second photograph. This means that if you put the bride on the right side of a horizontal composition, when you shoot the other half of the spread, "Groom and His Parents: Selective Focus," you'll place the groom on the left side of the frame. That way, when the images are viewed as a two-page spread in the album, they will fit together better and it will make selling the idea easier.

4. Bride's Parents Alone: Two Frames

Once again, this picture is a sure-seller, and it might even find its way into a parent album or a frame. As it's a must-have image, it's worth taking two or three frames.

Using the home as a setting for a photograph of the bride and her parents creates a feeling of warmth and intimacy. Always look for architectural details that can be used to create different levels at which your subjects can pose. Here the photographer arranged the bride and her parents on a staircase and used the diagonal lines created by the banisters to frame his subjects. Photo © In-Sync Ltd.

5. Bride and Mom: Regular and Soft Focus

The relationship between the bride and her mom can be a uniquely close one. Your photograph of the two of them should show that bond. I try to make this picture a special one and almost always shoot more than one.

One popular variation is of the two women together taken with a soft focus or diffusion filter over the lens. Almost any time you photograph a mature woman in this kind of stylized atmosphere, it pays to shoot a frame or two with a diffusion filter. They may like the effect. My wedding camera case has four different diffusion filters in it, so I have a selection to choose from (see page 115).

6. Three Generations: Bride's Side

Three generations of people in one photograph is something special. If they are all of the same sex, it is even more so. If the bride's mom's mom (whew) is present at the house, a picture of the three of them will almost always make the album. I don't know if the three-generation picture was the invention of some enterprising photographer, but regardless of whose idea it was, the picture has become a standard. If the bride has a sister who has a daughter and the mom's mom is there, then you have a four-generation picture. Once the picture has ballooned to five subjects (grandma, mom, the bride, the bride's sister, and the sister's daughter), you should add in any other sisters of the bride for one, grand, multi-generational extravaganza!

7. Bride and Sisters (and optional, Bride with Each Sister or Bride with All Siblings)

This group of images (and the next category as well) can create a sticky dilemma. If you shoot the bride and all her sisters together, chances are good that you won't sell pictures of the bride with each individual sibling. Likewise, if you shoot the bride with her brothers and sisters together, you won't sell the photos of the bride with her sisters and of the bride with her brothers. Why should she buy two (or more) photographs when she can have the same people in just one? This is a double-edged sword, because one photograph of all the siblings together usually finds its way into a parent album and is often the type of photograph parents display in their home.

Here are some suggestions: If you decide to shoot the bride and each sibling individually, you must get all of them if you expect them to sell. A bride won't include photos of just four of her five siblings in the album. It can become political. So you may decide to shoot all the siblings together.

And finally, if any siblings are married, you can leave their spouses out of the sibling shot, but later be sure to do a few special pictures of the married siblings and their spouses together with the bride and groom.

8. Bride and Brothers (and optional, Bride with Each Brother)

See above.

9. Bride and Bridesmaids (and optional, Bride with Each Maid)

The bride with all the bridesmaids and the maid of honor (and matrons of honor, and the junior bridesmaids, and the flower girls, etc...) is a must-get picture. However if the house is tiny or the yard unphotogenic, you can always pick up this group picture while the formals are taken after the church ceremony (see page 49).

Shooting a series of the bride with each maid is interesting for its sales potential. Although it won't produce photographs for the album, it will give the bride a nice memento to give to bridal party members. Remember, if you go this route, you'll have to produce the same set of pictures for the groom with his ushers. You might even try to get photos of couples within the bridal party for more sales possibilities. Because these pictures aren't specifically for the album, if you are pressed for time, they should be eliminated from your repertoire.

An image of the bride with her flower girls adds variety to the bride and bridesmaids' pictures. In this instance the photographer asked the two principal subjects to almost touch noses, which drew them closer together. Even though you can't see the face of the smaller flower girl, the picture still has a lot of appeal because it's different than more traditional images. Photo © In-Sync Ltd.

➤ *Bride and Flower Girl*
Like the extra photo of the bride with the youngest sibling, this picture is also a stellar seller because dressed-up little kids are so very cute. You can make this kind of photograph a real Norman Rockwell. Don't be afraid to ask them to touch noses or something else equally as sweet.

10. Bride Alone: Three to Four Close-up Poses, Two to Three Frames per Pose
Formals of the bride alone are often the centerpiece of the entire day. It pays to invest some extra effort here. Every misplaced flower petal and lock of hair will be proudly displayed for decades by the bride and her family!

To get as much sales potential as possible, vary the framing and poses you shoot. Traditional bridal close-ups are often framed from the bottom of the bouquet to above the top of the bride's head, but sometimes, when she's holding a long, trailing bouquet, you can do some poses that don't include the floral trail. Investigate both formal and relaxed poses

If you previsualize the pictures you're going to take, both of these images can be done in less than a minute, and although they look very different, they are very similar. You can easily create a white background for a close-up portrait of a bride if one of the bridesmaids holds the train up behind the bride's head.

A posing drape can make a quick dark background that's perfect for a double exposure. This is the only way I know of to get a smile and a serious expression onto the same frame of film, and because the proof shows the final result, the picture almost always sells.
Photos © Three Star Photography

The real secret to beautiful window-light portraiture is having the subject and camera in the right positions relative to the light. The first rule of thumb is to shoot across the window light, not into it, and the second is to place the subject so that the window light is hitting the front of the subject's face at 45° instead of from the side at a harsh 90° angle. If the bridal gown has embroidery detail or beadwork, side lighting skims the surface of the gown, making the details "pop." Pictures taken with natural light look different from traditional formal poses, and variety adds to sales.

and change the background frequently for variety. A few tight, facial close-ups with a longish lens are great to add into the mix. Remember to use your diffusion filter for some of the shots.

Don't be afraid to try unique poses either. Some of my most successful formal bridal close-ups have found me shooting from behind a couch with the bride leaning over the back, facing towards me, or with the bride lying on the floor among rose bouquets. The picture you take will probably be in someone's wallet for a long time. Even better, it will be pulled out of that wallet and shown to many people who are all potential customers. If you can make every bride look like a supermodel, your future's assured!

➤ *By Window Light: At Least Two*
Many of you are going to think that because I say you should shoot this picture twice, it is a "must-have" image.

While the resulting picture is attractive and different, the real reason you should shoot it twice is because the longish shutter speeds required mean that subject or camera motion might ruin one of the images. The real trick in window-light photography is to have the lens axis parallel to the window. In other words, the window isn't in front of or behind you, but next to you.

The bride must also be carefully placed. If she is next to the window, you will end up with lighting that will split her face down the middle...not an attractive effect. If, because of the physical layout of the room, the bride must be next to the window, you can snatch victory from the jaws of disaster by turning the bride's face toward the window's light. In a perfect world, if you have the space and you pose the bride just past the window's frame, the window light becomes a 45° frontal light, which is quite beautiful.

11. Bride Alone: Three to Four Full-Lengths

Like the close-up shots, these pictures are in the "got-to-be-good" category. Once again, variety is key. Show off the dress's line by placing the train behind the subject. Show off the train by posing the bride facing away from you and having her swivel at the hips so she's looking back over her shoulder at the camera. Try a frontal pose, but pull the train around from behind her and drape it in front of the gown. Every bridal album you see an be a source of new full-length poses of a bride in a gown. Buy a few copies of *Bride's Magazine* or *Modern Bride* for fresh full-length ideas. Considering the importance of the bridal formals, sometimes I'll reshoot a few ideas after the ceremony because the bride is more relaxed then.

12. First Half of a Double Exposure

This special-effect photograph is really two shots in one. It works best with cameras that have interchangeable magazines, and it helps to use a tripod. If you plan things carefully, you will do the first half of the double near the end of the first roll of film so you don't tie up a magazine unnecessarily.

In the first half of the double exposure, I photograph the bride's face in an upper corner of the frame while blocking off the remaining three-quarters of the composition. For this "in-camera masking," I use my hand to block off part of the frame, creating a soft-edged mask so the two images will eventually blend. By stopping the lens down to the taking aperture the edge of the mask comes into focus allowing me to see exactly what I'm blocking and what I'm including. I position the bride's face within the frame so that she is looking down at the opposite (lower) corner of the composition. After the first exposure I "save" this magazine without advancing the film, and later when I get to the church, I reattach the magazine and photograph the church interior with the alter in the place that the bride's face is looking. When I do the second exposure, I use a dark slide or a small piece of black cardboard to block off the quarter of the frame where the bride's face is.

Using Masks

To make double exposures, some photographers make black paper masks that slip into slots on the front of a matte box lens shade. This allows them to be very precise in placing the two images within the frame. The mask used when shooting the bride's face covers three-quarters of the frame and is large enough to support itself in the shade. However, the mask used when shooting the church (covering only one-quarter of the frame) won't stay in position without some type of support. This can be solved by mounting it onto a sheet of clear plastic. When the two masks are aligned, the image is completely blacked out.

Some shooters prepare a whole set of two-part masks for different situations, each made from black paper glued to clear plastic sized for the matte box they are using. Personally, I find it faster to work with my hands, darkslide, or pocket datebook (or some combination of them), but going the mask route is more reliable.

This is what the double exposure of the bride looking at her ceremony looks like in its completed form. You can make photographs like this only if your camera has interchangeable magazines. Take the first photograph at the bride's house and remove the magazine from the camera without advancing the film. Save the magazine until you get to the church and take the second half of the image. The only tricky part is to remember where you placed the bride in the first image.

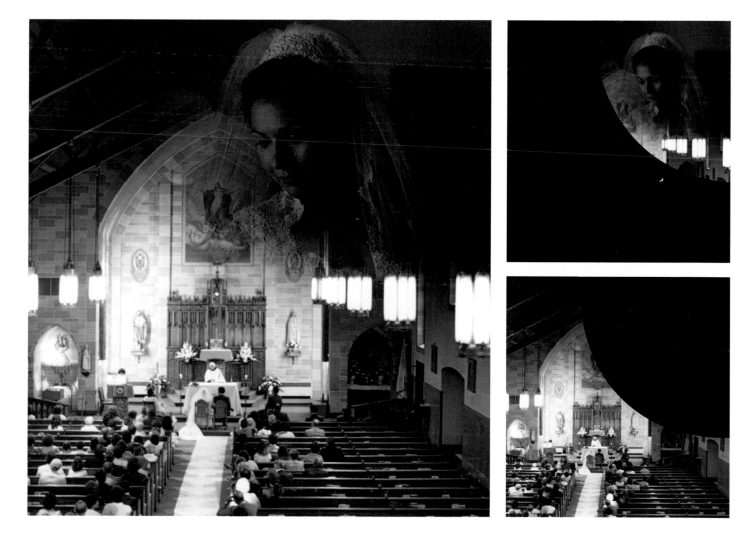

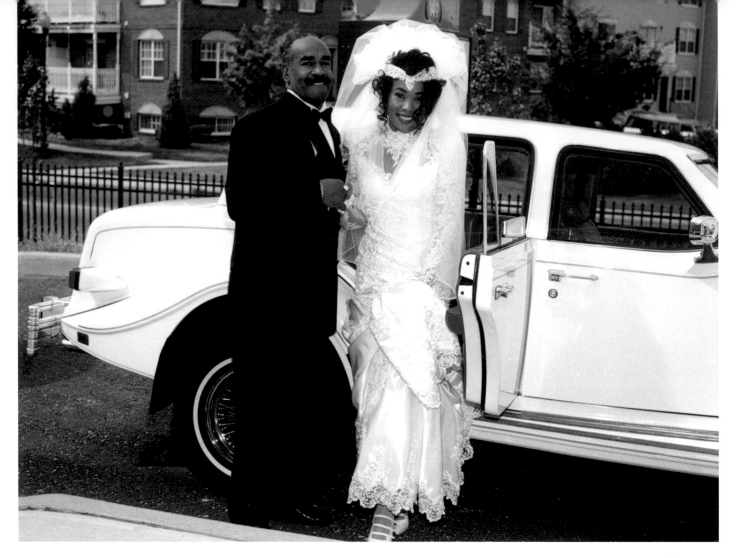

A photo of the bride being helped out of the limo by her father makes a perfect segue between images taken at the bride's house and the wedding ceremony.
Photo © Jan Press Photomedia

Leaving the House

1. Bride, Parents, and Bridesmaids in Front of House

This photograph gets all the principals and the bride's homestead in one photograph. It can be argued that if you're late to the bride's home (a flat tire, a car accident, your pet goldfish died, you had another wedding just before this one,... etc.), this is the one picture you must get. All the other photographs that you would have taken at the bride's house can be picked up later in the day. From mirror shots at the catering hall through formal bridals at the park after the ceremony, everything else can be patched up as the day progresses. But once you leave the bride's home for the church, you won't be returning there for the rest of the day.

2. Dad Helping Bride into Limousine

One night I was talking to a very good wedding video cameraman. He was doing a slow pan of a Viennese dessert table, and he was also shooting individual displays of desserts for wipes and dissolves. I asked him how he chose which ones to shoot, and he said, "If it costs extra money, I shoot it."

Now back to the limo. Limousines cost extra money. Couples spend even more money on top of that for specialty rides. Antique cars, white Rolls Royces, horse-drawn buggies, and other unique vehicles often spend their weekends hauling around bridal parties. If the couple went to the trouble of hiring a limo...or an even more unique vehicle...I include it in the pictures. After all, it cost extra money.

Arriving at the Church

1. Dad Helping Bride out of Limousine (or variations)

This picture doesn't really have to be of the bride being helped out of the car or limo by her dad. It could be the bridal party, the bride and the crowd, or the bride and her mom standing together. Whatever I shoot, I try to include the church in the background of this photograph. If the church is beautiful, this type of photo can set the scene for the ceremony section of the album. If the church exterior isn't photogenic (or the weather is crummy), I forget the limo shot and try to catch a photo of the bride and her dad in the church vestibule. This totally candid moment between the bride and her dad is often filled with emotion. Sometimes you can ask the bride to kiss her dad on the cheek or ask the father to kiss his daughter on the forehead... mom will cry for sure...AND they'll buy the photo!

All of this must happen quickly. I can't waste a lot of time, because I still need to meet the cleric and the groom before the ceremony starts. Before I walk down a side aisle to introduce myself to them, I stash my tripod in a rear pew of the church so it's available quickly when the time comes for some fairly long exposures during the ceremony. Last, I drop my small camera bag filled with film and spares in a front pew on the side of the church. Now I'm ready to go meet the minister (or priest) and groom.

Sync Check, Take Two

Check your sync and the frame number you're on before the ceremony starts! If you are on a "short end" (the end of a roll), it pays to dump it and enter the aisle with a full load. If you're using a camera with interchangeable magazines, switch to a fresh one now. You won't be able to change film easily once the processional begins!

THE CEREMONY

Although I am a hard-core professional, I try to remember that the reason for the entire wedding day, from flowers to fancy limos, is the ceremony. Without it there would be no bride, groom, or party to shoot in the first place. On a pragmatic level, your respect for the institution will also make your dealings with the clergy much easier. In the scenario this repertoire is painting, once you arrive at the church you have two important contacts to make: the person performing the ceremony, and the groom.

Meeting the Cleric

Once you walk into the church you are on G-d's playing field, and the cleric is the referee. Clergy have specific ideas about where, when, and how to take pictures in the church and during the ceremony. In their house, they make the rules. Because of this, I usually seek out the cleric first before meeting the groom.

In a small community it is good business to be friends with the local clergy. The longer you are in the business, the more familiar you will become with the churches and the clergy in your area. There have been times, on a busy weekend, that I have seen the same priest in the same church four times! Cultivating a good working relationship with area clergy will serve your reputation well.

Just as I do when I meet the bride in her home, I have a few agendas to cover when I introduce myself to the cleric. First, once again, I want to become an insider. After all, it never hurts to have G-d on your side! Usually the first words out of my mouth after "Hello Father," "Pastor," or whatever are, "Are there any rules you would like me to observe?" This question accomplishes a few things: I get information not only about the ceremony I will be photographing but, more importantly, about how rigid the cleric is. If I'm presented with a laundry list of "Don'ts," my first response to just about every "Don't" is to say, "I wouldn't do that!" If the cleric tells me he or she has seen too many photographers who have broken the rules, I usually say, "I don't know what other photographers do, but I know that I don't." Actually, I'm being very sincere, because I really don't want to do anything to spoil the couple's day. On the other hand, if the cleric tells me, "Anything goes as long as you don't climb up on my shoulders!" I know that the situation is more relaxed. Some clergy do not allow flash during the ceremony, others don't care, some will re-pose the important pictures after the ceremony, and even though I know there is no eleventh commandment "Thou Shalt Not Use Flash," I go along with the clergy's requests. Remember, it's their playing field.

After reading the cleric, I ask questions about the ceremony. Is it possible for the bride and groom to face each other during the exchange of rings? During the exchange of vows? Is the couple making any presentations or coming off the alter to greet the parents? Are they lighting a candle? Where will the candle be? When will it happen? Absorb, absorb, absorb.

My last question is conspiratorial. I ask if another ceremony is being performed in the church after this one. This helps me know how to pace myself, for instance, whether I should rush my photographs after the receiving line. These questions are usually the clincher, because the clergy know I am now thinking about their schedule as well as mine. This puts us on the same team! This two-minute investment of time usually leaves me satisfied with my relationship with the cleric. I can now turn my attention to the groom and best man.

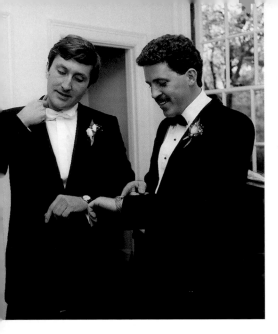

The second shot of the groom and best man can be a traditional grip and grin pose, or you can get a little corny by featuring tight collars and nervous glances at wristwatches.

Meeting the Groom

Meeting the groom is just like meeting the bride...except. When you meet the bride at her house, it is an hour or two before the ceremony. When you meet the groom, the wedding ceremony (probably the most significant life change he's ever experienced) is staring him right in the face.

If you're a studio owner, this is the first time you will be seeing the groom on his wedding day. If you're a candidman, this will probably be the very first time you will have met the groom, ever. Since you're going to be photographing this person for the next five to seven hours, first impressions are important. You could walk up, say hello, shake hands, and off you go. If only life were so simple. While the bride hadn't yet reached a precipice of panic when you met her, the groom is definitely there! And, although you had an hour to build a rapport with the bride, you've got just 30 seconds (literally) to make the groom comfortable with you. That is one tough act! So right after my hello, I usually start by telling the groom that his bride is GORGEOUS, and that she's a little nervous, too. Misery loves company. I shoot an easy photograph of the groom and best man shaking hands with some church-type stuff in the background, and then I'm off to the foot of the aisle.

The Ceremony List

Groom and Best Man: Two Frames (possibly the second as a gag shot)

As I've just mentioned, a photograph of the groom and best man in church can be a simple affair, but sometimes a corny gag shot can also be fun. I've seen pictures candidmen have taken of the best man holding onto the groom's coattails as he tries to bolt for the door, the best man wiping the groom's brow with a handkerchief, the best man pointing to his wrist watch as the groom tries to stretch his shirt collar with a finger tip, or as one last simple idea, you can always shoot the best man adjusting the groom's tie or boutonniere. Although I personally find some gag images tasteless, they do offer a variation on the typical "groom and best man shaking hands" shot. In certain instances, when the groom seems especially close to the person performing the ceremony, I've included him (or her) in a photograph with the groom and best man.

The Processional

For many people, the bride being escorted down the aisle by her dad is the most important photograph in the album. The problem is that many candidmen go weak in the knees when it comes time to shoot pictures of people walking straight at them.

There are some things you can do to ease these picture-taking willies. You can't possibly focus on your subject and shoot the picture simultaneously as he or she is walking towards you. By the time you move your hand from the focusing ring to the shutter release button, the subject will have moved out of the plane of focus. So, prefocusing on a specific pew can be a great help. When the subject is one step away from the prefocus point, raise the camera to your eye and push the shutter button. By the time you've brought the camera up, the subject will have walked into the prefocused spot!

There is another way to prefocus, but it requires a lot of practice. In this technique you must learn to judge distance accurately. All you need to do is preset your focusing scale to a specific distance (let's say, 10 to 12 feet [3 to 3.7 meters] with a 50mm lens on a 6 x 6cm camera). After all the practice I've had, I've learned how large the subjects look in my viewfinder when they are the correct distance away from my camera. My brain (twisted as it is) even takes into account the different heights of different subjects in order to simultaneously fill the frame and ensure sharp focus.

1. Mothers of Bride and Groom Being Escorted Down the Aisle

These two photographs are important because many times a mother is escorted down the aisle by one of her sons. While both pictures are important, I always take a moment to introduce myself to the groom's mom as soon as she is seated (remember, we haven't met yet). Because the ceremony is about to start, there isn't a lot of time, but I can usually say, "Hello, I'm Steve. Congratulations— We'll talk after the ceremony." Our after-the-ceremony "talk" will probably be limited to "Congratulations." While this may not seem like much, my simple introduction lets her know that I know who she is, and it helps break the ice for shooting the groom's family pictures later.

2. Each Bridesmaid Walking Down the Aisle

Many studio owners feel that a picture of each bridesmaid walking down the aisle is a waste of film. To a certain extent they are right. I've found that these pictures are used very infrequently in an album. They are effectively competing with those taken of the bride and her maids at home. However, the bride's and groom's sisters walking down the aisle are definitely worth a frame each. Even if they don't make the bridal album, they may be used in a parent book.

3. Maid of Honor Walking Down the Aisle

The maid of honor is usually the bride's best friend or a close sister. A picture of her often makes it into the album, and even if it doesn't, the bride often presents a print to her as a memento.

4. Flower Girl and Ring Bearer

As I've said many times before, little kids are cute. Pictures of them always seem to be purchased by someone. Many times they are the couple's nieces, nephews, or cousins. If the photograph doesn't make it into the main album, someone else in the family will buy the image.

Although all the other aisle photos are taken from an identical distance, these shots require the candidman to wait for the subjects to take one extra step closer to the camera so they fill the frame. This requires that you change the focus setting and the f/stop, but the results are worth it.

Children are cute to begin with, but at weddings they're all dressed up in their Sunday best, festooned with boutonnieres and flower baskets. There are usually three customers who want these pictures: the bride, the children's parents, and their grandparents. With so many possibilities for a sale it's worth investing a few frames of film on the little ones. Photo © Corel Corporation

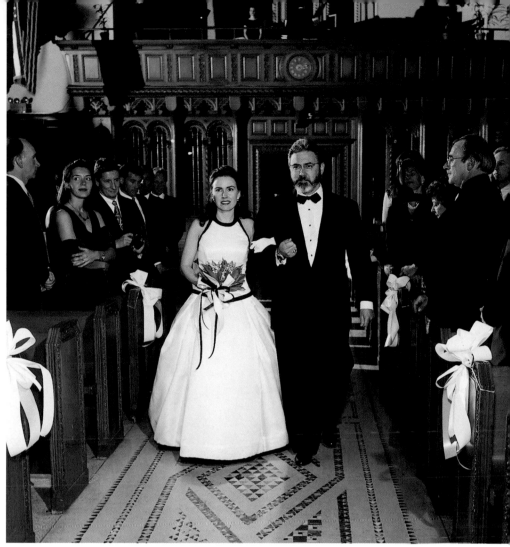

One of the most important images of the whole day is of the bride walking down the aisle with her father. This example shows the effect that room lights can have in illuminating the background and guests. While the bride and her father are lit by the two battery-powered frontal lights, there is a third AC-powered light set off to the side that is illuminating the rear of the church. Some of the third light's output is spilling onto the right side of the bride, but the overall effect is that the "miner's helmet light" look has been eliminated. Photo © In-Sync Ltd.

It is very important that you remember to reset the camera for the bride and her father walking down the aisle because they are next on deck—and that shot is the most important one.

5. Bride and Dad Walking Down the Aisle: At Least Two Frames

As I said before, this is "The Shot" to get at the church. Every album I have ever seen (and that's been thousands) has a picture of the bride in the aisle. While in many other situations, one frame of film is all that's required, in this instance you should splurge. Without this picture you have not completed the assignment, no matter how nice everything else looks. You can produce a beautiful 80-photograph album, but if you miss this picture, your "great wedding photographer" reputation will be very tarnished... at least in the eyes of this bride and groom's families!

With today's SLRs the mirror flips up and blocks the viewfinder at the moment of exposure. It's amazing how many brides and their dads glance at people along the aisle at that same moment. If they don't do that, then they blink. With a little practice, you can lock the camera in position and then move your head so you are looking at the actual subjects

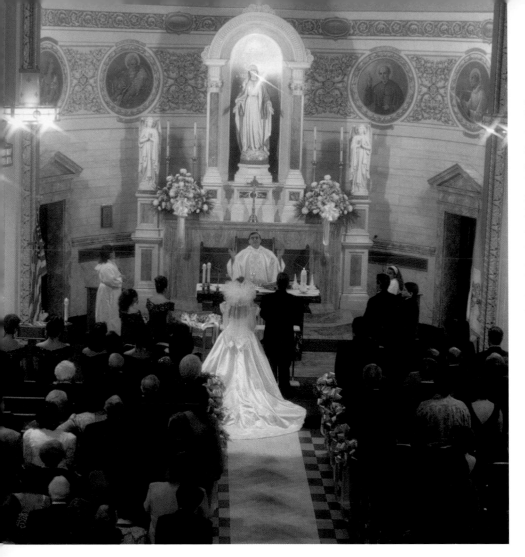

Once you've gone to the trouble of getting up to the choir loft, don't limit yourself to just one photograph. Shoot a few overall views of the scene below you. Try a frame with a soft-focus filter or a star filter in addition to a straight shot even if the straight shot seems perfect.
Photo © Glenmar Photographers, Inc.

instead of the image on the ground glass. That way, you can see exactly where the subjects are looking the moment you press the shutter release without having the mirror block your view. This is a technique that's well worth practicing.

6. Dad's Kiss Good-Bye

This scene is always viewed through tearful eyes, but you, as the candidman, can't afford to enjoy the precious moment, you have to record it.

If you back up into the alter area, getting this picture can be tricky—you run the risk of people blocking your shot. Filling the area where the father is kissing his daughter good-bye are: the groom, the cleric, the best man, the maid of honor, and assorted ring and flower little people. Not only are all the big folk approaching the bride and her dad, but as you try to position yourself, you have to avoid the stationary or moving children! Shooting the father kissing the bride from the "alter side" can sometimes leave me feeling like a pinball in an arcade game.

By doing some fancy footwork you can avoid the "alter-side" trap. Right after I shoot my last photograph of the father escorting the bride down the aisle, I stop back-pedaling and step forward, towards them. As I'm moving forward, I step to the bride's father's side of the aisle. I then step up against a pew as the bride and her father pass by. Right after they glide past, I re-enter the aisle behind them, being careful to avoid stepping on the bride's train. I take one more step back up the aisle, away from them, and when I turn around to face the alter the father is kissing his daughter good-bye right before my eyes. AND, all of the "problem people" in the "alter-side" scenario are now background onlookers helping my picture instead of potentially ruining it! As an added benefit, I'm approximately the same distance away from the subjects as I was when I shot them coming down the aisle (but now I'm facing the opposite direction), so without changing my camera's settings I can literally lift it to my eye, frame the shot, and push the button. That is, only if my picture is rushed. Given a few extra seconds, I reset the camera and move a step or two closer to the bride and her dad.

Although this dance of the candidman generally works well, there are some important rules worth remembering: 1) You must step to the "father's side" of the aisle as you're moving forward so that when you re-enter the aisle, you have less chance of stepping on the bride's train, which is a definite no-no; 2) If the aisle is very narrow (or very short), you might not be able to "get by" the bride's father, and your only recourse is the dreaded "alter-side" view; 3) The priest or minister may ask you to stay in one position during the processional. Whenever I'm faced with having to shoot from the "alter side" for the kiss good-bye, I consider it a challenge as opposed to a problem. It's a harder photograph to do than the "aisle-side" photo, but that can keep life interesting.

Readings or Music

During the readings or special musical entertainment, you must work as candidly as possible...that is, if you decide to photograph them at all. Since I left my camera bag in a front pew, it's readily accessible, and I can change to a longer lens and try to shoot these from a side aisle. I try to get these shots early so I can then leave the front of the church and go to the back, where I stashed my tripod, for the next few shots.

Second Half of a Double Exposure

Remember back at the bride's house when we did the first half of a double exposure? (See page 32.) Now is the time to find that film magazine and re-attach it to the camera. I use a dark slide to block off the area where the bride's image is and arrange my composition so that the bride appears to be looking down at her own ceremony. Although I used my hand to create a soft edge on the first half of the image, the hard-edged dark slide will suffice now because the soft edge of the first image is enough to create a nice blend.

You may be nervous the first time you do this, but after a while these types of simple double exposures will become the proverbial piece of cake. By the way, a photographer once told me that his long exposures of the church are always 1 second at f/4 on ISO 160 color negative film. In general, I hate sharing exposure information because of the variables involved in every situation, but after shooting 3,000 or so weddings I can tell you that 1 second at f/4 on ISO 160 film is usually just about right, as long as the sun isn't streaming through the church windows!

Because doubles sell, other double-exposure possibilities are worth exploring. If there are great stained-glass windows in the church, you might try shooting the couple at the alter while blocking off the top of the frame. You can then make a second exposure of a suitable piece of stained glass. One photographer I know often photographs the facade of the church while blocking off the area where the church doors are. The second half of his double is an interior view of the alter, positioned in the frame where the church doors would have been in the first half. When he does the second half of this double, he masks the parts of the frame that overlap his exterior view. The resulting double exposure is of the ceremony floating on the church facade where the doors would be. It's very effective.

While you are in the choir loft, remember to look for a stained glass window that might work as part of a double exposure with an image of the couple at the alter.
Photo © Glenmar Photographers, Inc.

Long Exposures from Rear

After the second half of the double exposure it's time for some overall views of the scene. Slower shutter speeds are possible and often necessary with these long views to achieve good exposure. And don't worry too much about motion blur, because even if someone moves, they will probably be too small in the frame to have it be noticeable.

You can do some things to add variety to these photographs, which can result in multiple sales. Place a star or soft-focus filter over your lens to create an interesting, romantic effect. Look for a door leading to the choir loft and get a bird's-eye view of the proceedings. Or, you might take your camera off the tripod and lay it on the floor for a worm's-eye view. If you go the floor route, you can slip your pocket calendar or wallet under your lens hood to raise the front of the camera a bit. Last, you might consider taking a few frames with a wide-angle lens and then switching to a short tele for more possibilities.

Once again, there is no time to dawdle. The instant you're finished with the long exposures it's time to put the camera back onto your flash bracket, because the ring exchange is next.

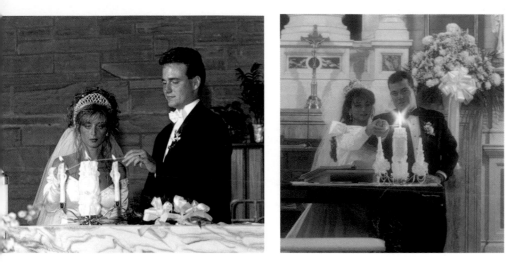

A candle being lit during the ceremony is always an important shot and can be done in two ways. You can take the photograph with a single flash or double light, or you can shoot the picture by available light if you have time to change your shutter speed and f/stop and mount your camera on a tripod! The latter method picks up some of the ambiance of the moment but is more difficult to control because of subject or camera movement. Trying to shoot the scene by candlelight is worth the effort, and you might be able to pose the photograph with flash after the ceremony. But, if you don't know whether you'll be able to repose the picture, using flash will guarantee a sharper image.
Flash photo © In-Sync Ltd., ambient photo © Glenmar Photographers, Inc.

Rings Times Two

Most ceremonies today include the exchange of two rings, and that's worth considering when you plan the album. It is a very easy sale to suggest placing both ring shots on facing pages. If it's only a single-ring ceremony you lose out, but that one shot is still a keeper for the album.

Candle Lighting

Very often today's couples light a candle during the ceremony. Because my camera's not on a tripod when this happens, I try to shoot a hand-held exposure just by candlelight, and if I can throw on a star filter, so much the better. Before I gamble on my steadiness however, I try to grab a quick shot with flash. While the flash picture isn't as unique, it is cheap insurance if my steadiness isn't up to snuff. If I can't get an available-light exposure of this moment, it can sometimes be posed after the ceremony, but even then it's usually rushed.

Special Traditions

1. Mass

It's hard to believe, but the most difficult thing to do during a wedding Mass is to stay focused (pun intended). During a simple wedding ceremony there is always something to shoot, and there is little down time. Everything you do must be carefully orchestrated to fit within a very limited time span. However, a ceremony that includes Holy Communion features long periods of time during which you do nothing but wait for the next photo op. While this may seem like a piece of cake, it could turn into a series of missed opportunities. Forewarned is forearmed, ...so leave your Nintendo game in the car and stay alert!

2. Couple Kissing at the Sign of Peace

Very often the priest or minister doesn't allow the couple to kiss at the end of the ceremony. But between the vows and Holy Communion (if it is offered), there is often an intimate moment between the couple at the Sign of Peace. So before the service, one of the questions I ask the cleric is if the couple will kiss at that point. If so, I place this moment in my repertoire. I also ask if the couple is going to share that moment with their parents. If the answer is yes, then...

3. Bride and Groom Kissing Parents at the Sign of Peace

When the bride and groom come off the aisle to exchange greetings with the parents, you are faced with an interesting dilemma. Usually the bride goes to the groom's parents while the groom goes to the bride's. After the exchange of kisses the couple switches sides, and each greets his or her own parents. If you try to shoot the bride with the groom's parents, you miss the groom with hers, and when the two exchange places you're faced with the problem again. I wish there were some pat answer for this, but there isn't. Who's paying your fee?...you make the choice. Whichever way you go you'll be leaving someone out. Even if you try every trick in the book to speed up the operation of your camera, you will still probably be limited by your strobe's recycle speed. Get over it.

In the rare instance when the couple (as a unit) greets each set of parents, your problems still aren't over. As the bride kisses the groom's mother she leans forward, effectively blocking the exchange between the groom and his father. It happens again on the bride's side, but now the groom is the blocker (and the bride's the blockee). Once again, get over it!

4. Drinking Wine and/or Receiving the Host

Photographing the bride and groom receiving the host and drinking the wine during Holy Communion is a bit tricky. In the first place, you're going to need to take at least four frames in rapid succession, so you need to check which frame you're on (just as you did when the bride was coming down the aisle) and reload your camera if necessary. You can often get these pictures through the door to the

sacristy, but it still requires quick thinking and reactions. Watch out for wine cups and hands blocking faces. Sometimes the bride watches the groom, or vice versa, and that too makes a great image. So as not to intrude on this sacred moment, it is a good idea to use a medium or short telephoto lens.

5. Presenting Flowers to the Church

Often at the conclusion of the ceremony the bride will present a bouquet of flowers to the church. In all the times I've seen this, she has been accompanied by the groom as she lays the flowers at the base of one of the statues in the church (Blessed Mother, Our Lady,...etc.). Sometimes you can move in for a close-up of the scene, but you might consider shooting from a greater distance to include the groom, statue, and some of the ambiance of the church. If you move in too tight on the scene the shot can become meaningless...after all, the statue and floral arrangement could be anywhere. Including the groom in the scene is a nice touch because this is one of the first things the couple does as husband and wife.

6. Other Religious Traditions

In different parts of the country there are sizable ethnic communities that don't have typical religious ceremonies such as those I've discussed. Many of these communities can be large enough to support a wedding studio all by themselves. Developing an ethnic specialty can be very lucrative. In the greater New York area (a diverse melting pot) there are large communities of Italian Roman Catholics; Greek Orthodox Catholics; Ukrainian Catholics; and Reform, Conservative, and Orthodox Jews to name only a few. Some religious customs you might encounter include placing floral wreaths on the bride and groom's heads, binding the couple's hands together, breaking a glass, and the bride and groom circling the alter.

Through my years of photographing weddings for these groups I have found that first (and sometimes second) generation immigrants tend to buy pictures.

Why is that? Though many of these people left their countries willingly, they also left behind their roots. Language barriers and differences in customs sometimes make assimilation into American culture difficult, therefore preserving both family and community customs offers these communities a sense of comfort and security within this new, foreign culture. This makes their family photographs treasured items, which can be very profitable for a good photographer. Shoot a photograph of grandma, and you'll sell a bunch of photos!

These groups also have a tendency to be clannish, and if one member uses a particular photographer, many others in the community follow. With this thought in mind, investigate the ethnic groups living in your area. Try to understand their

Capturing a full-length photo of the couple coming back up the aisle is easily accomplished using a wide-angle lens. If you prefocus, the whole operation can be done before the other bridal party members stack up behind the couple. Speed is important because you can't stop the recessional, and the bridal party is usually right on the heels of the bride and groom. Photo © Jan Press Photomedia

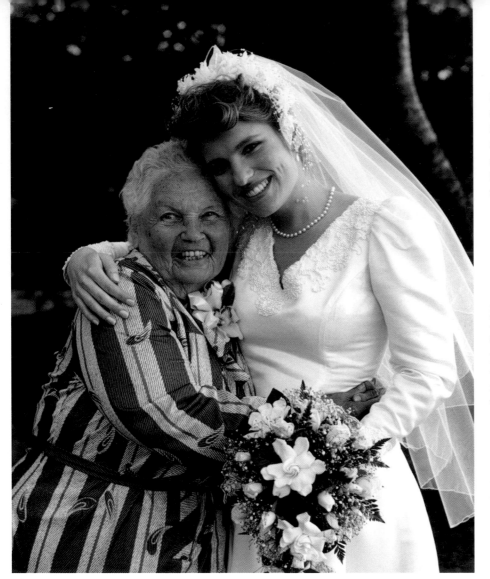

(3 meters) away from them, which is what my camera's distance scale is preset to, lift my camera to my eye, and press the shutter button. As when shooting the processional, you must learn to estimate distances accurately. Thankfully, estimating distances between 5 and 15 feet (1.5 to 4.6 meters) is pretty easy. With shorter and longer distances I find it harder to be accurate.

Receiving Line: Three to Twelve Candids (Finish the roll of film you're on, if possible.)

Because I use multiple magazines with my roll-film camera, I often find myself with two or three magazines that are each near the end of the roll. I started a fresh magazine for the processional and a fresh magazine for Holy Communion. Now is the time to finish off all of these half-used rolls. Try to concentrate on getting candids of parents, grandparents, siblings, and other bridal party members.

Sometimes the receiving line is positioned outside at the front of the church. If this is the case and there are stairs leading up to the church entrance, I put my camera on a tripod and work from the top of the stairs. (I'm always on the lookout for a different viewpoint.) Even though some might think candids are hard to shoot with a tripod, I find that a tripod allows my shots to have greater depth of field because I can use slower shutter speeds, and it minimizes camera shake. Also, I can pick up some great candids with a short tele lens.

As soon as I have a few candids, I put my shoulder bag and tripod into my car because I want to travel light for the next group of pictures. All you'll need is your

culture and their photographic needs. Ask their clergy what is important photographically and find out why those scenes are important. You might find yourself with a lucrative specialty.

The Recessional

The recessional can turn into a bit of a footrace, so you have to be on your toes. Like the processional, it is a time for prefocusing so that you don't have to worry about focusing on the subject as you backpedal up the aisle.

1. Bride and Groom: At Least Two Frames

If you've been relating well to the bride and groom up until now (and as mentioned earlier, that's an important part of the game), it should be easy to catch their eye for a photo of them looking at the camera. Before you try that, though, watch to see if they stop by their parents on their way back up the aisle. Sometimes

they stop for a kiss from a grandparent. Keep your wits about you! A shot of the recessional with the couple smiling at friends as they pass by is often as interesting as a shot of them looking at you.

2. Bride and Groom: Kissing in the Aisle at Rear of Church

When the couple reaches the very end of the aisle at the rear of the church, I usually ask them to stop and kiss each other. I wait for them to get to me and then say to the groom, "Stop here and give her a kiss." Be warned, though, if you can't get this shot quickly, things are going to get crowded very fast because other bridal party members are coming up right behind the couple. Therefore it is imperative to take this picture by prefocusing. There just isn't time to stop the couple, backpedal, and saw at your focusing ring.

While they are moving their lips towards each other, I backpedal 10 feet

Catching a shot with the rice in midair is easy if you can cajole the crowd into working with you. By dragging the shutter a little (say, 1/60 second), you can blur the rice a bit, which adds to the effect.

camera, a flash, and an extra magazine or, if you shoot 35mm, an extra roll of film.

Two Quick Pictures of the Bride and Groom with Each Set of Parents

Once the receiving line is finished (with a big wedding it can take 30 to 40 minutes), I try to get a shot of each set of parents with the bride and groom. I arrange the two women (the bride and a mom) in the center with both men (the groom and a dad) on the outside. I have the men shake hands with each other, and their outstretched arms form the bottom of my composition. While I usually get some candids of the parents and couple exchanging hugs, this posed picture is usually the one that makes the album because all four faces can be seen. It is also an easy two-picture sale because the couple can't slight either set of parents by leaving out one set or the other, and the two photos together make a great album spread.

1. Possible Pictures of the Couple with Their Grandparents

Sometimes, elderly grandparents make it to the ceremony but don't go to the reception. If that's the case (and you'll know only if you ask), then you should get some photos of them at the end of the ceremony. At the same time, if the grandparent is the bride's mother's mother or the groom's father's father, you should pick up a three-generation picture. This photograph is almost always included in one album or another, and having three (or even four) generations of a family in one photograph is a nice thing to have (see page 28).

Leaving the Church

While I'm shooting the photographs of the couple with the parents, I try to work very quickly because there is usually a large group of guests milling about outside the church waiting to throw rice or confetti at the bride and groom. However there is another reason to work quickly. Church time during the wedding season is often at a premium, and frequently there is another bridal party waiting to use the church for their ceremony. If you didn't have time to ask the cleric at your first meeting, now is the time to touch base and find out what his or her schedule is like for the day. Your consideration for the church's schedule will always be well received and appreciated, and may result in recommendations later!

1. Bride and Groom: Silhouette in Church Door

One of the easiest special effects to do is a natural-light silhouette, and an ornate church doorway gives you the perfect opportunity to shoot one. I ask the bride and groom to stand in the church doorway facing each other, and I have the groom place his hands on the bride's waist. I turn off my flash unit and set my camera's f/stop and shutter speed for an exposure that is correct for the light outside the church. I stand inside the church, looking out towards the doorway that's framing the couple. The resulting picture silhouettes the couple in the doorway, and I have a winner...as long as I remembered to turn off my flash unit!

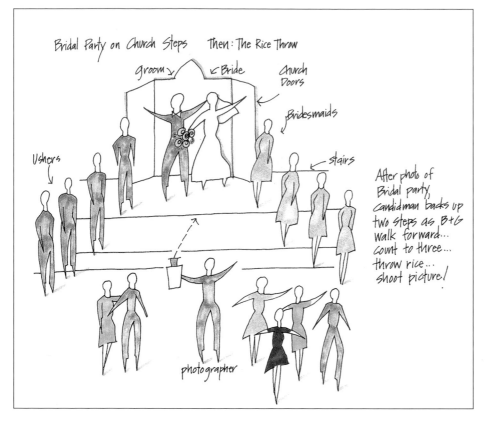

Bridal Party on Church Steps Then: The Rice Throw

groom Bride Church Doors
Ushers Bridesmaids
stairs
photographer

After photo of Bridal party, candidman backs up two steps as B+G walk forward... count to three... throw rice... shoot picture!

2. Bride and Groom with Bridal Party on Church Steps and the Rice Throw

Trying to get a photograph of the bridal party on the steps of the church while controlling all the guests who are waiting to pelt the bride and groom with bushels of rice is an exercise in mob psychology. I usually line the bridal party up inside the church (women to one side, men to the other, in order of size, with the bride and groom in the middle flanked by the maid of honor and best man) and tell them to wait there for an instant while I go outside to talk to the crowd. The next part is tricky.

I walk out onto the top step of the church, and as I look at the crowd I say loudly (with a big smile on my face), "I heard some people here want to throw some rice at the bride and groom, and I want a picture of it!" Then, after the laughter and jeers die down I say, "Look, if we all wait until I count to three, we can pull this off together." By using the pronoun "we," I've made myself part of the mob. Next, I pick out some young person in the group, look him right in the eye (again with a smile on my face), and

say loud enough for everyone to hear, "Now remember, when I count to three....No cheating!" It doesn't really matter whom I single out (although I try to single out someone I think could be trouble), it's just something I do to repeat the message for the crowd, and I always do it with a smile!

I then go back inside to the bridal party and tell the bride and groom (but directing my comment to the entire bridal party), "There are some people outside who want to throw stuff at you!" I then explain my plan to the bridal party. I ask all the ushers and bridesmaids to file out first and form a "V," then, at the last moment, the bride and groom will step through the doorway and stop in the center of the V.

As the bridal party is filing out, I move into the crowd saying all along, "Remember now, wait until I count to three!" By the time I get into position, the bridal party is in place, and I grab a quick shot of the entire bridal party in front of the church. This picture has to be made quickly because my control of the crowd doesn't last long. The instant I get my

picture, I immediately tell the bride and groom to start walking towards me, and I start to count loudly to three. The trick is to get to three when the couple is about 12 feet (3.7 meters) away from me. My camera is prefocused to 10 feet (3 meters). As they cover the last 2 feet...the rice is in the air...I push my shutter button...and usually the bride and groom (and I) are rewarded with a scene that looks like a snowstorm! The downside is that I also get pelted with the rice and it gets into everything. Sometimes by the end of a double-ceremony day my tuxedo is filled with it. It goes with the territory.

Getting into the Limousine

As I mentioned previously, limo pictures are special because the car itself is out of the ordinary, and it helps signify that the day is something extraordinary. Cars are so much a part of American culture that they can't help but creep into the gala event you're shooting. For some people, a ride in a limousine will happen only on their wedding day. Other people may hire other types of exotic or antique autos. Actually, I have done many a wedding where the bride and groom travel by horse-drawn carriage. I've seen Rolls Royce drivers in English chauffeur livery, rolled-out red carpets, champagne on ice in a silver bucket on an ornate stand inside, twenties gangster cars complete with gangster-type drivers, and I've even taken shots of a bride and groom laughing and hugging while they stood through the sunroof of their VW beetle. You can call it what you want, but to me, they're all limo shots. The more unique the vehicle is, the more I include it in the frame. Although there are a few other opportunities for getting great limo shots, you can pick up a few right now. As far as the album is concerned, limo shots taken before and after the church ceremony are great pictures that can be used to link the different parts of the day.

The bride and groom usually enter the vehicle from the curb, so if you shoot from the street, you might be able to get the limo and the couple, with the church in the background. If there's a "Just Married" sign on the trunk of the car, get

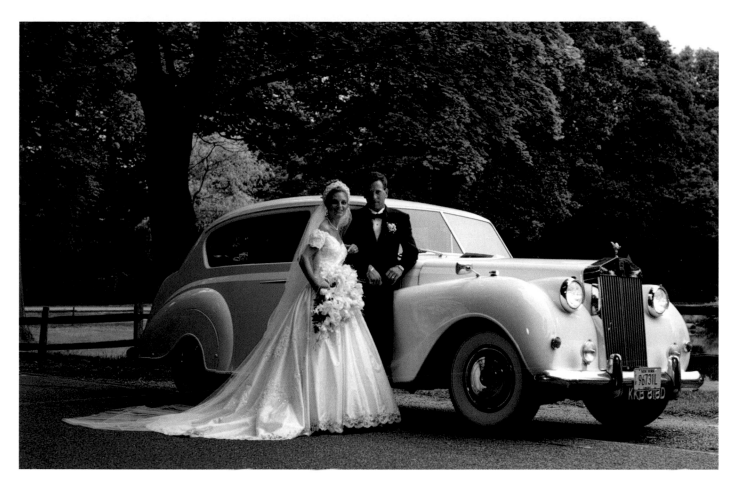

a shot of the couple with it now. It'll probably blow off later, once they're on the road.

1. Shooting through the Far Door, Looking in at the Bride and Groom

You can shoot through the limo's open street-side door as the bride and groom, standing on the curb, look at the camera through the limo's open curbside door. If that's your plan, check the traffic before you open the limo's street-side door.

2. Bride and Groom Looking out Limousine Window

You might shoot a picture of the couple through an open limo window. If that's the plan, use your camera-mounted flash to "open up" the inside of the car, but make sure the door frame doesn't create a shadow across the bride and groom when flash is used.

3. From Front Seat Looking into Back of Car

You might get into the front seat of the limo and shoot over the seat back. If that's the plan, make sure the window between the front and rear seat is down. Don't laugh...I've seen it happen.

➣ *Bride and Groom Toasting*
If the limo is equipped for a champagne toast, a picture is in order.

➣ *Bride and Groom Facing Camera and Facing Each Other*

➣ *Bride and Groom Kissing*

Finally, discuss with the couple where they would like to go for formal pictures and tell the limo driver two things: 1) where you plan to go, and 2) that you will be following him, so you both arrive at the same site together. Nothing is worse than losing the bride and groom as the limo speeds off! When you shoot weddings, you should always have local street maps in your car.

Unless they are very lucky, most couples won't get to ride in a Rolls Royce again until their kids get married, and then it will only be to the church. If the limo is unusual, invest a frame or two to create a salable memory. Photo © Franklin Square Photographers, Ltd.

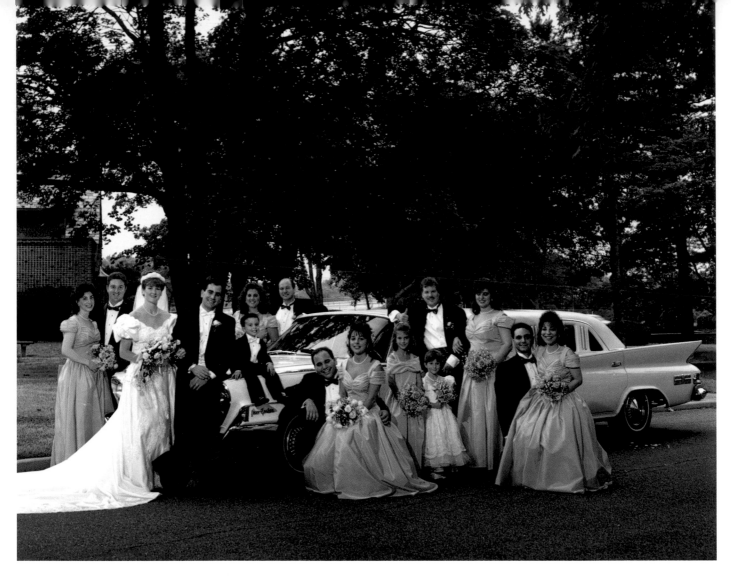

Sometimes a vintage car makes a better backdrop for a bridal picture than a park. If you decide on this approach, check with the limo driver before you seat people on the car's fender and bumper. Photo © Franklin Square Photographers, Ltd.

Faking the Getaway

If you decide to take formals on the church grounds, have the bridal party load into the limousines as if you were all going somewhere else. Have them drive around the block, and then come back to the church. Otherwise you'll be shooting formals with all the guests (who mill about in front of the church until the bridal party leaves) shooting over your shoulders! Before I bring the bridal party out of the church, I secretly explain my plan to them and tell them how it will make for better and quicker pictures. Everyone loves to be an insider on a conspiracy!

It is very important to clear this plan with the clergy first. Remember the words "please" and "thank you," and remember to smile. Sometimes I jokingly explain to the priest or minister that my life is over if he or she doesn't help me (a downtrodden, harried look helps)!

FORMAL PORTRAITS

After the ceremony and before the reception is a perfect time to fit in the formal portraits of the couple and the bridal party. The question is, where? Very often there is a park on the way to the reception hall. That is the easy solution, but there are many others. Some reception halls have beautiful grounds, and if the reception is at a golf or tennis club, these too offer nice backgrounds. It might even be possible to go to the groom or bride's backyard and shoot there. But don't overlook the possibility of using the church grounds. Not only are they convenient, but they can also be very beautiful.

In the late spring, summer, and early fall, finding a suitable background is a piece of cake, but finding a location on a rainy day or in the dead of winter can really test your creativity. Sometimes catering halls have a large, separate bridal room that can double as a studio. If not, the lobby can be used, or you might find a drape in the dining room itself which can be used to create a neutral background. Become friendly with the caterers or banquet managers at the reception halls in your region. These people can

It is always a good idea to keep your eyes open for stairways in parks and gardens. They offer natural tiers on which to pose a group, creating a much more pleasing picture than a straight lineup. A location such as this could just as easily be used to photograph the bride and her bridesmaids or the entire bridal party. Photo © In-Sync Ltd.

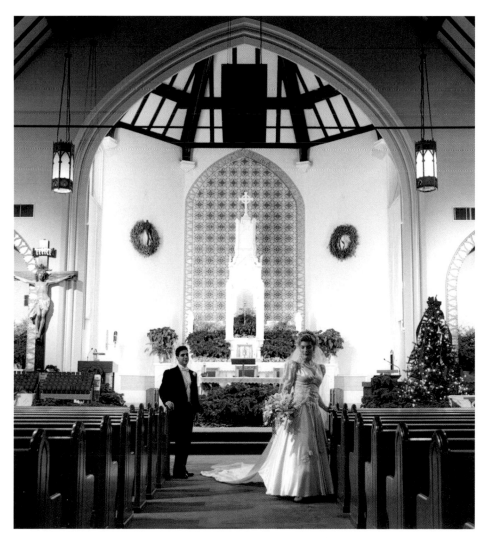

Even if you don't take all your formals in the church, you might try one or two quick photographs of the bride and groom using the empty church as the background. Not only did the photographer feature the bridal couple, but the church as well. While the bride and groom are lit by flash, the photographer put the camera on a tripod and set the shutter speed on the longish side to pick up the ambient light illuminating the alter. Photo © Franklin Square Photographers, Ltd.

help you easily come up with an appropriate background. There have been times when I've done all my formals on the steps of the church alter. Again, it helps to have good relations with the clergy in your area.

Other possibilities include going back to your studio or even to the bride's or groom's home for pictures (some living rooms I've been in are nicer than any catering hall or club). While many candidmen feel comfortable working in front of a simple drape, a living room set can also be beautiful. If that is the plan, remember to use staircases, chairs, couch arms, piano benches, and anything else that is handy for staging multiple subject levels. Try to stay away from lineups if at all possible (see the Framing and Posing chapter). For those days when I'm forced into working against the bare, wood-paneled walls of a VFW hall (for instance), I carry a 10 x 20 foot, gray dappled muslin background and support stands in a small case in the trunk of my car. It has often saved the day.

Before looking at the list of photographs, remember to shoot more than one frame of each picture. In fact, the number of frames you expose of each pose should increase with the number of subjects in the picture. It is easy to watch for good facial expressions and blinking when shooting one or two subjects, and with practice you can even catch these kinds of problems when shooting groups of three or four. Once you get to larger groups (five and up), especially in full-length situations where you are 15 to 20 feet away from them, it is impossible to watch everyone's face at once. With larger groups I concentrate on the bridal couple (or the little kids) and shoot more frames. Sometimes I do a countdown for the subjects and try to prepare them by telling them to get ready before I push the button.

Moving 15 to 20 people around a park as a unit can be frustrating, but there are certain things you can do to smooth the situation and make it less of a burden on your subjects. For instance, take the biggest groups first so you can send the bulk of them back to the limos where they can relax. Smaller groups are easier to organize, and I don't want any distractions at all when I'm doing bridal couple formals.

How well you relate to the bridal party is probably your most important tool when it comes to taking great formal pictures quickly. For instance, I always try to call everyone by name. Instead of saying, "Hey you!" or "Could the usher on the end drop his hand to his side?" I prefer saying, "Janet, point your left toe towards me," or "Bob, drop your hand down a little."

The Formal Portrait List

Entire Bridal Party

You should do this shot two different ways (remember to shoot three or four frames of each pose). One might be a tight grouping (see the Framing and Posing chapter, page 76), and the other might be of the group arranged by couples, spread out on a lawn, hillside, or wide staircase. If you do the second shot with a wide-angle lens (about a 50mm on a roll-film camera or a 28mm on a 35mm camera), place the bridal couple about 10 feet from the lens and put the rest of the couples 15 feet (or farther) from the camera. This will give you an interesting composition, with the bride and groom larger than their attendants.

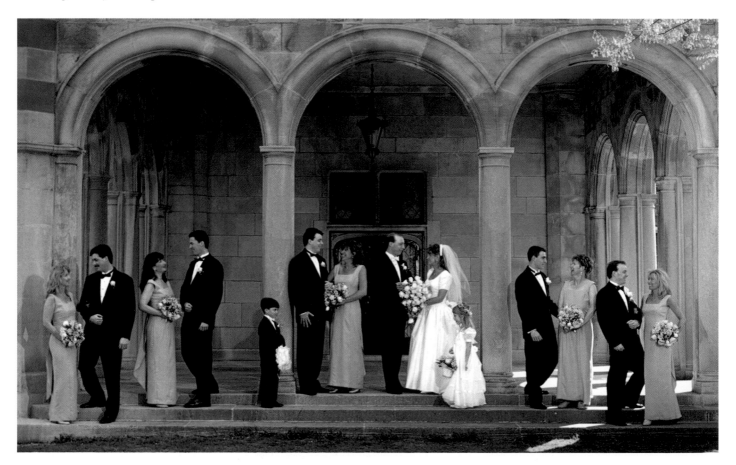

Sometimes the bridal party can be stretched out over a multi-level architectural structure. These panoramic images can make a nice two-page spread in the wedding album. They are very profitable, but if you decide to offer them, you have to take a few things into consideration. First, this type of presentation demands a 16 x 20 or 11 x 17-inch print, which requires a sharp medium-format negative. Second, when you arrange your subjects, you must consider where the break between pages will fall and not place anyone on that line. The photographer who shot this image was very aware of panoramic possibilities when he placed the bridal couple in an off-center position. Photo © Franklin Square Photographers, Ltd.

Telling the Twins Apart

When shooting multiple frames of group poses, remember to change something in every frame. It can turn searching through the negatives from a nightmare into a joy! It can be something simple like having an usher rest his hand on the shoulder of a seated bridesmaid instead of having it hang by his side, or having the groom put his hand on the bride's arm instead of hanging by his side, or something complex like switching the placement of the ring bearer and flower girl. Any change that lets you tell one negative from another is a blessing!

Quick pictures of the bride with the maid of honor or bridesmaids can be picked up anytime throughout the day. Arrange the faces close together or along diagonal lines, or use the bouquets to reinforce a diagonal composition. If you make the pose simple you can take five or six photos in a few minutes. Photo © Jerry Meyer Studio

Gag Shots of the Bridal Party

If the bridal party is playful, you might do two gag shots with the groom surrounded by a harem of bridesmaids and the bride encircled by a bunch of ardent ushers. Though these photos are sometimes tasteless, often they're just fun and popular.

Groom and Ushers (and optional, Groom with Each Usher)

While this photo seems self-explanatory, consider the personalities you're photographing. Sometimes they all have sunglasses, and a "shades down" photo is fun. Sometimes the groom can be laid across the usher's outstretched arms or a pyramid can be set up. Before you decide to try these ideas, try to read your subjects' reactions. Look for hints as to how frisky these guys are to gauge how far you can push things...but, if they go for one, they'll go for all of them.

Also remember, if you shot individual photos of the bride with each of her bridesmaids at the bride's home (see page 29), you should now shoot individual poses of the groom with each of his ushers.

Bride and Bridesmaids

Notice that you've already gotten this photograph at the bride's house. By shooting it now, however (a second time), it will match the photograph of the groom and the ushers, and the two can be used as an album spread. The first shot of the bride with her maids at the bride's house wasn't necessarily wasted. They may still choose to include it at the front of the album.

Full-length portraits of men can be a bit dull compared to those of the bride. For variety, try having your subject take off his coat and drape it over his arm or swing it over his shoulder, then have him place his hand in his pocket or on his hip. The finished picture might not have the impact of a full-length bridal portrait, but it will hold up well next to one. Photo © Three Star Photography

Bride, Groom, Maid of Honor, and Best Man

Bride and Maid of Honor

Groom and Best Man

Groom Alone: Four to Six Poses— Two to Three Full-Length and Two to Three Portraits

Sometimes, with all the hoopla surrounding the bride, it is easy to forget about the groom altogether. Don't do it! I once fell into this trap and shot a beautiful wedding but forgot to get a picture of the groom alone. Chop my fingers off! Banish me to Siberia! I did it! I'm guilty! I saved the situation by shooting the groom on another day, but I ate the cost of his tuxedo rental and boutonniere and threw in a few free 8 x 10 prints. Still, I got off cheaply. The couple was happy eventuallybut it took some doing.

Bride and Groom: Three to Four Different Poses (minimum)

One of these pictures will be the most displayed picture of the wedding, and everyone who sees it will consider it to be representative of your work. Because of this, I like to get the bridal party pictures out of the way quickly and concentrate closely on the couple. In terms of importance, these pictures rank up there with the bride and her father walking down the aisle. Good coverage demands 4 to 6 full-length poses and as many close-ups...probably a few frames of each. I try to get variety in both the posing and the background. No matter how lazy you feel (it's hot...you're late...), no excuses are allowed here. The only time that rushing these pictures is worth it is if the sun is going down and you're losing your light. You can't control the sun.

Variations on the Bride and Groom Portraits

Even though you are looking to produce a variety of basic bride and groom formals, you might try a few very different approaches for even greater sales potential. Most of the following don't fit into the classic definition of a bride and groom formal, but each can add to the overall look of an album. In addition, they can make great beginning or ending shots in an album and might even end up as a large-print (bigger than 16 x 20) sale.

1. Close-up of Rings on Hands

For many couples, a photograph of their hands together wearing wedding bands is a sentimental favorite. However, hands are not easy to photograph beautifully, and in general they look best when shown from the side and bent back at the wrist. Try to avoid showing the backs or palms of the hands broadside. They will usually appear too large, and you run the risk of having them look like lobster claws.

For really top-notch hand positions, go to a local museum and study how some of yesteryear's painters handled them. After the museum trip, study your own hands in poses by doing variations in front of a mirror—close the bathroom door so no one sees your antics! Fingers can create repeating patterns that fit into classical rules of good composition.

While you're considering close-ups of the rings, throw in a few really tight shots of the couple's faces. The vastness of the outdoors will let you turn the background into a beautiful blur, and the variety of these shots will make them stand out among the rest at the proof return.

2. A Scenic Image

If you are shooting in a picturesque park, try backing up from the subjects so that the bride and groom are part of a larger scene. Architectural or natural elements can add variety and mood to the photos you offer your customers. The couple could be sitting under a tree, by a lake, on a great lawn, or in a gazebo. Consider

Expression is the key to great pictures. Some photographers are overly careful about such things as how high the bouquet should be or making sure that the hand holding the flowers is covered. At the center of the issue is the subject's expression, and this picture excels in this regard. Photo © Phil Cantor Photography

using soft-focus or graduated color filters for these pictures to increase their painterly, romantic quality.

3. Bride and Groom: Selective Focus

These shots offer a lot of room for creativity. For instance, you can arrange the bride in a bust-length pose and place the groom 5 feet (1.5 meters) further away from the camera, but still within the frame. Have him look at her (either facing or behind her), focus your camera on the bride, and you'll have a picture of the bride, with the groom in the background, softly out of focus. Then reverse the pose, with the groom in the foreground and the bride farther from the camera.

Two selective-focus pictures of the couple can make a great two-page spread, but placement and posing are crucial to their success as a double sale. When you position the subjects, you must consider how the album pages will look together as a unit. To sell the double-page spread, the poses should be reversed entirely, placing the in-focus subject on the opposite side of the frame than the in focus subject of the previous pose. This makes a big difference to the two images' final presentation.

If There is Time...

or the light is beautiful, catch a few additional full-lengths and close-ups of the bride, even though you did a thorough work-up of her at home before the

A close-up of the couple's hands displaying their shiny new rings makes a worthwhile image. Sometimes the bride's hands and manicure are beautiful, but that isn't always the case for the groom. Careful posing can eliminate this problem if you have the couple clasp their hands in a flattering manner. I use the bouquet as a base for my images, and I try to take the picture with a longish normal lens (100mm to 120mm for medium-format). If you are using regular non-macro focusing lenses, you are going to need a short extension tube or a close-up lens to pull this off.

Don't forget to include the environment in your portraits of the bride and groom, especially if it is tranquil and romantic. Photo © Franklin Square Photographers, Ltd.

ceremony. You've got a different background to work with now, and because it's later in the day, the lighting may have a different effect.

Ask her if there are any bridal party couples she would like photos of, and if the answer is yes, pick those up at this point. If the groom has any siblings in the bridal party, catch him with them now. When you get to the reception, you're going to shoot his family pictures, and this will give you a head start on that list.

End your park coverage with a relaxed group picture of the bridal party around the limos (ask the drivers first, but try to seat bridesmaids and ushers on the fenders and bumpers, popping through open sunroofs, or anywhere else you can stick them that looks fun), and then you're ready for the reception.

Shooting the wedding of a couple in the bridal party could be your next assignment. With this thought in mind, you might try to establish contact by getting pictures of each bridal party couple throughout the day. These pictures might be given to couples as a gift from the bride and groom or the couples may order them themselves. If the bridesmaid and usher are paired up only for the day, a photo of them really isn't very valuable, but I take one as a courtesy. If a member of the bridal party is escorting someone who is not, I try to get a picture of that couple as well.
Photo © Jerry Meyer Studio

FAMILY PHOTOS

If the families are small, you might invite them to the park for pictures after the ceremony. If that's the case, take these pictures immediately after the ceremony before you take photos of the bridal party. That way you can photograph the parents first, and they can be on their way to the reception. Nothing stifles creativity more than an anxious father wanting to get to the party.

If the families don't come to the park with you, these family photographs will have to be done at the reception hall. When they are scheduled over the course of the reception can vary. Often at the weddings I have covered, the bridal party has had a cocktail hour separate from the other guests before the reception begins, and if that's the case, I suggest you take the family pictures at that time. By then, however, the bride and groom are probably fed up with pictures (and with you). They want to relax and enjoy a drink, so broaching the subject of taking more pictures should be handled diplomatically.

There is an old saying that it is not what you say but how you say it that gets the response you want. Here's my approach. I go to the bride and groom and tell them two things: First, I thank them for helping me get beautiful pictures at the park, and second, I tell them the only posed pictures we have left to do are a few family portraits. By mentioning that these are the last posed pictures to be taken and that there are only a few left, I've made the idea more palatable to them. I also say that I would like to do these photographs now so that once the reception starts I will be shooting only candids and won't have to bug them. Any of those words, "last," "few," or "won't bug," usually do the trick, and I then ask an usher and bridesmaid to go to the main cocktail hour to round up the people needed for the family pictures. I have found that many people like to question everything or are just contrary, but if I can give them a good, solid reason for doing something, they will usually cooperate. In this instance, the good, solid reason is an uninterrupted reception. It works. From a pictorial point of view, it is better to take the family pictures early because as the reception progresses, people undo ties, remove jackets, get sweaty and flushed, hairdos fall, and generally subjects become less and less photogenic as the event wears on.

Anything you can do to avoid arranging family groupings into lineups should be explored. In this example the photographer placed two chairs in front for the parents and then arranged the siblings around the bridal couple. Photo © Jan Press Photomedia

The Family Picture List

(Note that the first six shots of this group are the same as the set you did of the bride and her family before the ceremony.)

Groom and His Dad

Groom and His Mom

Groom and His Parents: With or without Selective Focus

This photo is required for selling a two-page spread with the "Bride and Her Parents" photo.

Groom's Parents Alone: Two Frames

Groom and His Siblings

Three Generations: Groom's Side

The groom, his father, and his father's father. See page 28, "Three Generations: Bride's Side," shot at the bride's house. Now it's time to add the bride to this mix.

Bride and Groom with Groom's Parents: Two Frames

Bride and Groom with Groom's Family: With and without Grandparents

Bride and Groom with Groom's Siblings

Bride and Groom with Groom's Grandparents

You might take photos of the couple with each set of grandparents separately.

Once you've finished with the groom's family, it is time to turn your attention to the bride's family.

Bride and Groom with Bride's Family

Repeat the previous four pictures with the bride's family.

Bride's Family Miscellany

Pick up any bride's family photographs that you missed at the house.

Grandparents Alone or as Couples

If successful, these shots of the grandparents can become heirlooms, lovingly displayed on the dressers and side tables of many family members' homes.

Extended Family

Some families are very close-knit, and when this is the case, an extended family picture is in order. This picture includes aunts, uncles, and cousins. There are a few ways to handle these photographs. If the families are truly huge, you can break them down into two separate pictures: one of the mother's family, and one of the father's. Note that this creates four separate family pictures—two of the bride's relatives and two of the groom's. Remember to get the right grandparents in the right photograph!

Even this separation isn't always enough to make the group size manageable. I've actually organized 100 people in a family grouping on catering hall steps! If you're faced with shooting a 100-person family, the quality of the posing isn't the issue, as long as the photograph's sharp and centered. Forget about light quality or composition, just make sure you can see everyone's face and that no one is cut off. If possible, to avoid having to organize such a mob, you might suggest breaking down the family by generations, photographing the couple with all the aunts and uncles and then doing one with all the cousins.

I must point out that you can kill the ambiance of a reception by asking 100 of the guests to get up and go outside for a picture. So, to remain on good terms with the banquet management (remember you'll be seeing them the next weekend at another reception, and you want to keep them as friends) if I'm faced with a humongous group, I ask the manager when he or she would like me to try and organize the photo. Because banquet managers are interested both in serving a delicious, hot meal and having the party run smoothly, they will usually suggest that these photographs be done either during the salad course (it's a cold dish, so it won't be ruined if it has to sit on the table for a few minutes) or after the cake ceremony (when they're finished serving food). If the banquet manager has any preferences, I follow them to the letter. Once again, I'll probably be back there next week!

THE RECEPTION

After having had such control over your subjects and events for the last few hours, it is difficult to switch gears and become just an observer, but that's the way you'll get some of the best candids. Instead of carefully directing the scene at a reception, it is better that you react to it. One reason that good wedding photography is difficult, challenging, and fun is because the assignment calls for you to have talent in many diverse areas of photography: formal posing one minute, photojournalistic candids the next. While successful formals depend on photographer control, great candids require a photographer's quick reactions. Both are important, and both are very different.

I recommend that you begin shooting the reception with a fresh roll of film so that you are ready for a candid when it presents itself. Before you load a new roll, if you're shooting a leaf shutter camera with interchangeable magazines, now is a good time to check the flash sync on your camera.

The best candidmen usually set up slaved room lights to eliminate the light-in-a-tunnel effect so common in banquet hall flash pictures. I use 1,000-watt-second AC strobes. (My choice is Dyna-Lite, but any brand that doesn't draw a lot of amperage will work.) When I place my room lights I try to imagine where I'll be shooting from and position one or two units around the room to "open up" the potential backgrounds. I put my lights up on 10-foot poles, and if the ceiling is white, I aim the strobe heads upward at a 45° angle so they are bouncing some light off the ceiling. If the ceiling is dark or colored, I feather the lights slightly toward the ceiling so the subjects close to the strobe are softly lit without being tinted by the color of the ceiling.

With smaller weddings (fewer than 100 guests) it is sometimes possible to take a picture of the entire party. Usually to pull this off you need the help of both the caterer and the band leader or DJ, but the results can be fabulous. In this instance the photographer also had the hall on his side because a short flight of stairs allowed him to arrange the guests so that everyone could be seen. While it is hard to pose an image like this, you should try to make sure you see as many faces as possible. Remember to place the bride and groom prominently in the middle of the group. Photo © Vincent Segalla Studios

As the bridal party relaxes with a drink, I seek out the banquet manager, maître d', headwaiter, or whoever is running the party, and find out the plan for the entrance and first dance.

The Reception List

The Entrance

As when photographing in the church aisle, your quick reaction to candid situations at the reception depends on estimating subject distances and presetting the camera's focusing scale. For the bridal party's grand entrance, you might want to prefocus on a specific spot and shoot the couples as they cross that line. One of my favorite prefocus points is the edge of the dance floor, because the line of demarcation between the carpet and the wood is an easy focusing target.

1. Siblings

Although it isn't important to photograph every couple in the bridal party as they enter the room, sibling couples are worth a frame of film. You never know, it might be little Johnny's first time in a tuxedo...and without sneakers!

2. Best Man and Maid of Honor

This picture rarely sells (and if they are husband and wife you should have gotten a formal portrait of them earlier, see page 52) but I'm usually so adrenalized waiting for the bride and groom to enter that I shoot a frame of them anyway.

3. Flower Girl and Ring Bearer

When the little kids make their entrance, their parents beam and people clasp their hands in joy. Sometimes the children's mothers run in front of the kids using a favorite stuffed animal as the proverbial carrot on a stick. All this fanfare should not go unrewarded, so I shoot a frame.

If the flower girl or ring bearer is a niece or nephew of the bride and groom (i.e., their parents' grandchild), the picture will probably make it into someone's album...especially if you remember to mention it during the proof review.

4. Bride and Groom: Two Frames

Some banquet managers arrange the bridal party into an archway through which the couple passes (check with the banquet manager beforehand). You may even have the opportunity to shoot a full dress military wedding in which the couple passes under drawn sabers!

If you move quickly, you can get both a picture of the bride and groom coming through the arch and a "straight" shot. The straight shot is good insurance, because when an archway is formed, the couple sometimes lowers their heads as they pass through it, and you end up with photos of the tops of their heads instead of their faces. No matter how good a salesperson you are, it's tough to sell a picture of a bald spot!

Sometimes, with today's technologies, the first dance can become an extravaganza with disco lights flickering and smoke billowing from machines. The photographer who shot this realized that a silhouette would add to the mystery and romance of the scene. The assistant placed a strobe behind the couple (pointing towards the camera), which accentuated the smoky effect. Remember to photograph those things that are unique to each wedding. Photo © Franklin Square Photographers, Ltd.

The First Dance

When I was shooting 10-exposure rolls of 120 film, I often used two or three magazines on the first dance alone. Today, I shoot 24-exposure rolls of 220, and I can usually make it through the entrance and first dance with one magazine change. If you are shooting with a motorized 35mm camera, you'll have a tendency to blow frames more quickly, so you might consider using a quick-release coupling on your flash bracket and having a second, pre-loaded camera body at the ready... just in case.

1. Bride and Groom: Two to Three Full-Lengths and Possibly a Close-up

Three possibilities are for the bride and groom to look at the camera, look at each other, or kiss. Instead of stopping the couple to take photographs, as many candidmen do, I prefer to move with them. Since I prefocus my dance pictures, I have taught myself to move in a circle around the bride and groom following their rotation as they dance. By moving myself in arc I'm always the same distance from the couple, which is important since I've prefocused my camera (10 feet [3 meters] for a full-length using a 50mm lens on a roll-film camera). Because I put up room lights, I "roll" with my subjects until they are in front of one of my illuminated, predetermined backgrounds.

If you work with an assistant, you can have him or her carry a slaved strobe on a light pole so you can try a few special effects. By placing the second (assistant's) light behind the couple (especially as they kiss) and covering a portion of the camera-mounted strobe with your hand, you can come away with a very unique silhouette.

2. Bridal Party Couples (especially married ones)

After the bride and groom have danced alone for a few minutes and I've gotten my shots, the rest of the bridal party is invited to join in. With large bridal parties I have to work quickly to get all the couples on film because within a few moments the parents join in.

To speed things up, I usually switch from full-lengths to close-ups for a few

Very often when you arrive at the end of the arch for your second shot, guests are already stationed there with their cameras waiting to get their big picture. It is impolite to bowl these people over (even if you want to). But if your camera is prefocused, you can stick your camera into the path for a split second, grab your shot, and be gone before the guests are at it. If you're using a wide-angle lens, framing when you're shooting blind is not very difficult. You don't need to be peering through the viewfinder for a well-framed candid shot, but to pull it off well all the time does take practice.

reasons. To take a close-up I have to backpedal out to only 6 feet from the subject instead of the 10 feet required for a full-length. It is a lot quicker to move 6 feet instead of 10, so I save precious seconds on each couple's picture. Furthermore, if the dance floor is crowded with a lot of bridal party couples, there is less room to easily back up the full 10 feet. Lastly, with a full-length dancing picture, the couple doesn't fill the frame from side to side, so other, unwanted couples are often included in the picture.

Even in this difficult circumstance, I try to pose each picture professionally. I approach each couple and place my hand on their clasped hands. When they turn to me I say, "Get close together and smile." As I say this, I'm already starting to backpedal out to my 6-foot prefocused distance. The whole thing, hand contact, instructions, and taking the picture takes just a few seconds.

3. Parents

While taking pictures of the parents seems straightforward enough, keep your eye on the two couples, because sometimes they switch partners. The parents might switch off with each other or they might even invite a grandparent out onto the dance floor...all are worth a picture.

4. Grandparents

If the grandparents are out on the dance floor, get a picture of them!

The Toast

Almost every wedding album I have ever seen includes a picture of the bride and groom toasting. Some wedding labs even have a stock shot of a champagne glass into which they superimpose an image of the bridal couple. But even a standard rendition of this picture has become a big seller for the album.

1. Best Man Toasting

The best man may be called up to the bandstand to offer his toast to the couple, who are seated at the head table. If that is the situation, a photograph of him toasting is in order. Be aware that the maid of honor often follows with a toast of her own, so be ready to take another photo in case that happens.

2. Bride and Groom with Best Man and Toasting Glasses, If Possible

If the best man stands next to the couple while proposing his toast, try to include the couple and the best man toasting. That way you've got a better chance of making a sale.

3. Bride and Groom Toasting Each Other

Once the toast has been completed, the guests seat themselves, and the dinner commences. My last duty before leaving the couple alone for a while is to take a picture of the two of them toasting, especially if the picture of the groom's toast did not include them. I ask them to move closer together and to hold their glasses with their outside hands. Their outside hands come together in the middle, clinking their glasses, and I have my shot. For this rendition of the toast shot they can look either at each other or at the camera....Both look great.

Sometimes the couple tries to intertwine their hands as they drink the champagne. Although it sounds like a great idea (and I always shoot a frame if they try it), it never looks as good as the straight shot. The interlocking arms look very confusing in print, and one of the couple always seems to be on the verge of taking an elbow in the eye or nose.

Table Pictures

If you ask a candidman what he hates most about wedding photography, chances are he'll say, "Table pictures." Someone is always missing ("Please come back later,"…"Martha is in the lady's room,"…"Chuck is in the parking lot…"), or someone doesn't want to get up and move around to the back of the table ("Don't even think about asking me to stand up. I'm exhausted…"), or someone doesn't want to stop eating ("Come back after the coffee is served, or better yet, tomorrow!").

Many times, even after most guests have cooperated, other guests can still be a nuisance—someone at the table thinks it's funny to cover another person's head with a napkin, make their fingers into rabbit ears, or grab someone else's private parts.

After a few years, this type of behavior gets very old, but there are some ways to ease the burden. I make a point of first looking at the table's guests to note if anyone is physically handicapped or if there are any elderly people sitting there.

Next I arrange my picture so that they can remain seated. That way, if someone gripes about having to get up I say that I'm arranging it so that he or she can remain seated. Before asking anyone to move, I tell them that the bride and groom asked for a picture of the guests at this table, and if I do it now I won't have to bother them later. Then, I personally ask each couple that I want to have stand to step around to the other side of the table. I usually ask the man and say, "Excuse me sir, but could you and your lady please step around to that side of the table for a picture?" Invariably, some guy retorts, "That's no lady, that's my wife!" I respond by smiling and saying, "You wouldn't marry anyone but a lady." At that point the wife usually steps in and takes her husband to the back of the table for the picture. The whole scenario is repeated so often I can do it in my sleep, but every guest thinks he (and it's almost always a guy) is being totally funny, unique, and innovative by creating a hassle.

Another potential fly in the ointment has to do with the many courses of food that have to be served and removed. It is very difficult for waiters and waitresses to serve hot food from hot cauldrons and clear tables while guests are being photographed standing behind a table they are attending to. Etiquette demands that I not disturb their work. To add to the difficulty, at the end of each course the table is covered with dirty plates, and food scraps don't make for an appetizing picture.

Because of all this, my studio rule is that I will do any table photographs requested, but they must be used in one of the three albums, over and above the contracted number of pictures. Because I've done it so many times, I actually enjoy the quick-witted repartee that goes into making good table pictures….I use it to keep myself sharp. Even so, I don't want to waste my time playing the table picture game with all the guests if my customer isn't interested enough in the pictures to put them in the album.

1. The Two Parents' Tables

Whether the couple wants table pictures or not, I always get a picture of the two parents' tables. There are two ways to shoot these photos, and the style I choose depends on the floral arrangement at the table's center. If the centerpiece is low and the table has 10 to 12 guests seated at it, I ask 6 guests to remain seated and ask the remaining guests to stand behind them. I try to let the parents and grandparents remain seated, and I shoot my picture in a head-on style.

On the flip side, if there is a large, high centerpiece in the middle of the table, I let four guests remain seated and stand the other three or four couples behind them. While my assistant stands to the far side of the flowers and aims his or her light at the people at the rear of the table, my camera's flash unit illuminates those guests in the front. For this style of table picture you'll need a wide-angle lens to gain greater depth of field because the subjects are at various distances from the camera. However, instead of shooting this type of table shot head-on, I shoot it

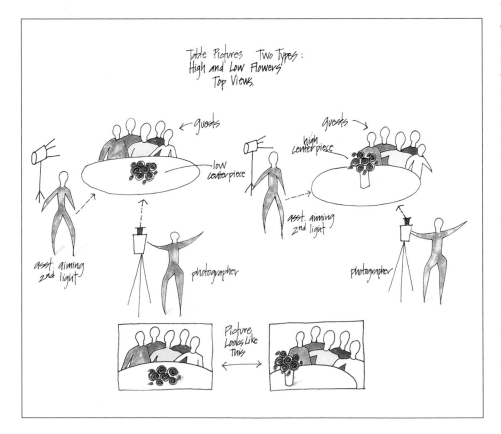

from the side so that the floral display is on one side of my composition and the people are on the other.

Candids: 24 to 48 Photos of Bridal Party and Guests Dancing Fast and Slow, and Groups on the Dance Floor

Many couples tell the photographer that they like candid pictures of people dancing when they book a photographer, but I have found that most customers choose only a few when it comes time to make selections for the album. The main limitation with totally "undirected" dancing pictures is a lack of focus. I'm not talking about correct camera focus...that part is easy. I'm talking about the lack of distinct subject matter. Typical photographs of people dancing show half of the subjects with their backs to the camera. Shoot 48 of these typical dance photographs, and two will make the grade as an album selection. There are certain types of pictures that are consistently chosen, and they should be your prime focus.

1. Two-Up Dancing Photos: Faces toward the Camera

These include photos of moms and their sons, dads and their daughters, the flower girl and ring bearer (only once), and moms and dads with their parents.

2. Three- and Four-Up Groups Dancing: Facing the Camera

Getting this type of picture requires a bit of extra effort. I dance up to the people and say "Keep dancing, but look at me!" Sometimes I pantomime putting their arms around each other or getting closer.

3. Large, Impromptu Groups of the Couple's Friends

This shot is best if the bride or groom is included in the jumble of bodies. I have actually seen friends throw themselves into these photos and watched as they slid across the dance floor on their backs trying to be included in the picture!

The photographer was wise in timing his table picture taking during the salad course. Both guests and caterers prefer that you do not intrude during the main course.

The flower arrangement was tall enough to have blocked the camera's view of some subjects, but the photographer framed the scene with the centerpiece on the left side of the composition. Remember that the floral display choices are carefully considered by the bridal couple, so including the flowers in the photo is a nice addition. Photo © Jan Press Photomedia

4. Totally Candid Tight Shots (Close-ups) of the Bride and Groom

The idea of working from your stepladder and using a short telephoto lens shouldn't be overlooked. By shooting from a high vantage point you can eliminate some of the "back of someone's head in the foreground" problems.

Bride and Dad Dancing

Whether the band makes this into a ceremonial rite or not, this is a picture to get. Watch and be ready for a quick kiss or hug between the two. If the band or DJ gets into the act, ask them to have the groom join in with the bride's mom. It'll make a great two-page spread.

Groom and Mom Dancing

This picture is the converse of the previous one, and it too is a keeper. Once again, be ready for a possible kiss or hug, and try to get a photo of the bride with the groom's dad.

Romantic Interlude: 10 or 12 Photos

I usually ask the bride and groom if we can do a few romantic photos after they've finished the main course. They take only about five minutes, and I try to get them in before the cake-cutting and bouquet- and garter-tossing ceremonies. It is important to fit them in now because right after the cake cutting, guests start to leave the party, and amid all the goodbyes it is often impossible to get any alone time with the bride and groom. Early in the evening while the guests are eating, I take a walk around the reception

These pictures work as a duet, and after the photographer took the first image, he went looking to create the other half. Part of being a complete wedding photographer includes being aware of which pictures you have already taken and what images are needed to complement the ones already in the can. Part of the game is to consider yourself a book designer while you're shooting the images. Remember to think in terms of two complementary pictures to increase sales and produce a better album. Photos © Three Star Photography

Spend some time during the reception looking for suitable scenes into which you can place the bride and groom. Consider staircases, chandeliers, and other decor that can add a romantic air to the picture. In this instance the photographer hid a strobe behind the bride and groom, which added to the ambiance. Photo © Franklin Square Photographers, Ltd.

You can create special images with sales appeal with something as simple as a black posing drape as a background. This double exposure is the result of just such a technique. When you're faced with cinderblock walls or distracting wallpaper at the local reception hall, you must arm yourself with creative alternatives. Photo © Three Star Photography

hall with my light meter in hand. When the time to take these pictures comes about, I have very specific ideas about where and what I'm going to shoot. I try to get some romantic images, and at the same time I try to include some of the ambiance of the reception hall or club. Even in a VFW or Elks lodge you can usually come up with some creative backgrounds or lighting effects.

1. Double Exposures

One of the easiest pictures to do is an in-camera double exposure of the bride's and groom's faces. The picture looks like a special effect (it is!), but because it isn't done in the lab and can be seen on the proof, it is always well received. The trick is to find a dark background, but even if you can't, you can get your assistant to hold a black posing drape behind the subjects for each of the two images. If you block out part of the scene with a dark-slide or datebook, be sure to view the scene at your lens' taking aperture (use the depth-of-field preview button) so you

can see how much of the frame your mask is really blocking out.

Many times I've made my last exposure of the bride and groom in an upper corner of the frame with both subjects looking at the opposite lower corner of the frame. I then take the couple outside and put them in the doorway of the reception hall. I take a second image of the bride and groom caressing in the doorway on the same piece of film. The finished picture has the bride and groom in the upper corner of the frame looking at themselves embracing in the lower corner of the same image. I've even mimicked a pose from a print on the wall of a catering hall and placed the couple in the same pose in front of the picture. It's a fun image (see page 73).

2. Candlelight Photos

3. Good-Bye Shots or Gag Shots

4. Available-Light Night Scenes Including Reception Hall Scenery

The Cake

The cake-cutting ceremony can be a major focal point of the evening or just a small event that takes place on the side of the ballroom, accompanied by some background music. Some couples do away with the feeding and kissing parts and just cut the cake. Although there's a chance that the whole set of photos may be chosen for the album (cutting, feeding, kissing), many couples include just a cake-cutting picture...which is why I do two. If you double-light this picture, put the assistant's light off to the side and behind the cake so that it illuminates the couple and provides a rim light on the cake without burning up the cake's decorations (photographically speaking, of course!).

1. Bride and Groom Cutting Cake: Two Frames

Bride and groom looking at the camera and then looking at the cake.

2. Bride Feeding Groom

3. Groom Feeding Bride

4. Bride and Groom's Hands over Cake, Showing Rings

If you didn't get a ring shot during the formals, you can grab a quick picture of their left hands clasped together in front of the headpiece on the cake.

5. Bride and Groom Kissing Each Other with Cake in Composition

Even if the couple doesn't use the cake-cutting photos in the album, this picture is a great album closer.

With all the other guests taking photographs during the cake cutting you can seamlessly change things in seconds without bothering anyone. In the first picture notice that the bandstand is prominent in the background and the groom's hand is obtrusive on the bride's shoulder. By simply switching places with the flash-toting assistant the photographer was able to improve the background and eliminate the hand-on-shoulder problem quickly. Photos © Three Star Photography

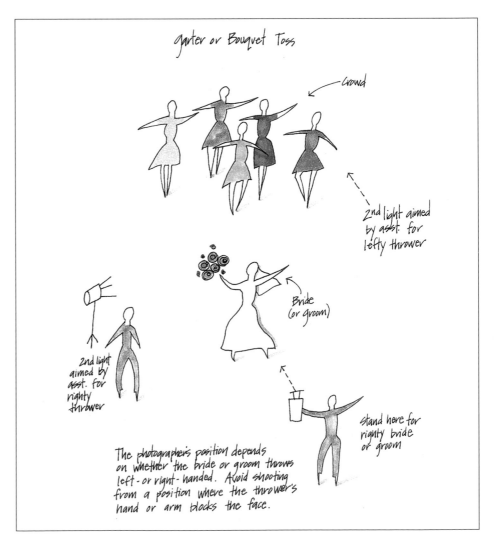

MAKE IT YOUR OWN

Everything you've just read is meant to augment your own photographic style. None of the suggestions I've presented are the only way to approach your assignment. Pick what you need and add it to your own set of ideas, or use it as a foundation to establish your repertoire. For two years my number one assistant was with me at every wedding I shot. He took a six-month vacation from the business and, when he returned, we went out on an assignment together. After working through a set of formals with me, he told me that my entire repertoire had changed. Well, that's the way it's supposed to be! A repertoire is a fluid thing. It changes as you mature and grow. Sometimes, after not doing a particular picture for years, I revisit the idea, make some changes, add some new wrinkles, and reincorporate it into my current repertoire. Whoever is my current assistant says, "Wow! That's new!" Little do they know! That's the way it should be. It keeps you fresh and makes it fun.

Bouquet and Garter Toss

1. Tossing Bouquet

2. Removing Garter

3. Tossing Garter

4. Putting Garter on Bouquet-Catcher's Leg

Whether you advocate these rituals or not, they are usually popular additions to the evening's festivities. Sometimes the bridal couple doesn't go for the entire set of pictures and elects instead to just do the bouquet toss. Whatever the case, I try to get at least two lights working for this type of situation. While the flash on my camera lights the bride, I make sure that either my assistant's light (or my room lights) shine on the catchers. Very often the band runs this part of the show, and if they do there is usually a countdown, which makes timing the shot a bit easier. For a general idea of where the tosser, catchers, photographer, and lights are, look at the illustrations. If the couple is into the whole ritual, at least one (if not more) of the pictures will be in the album.

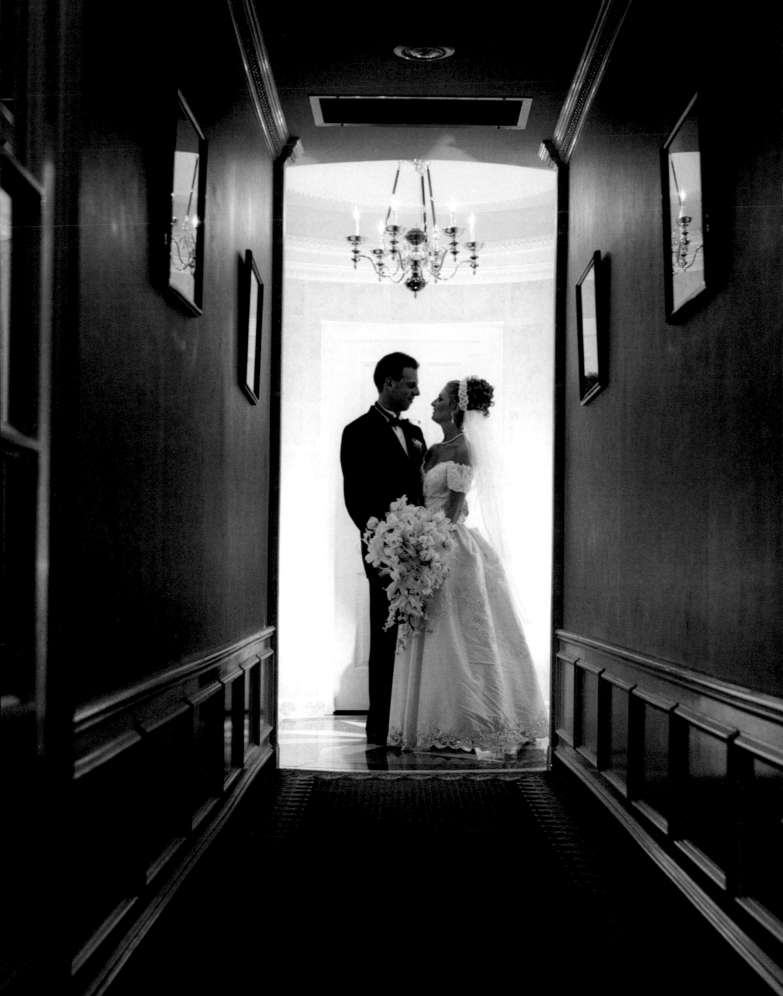

FRAMING AND POSING

I'm shooting a party at a major New York hotel, there are 800 guests, 80 tables, and each table has a bouquet of 100 roses. Four photography crews have been hired to handle the assignment. As a member of one of the first two crews, I have been shooting since 12:30 p.m. The third and fourth crews are scheduled to start at 8:00 p.m. Immediately following the ceremony, at 7:45 I go over to my studio manager and say, "I've established a beachhead and secured my perimeter—bring in the reinforcements."

Over the years, I've watched some friends who are view camera-toting nature specialists agonize over whether an image should be vertical or horizontal and whether they should crop out or leave in a certain branch, leaf, or mushroom. Candidmen don't have the luxury of that agony because in wedding photography everything happens too quickly. I've also seen fashion photographers zip roll after roll through their motorized 35mm cameras while a professional model dances joyously in front of their lens, hairdressers and makeup artists ready to jump in for touchups at any break in the action. They might burn ten or more rolls of film just to get one picture. Candidmen don't have the luxury of wasting film or working in a controlled studio environment to make their subjects radiant. In wedding photography, every extra frame of film you shoot affects the profitability of the assignment, and you must do what you can to help your subjects look great in front of the camera.

So, to be good (and successful) at the game, you must get to the heart of the matter quickly! That demands that you have some preconceived notions about how the final photograph will look. Framing and posing, two separate and distinct operations, can be governed by two sets of rules that eliminate wasting time while you're searching for an elusive image. The rules speed up the process of capturing the "bread-and-butter" pictures, which creates time for you to try to get those extra pictures that are out of the ordinary and produce additional sales. Without casting anything in stone, let's explore some simple framing and posing axioms that can add a professional touch to your pictures, let you take more photographs in less time, and make your subjects look better. But remember, every rule needs to be broken occasionally.

FRAMING

In the good (?) old days when photographers used press cameras, framing and focusing were two separate and distinctly different operations. Most press cameras (both 4 x 5 and early Leicas) had peep sight rangefinders through which the photographer performed the focusing operation. The peep sight was too small to view anything more than the spot on which the candidman was focusing. After correct focus had been achieved, the photographer shifted his or her eye to a framing device and decided whether the picture was a vertical or horizontal and what the image's boundaries were. By separating the focusing and framing operations, this design made each act important and minimized neither. Then the range-viewfinder camera came into being, followed by the twin-lens and single-lens reflex. All these designs combined the framing and focusing operations through a single eyepiece.

Now, with the advent of the autofocus SLR, the placement of the autofocus sensors often dictates composition, causing the art of framing to have lost some of its individuality and importance. This is a pity. Many images shot with autofocus cameras have the subject placed right smack-dab in the middle of the composition. Framing is achieved by default: The autofocus spot is placed on the primary

subject, focus locks onto it, and then, regardless of where the other elements fall in the composition, the picture is taken. Also, many novices who use 35mm SLRs shoot mostly horizontals simply because the cameras tend to be easier to hold that way. But this does not necessarily result in the best picture.

The first point to realize is that there are basically three types of posed, formal wedding photos. These are full-length pictures, bust-length pictures, and close-ups. At one time a bust picture was considered a close-up, but with the emergence of the SLR (and its parallax-free viewing) and the growing popularity of portrait teles for wedding work, photographers have been able to get in closer and explore the intricacies of the face. This led to the bust-length image changing in status from being a close-up to a mid-range shot.

One image that smacks of amateurism is the ankle chop. This occurs when the photographer can't decide between a bust-length or a full-length shot and goes for something in between. In my opinion, it looks awful, is a waste of good film, and should be avoided at all costs. Of course, in a fast-action, candid situation in which expression and subject interaction are paramount, sometimes the candidman must settle for an ankle chop or risk missing the moment. In that case it's better to have a great ankle-chop candid than nothing at all. If the image is posed, however, there isn't much excuse for shooting the "dreaded ankle chop." Take a look at my example so you can remember to avoid it!

Horizontal or Vertical?

Individuals are generally vertical subjects (unless they are sleeping!). Groups of people standing in line are generally horizontal subjects. Hold those thoughts while we look at the rules of composition.

For Full-Length Photographs

1. Images with one, two, three, and four people are vertical compositions.

2. Images with six or more people images are horizontal compositions.

3. Images with five people in them can go either way. When all the subjects stand in a line and they are heavyset, the image is horizontal. If they are thin, the image might be a vertical. If you can pose them at different heights (such as a mom sitting, dad standing, and their three kids sprinkled around), the "lineup" can be rearranged into tiers and fit into a vertical composition.

For Bust-Length Photographs

1. Images with one or two people are vertical compositions.

2. Images with four or more people are horizontal compositions.

3. Images with three people in them can go either way. Again, depending on the subjects' builds, the composition could be framed as a horizontal or a vertical. Sometimes a vertical frame can crop out the shoulders of the subjects at either end of the frame, while a horizontal frame can leave too much empty space to either side. Often by arranging the subjects so that they are at different heights, you can easily fit them into a vertical.

While these rules are just guidelines, 99.something percent of the time they hold true. Even though they are worth remembering, try and break them creatively from time to time.

The Dreaded Ankle Chop...something to avoid!

POSING

Once you figure out how to arrange the frame around the people, the next step is to arrange the people within the frame. That's posing—and it's an art, not a science. Posing sometimes strikes terror into the hearts of subjects. Often, photojournalistically oriented photographers treat it like the plague. They consider it dishonest, disingenuous, manipulative, intrusive, and a whole bunch of other nasty, slimy, evil words. My response? "Phooey!" However, I do believe that there are times when no posing or photographer's control will get you the best picture. In other words, at those times, the photographers who extol the virtues of candid photography are right.

Important Hint

Looking at a pose and deciding that it is stiff and unnatural is easy. But deciding what to change so it will look more relaxed and natural is hard. One trick that works for me is to break the subject's pose down into sections and examine each one separately. Many times the subject just has to relax her shoulders, shift her hips, or tilt her head a little (one way or the other) to create the natural, relaxed look you're after. I have found, through sheer repetition, that most subjects often show a lot of tension in their shoulders. You probably know the look—their shoulders are up around their ears. I try to pose using a soothing voice and frequently remind my subjects to relax their shoulders and breathe!

"Stand over there and smile!" versus...

"Stand over there, turn your body slightly, point your left toe towards me, move your left arm a little,...and smile!" The three rules for slimming anyone in a full-length pose are:
1. Turn the subject's shoulders to a 45° angle.
2. Have the subject point the forward-most toe in the direction of the camera.
3. Have her hold her elbows slightly away from her sides.

Over the course of a wedding day there is more than enough time for both posed and candid photographs. Your coverage should include a great number of pictures that you take as a casual observer. Don't direct, just observe. A candid situation is just that. However, that said, many of my best wedding photographs are posed.

And what of posing and truth? Although I'm trying to create an accurate record of the wedding day, my photographs are not intended to be a hot news item for a supermarket tabloid. I can picture the headline: "Bride Has 73 Chins!" A wedding is a celebration of love that I personally will not tarnish. The bride and groom are my clients. There is no reason for me to expose their flaws to the world. In fact, I strive to make them look as attractive as possible on their important day. If I move a light or suggest to my subject a slight turn of the body so as to present him or her in a more flattering light, then I'm just doing my job. If my clients want to live a fantasy day, I'll do my best to help them create one. I see no difference between doing this and making an advertising client's product beautiful, sexy, or desirable.

Poses can produce overbearing or subtle effects. Turn a body slightly, and in the resulting photograph the subject appears slimmer. Extend the subject's hand gracefully, and instead of it looking like a lobster's claw, it beckons the viewer with a sense of intimacy—a secret revealed.

During my 30 years of professional commercial photography, I never shot an advertising photograph that wasn't rigidly controlled, contrived, planned, and posed! Posed photographs run the gamut from images in which the photographer controls the subject's every finger position to images in which the photographer's input amounts to, "Stand over there." I find there's room for both, and my only criteria for success is that it looks natural. Aha...that's the real issue. People can position themselves many different ways. Some make the person look much better, some make the person look much worse. But any position is natural if the person does it without direction.

Posing is the art of placing people in natural-looking and flattering positions.

My last rationale for posing is this: I've found that the vast majority of the photographs my customers purchase were manipulated by me in some way. Shoot 100 totally candid photographs and the bride and groom will buy 10 (if you're lucky!). "But mom's face is turned away,"... "But my veil is in his face,"... "But you can't see Aunt Martha,"... etc. Shoot 100 posed pictures and, if you're good, the couple can choose 100.... OK, OK, 80.

A Quick Guide to Posing

With all the layers that make up a bridal gown and all the accessories that go with a tuxedo, it is sometimes hard to see how the subjects' bodies are positioned. But posing starts with the subject's body position. Therefore, instead of explaining how the subject's body is positioned under all the vestments of the wedding day, I decided to show just the basics, the bodies, unencumbered by the clothing of the event.

To do this, I got some help from the students and teachers at Great Expectations, a Staten Island dance school. Although I've also included standard bridal photographs, those that are worth extra study are of the dancers in leotards. In these photographs you can see how bodies are arranged to fit together and look flattering. As a counterpoint I've also included a non-posed, "Stand over there" image of various groupings so you can understand and visualize the difference. The time it takes to clean up a pose (tucking someone's belly behind someone else's elbow, showing a shirt cuff at the end of a tuxedo sleeve, strategically placing a hand, or flaring an elbow) takes seconds and is well worth the effort. The decision about how "tightly" to pose at any given wedding is a matter of choice, both the photographer's and the subjects'. The candidmen who are best at this art form can make it into a gentle game for the subject and even their tightly posed work is not bothersome and does not appear overly intrusive to the subject.

Full-Length vs. Bust Length

Applying the three full-length rules to a bust-length pose isn't the whole story because as you move in for a closer view, the bouquet becomes a much larger design element in your composition.

The Bride

The star of the wedding day demands extra attention, not only because she's the bride, but because a bridal gown and bouquet offer so many aspects to show off. Here's the scoop: While the groom may rent his tuxedo or even wear his Sunday best, the bridal gown is a one-day dress. After the wedding day it will be lovingly cleaned, wrapped, and stored in a box. It will become the first of the new family's heirlooms. On a very mercenary level, try as you may, you won't get more than two poses of the groom into the album (a full-length and a bust). But, conversely, the chances are good that you can sell a half-dozen (or more) of the bride, her gown, and her bouquet for the book...if you can shoot pictures that offer variety. Variety starts with full lengths, busts, and close-ups, but continues on to include background and lighting changes.

Three Simple Rules

The three basic axioms about full-length pictures of a person (in this case the bride) are: 1) Turn the subject's shoulders to a 45° angle; 2) Have the subject point the forward-most toe towards the camera slightly; and 3) Place the subject's elbows slightly away from her (or his) sides.

The 45° turn narrows the subject's shoulders. Because the camera has a monocular point of view, narrower looks thinner, which is almost always a plus. The toe-pointing routine forces the subject (unknowingly) to put her weight on her back foot, which creates a better set to the hips. Finally, if her elbows appear to touch her sides in the resulting photograph, she will appear as wide as her elbows (remember, narrower looks thinner!) but if there is a touch of daylight showing between her elbow and her side, it shows off her waistline, which usually

In the "Stand over there and smile" non-pose, notice that the bride's bouquet covers the bodice of her dress (I know the model is in a leotard, but use your imagination!), and it looks like she's growing out of her flowers. When I see this I usually say, "The bodice of your dress is beautiful, lower your flowers." If the bride still doesn't get it, I tell her to rest her wrists on her hip bones. That's usually about the right position.

In the more finished pose I've added two wrinkles to the full-length rules. In addition to lowering the flowers, I had the bride move them to one side, which shows off the bodice of the gown, and I tilted them at a slight angle so the bottom of the bouquet wasn't lost in the crop. Finally, I used her left hand as a place to drape the bouquet's ribbons, which allowed me to 1) show the ribbon train, and 2) take her elbow off her side.

Long-stem bouquets are usually best laid in the crook of one arm. The free hand can be used to stabilize the lower end of the bouquet. This type of bouquet almost always looks best with the flowers presented in the camera's direction. The hand used to stabilize the bouquet doesn't allow you to use the "elbow out" theory to achieve a slimming pose, but you can try a shot with the bride placing her free hand on her hip, which will also show off her waistline. In either event, pay attention to how the ribbons fall in the frame.

Cascade bouquets often have a handle underneath. I ask the bride to hold the handle with her back hand (remember, her shoulders are at a 45° angle, so there is a front and a back hand) and use the front hand as a palm-up support under the bouquet. This helps with the elbow game and, because the hands are at different positions under the bouquet, the arms appear asymmetrical, which is usually pleasing. If the bride is holding a cascade bouquet and the gown has a long veil, you can often drape the veil over her arm to create a diagonal line that leads the viewer's eyes back into the photograph.

makes a good pose. The elbow move is a tricky one because if it is exaggerated it looks like she's doing the chicken dance, and sometimes in moving her elbows her shoulders lift. Both of these problems can really detract from the image and should be gently corrected. Usually when it happens I smile and say, "Don't let it look like you're doing the chicken dance," or "Relax your shoulders."

The three rules are so telling that many a good close-up can be taken just by moving in on a properly posed full-length and simply reframing, refocusing, and reshooting. Look at the examples on pages 68 and 69 to see the differences between "Stand over there and smile" and posing the subjects using these three little rules.

Different Poses for Different Bouquets

Bouquet shapes and sizes can dictate how they are held, and they can even dictate the pose. Different names include snowballs, cascades, and long-stem bouquets. Snowballs often have ribbon cascades, and in the poses on pages 68 and 69, the bouquet is a floral cascade with ribbons. Florists mix and match all three varieties between brides and their bridesmaids, and one type isn't better or worse than the other...just different. Here are examples of how poses are affected by cascade and long-stem bouquets.

Don't Forget the Groom

A guy in a tuxedo (or a suit) is just a guy in a tuxedo (or a suit), and that is what the groom is. In reality there is less to work with in shooting a portrait of a man compared to a bride, with her gown, veil, and bouquet. Still, he is the other star of the wedding.

Just as with the bride, the groom should hold his shoulders at a 45° angle to the camera. The feet, however, are a different story altogether. Usually, separating them slightly and splaying one foot slightly outward will do the trick, but the elbow game is an even more difficult one to play. Many suit jackets have no waistline to show off. You can have the man put a hand in his pants pocket or rest a hand on his hip. You might try having him remove his jacket and drape it over his arm or flip it over his shoulder à la Frank Sinatra. The simple fact is, a woman's gown, usually with a wide base, lends itself to a pleasing composition, while men's attire often makes them look as if they are about to topple over (especially if the men have broad shoulders).

The shoulder width and its potentially top-heavy aspect is a problem in the bust-length portrait as well. There are ways around this, but my favorite is to lean the man's torso into the picture. I use whatever is handy for the groom to lean an elbow on. This can be the back of a high-backed chair, a fence post, the fender of a limo, or a camera case on a posing ladder covered with a posing drape depending on how tall he is and what is available.

Leaning the groom into a pose tilts the body slightly and eliminates the tension caused by the ramrod stiffness of a "Stand over there and smile" pose. You can be very creative in finding things for a man to lean on. In this particular instance I had the model lean on a camera case standing on end on a step of my posing ladder. You could just as easily find a more natural prop for him to lean on.

Just as when photographing a woman, try to slim a male subject with a flattering pose so that he presents a better silhouette to the camera. Once again the shoulders (and the rest of his body) are turned at a 45° angle to the camera, but in this instance, unlike his female counterpart, I had the subject move his rear foot out slightly to give his body a wider base on which to rest. With someone as fit as my model, placing his hand on his hip shows the "V" of his torso, but you might try having the subject place his hand in his pants pocket or having him take his jacket off altogether.

Posing Hands

One of the most difficult subjects to photograph are hands. Many fine photographers have nightmares about how to pose hands and where to place them in their wedding photographs. Often the best solution is to crop the hands out of the picture altogether! But there are times when hands are a part of the picture. They can help tie two subjects together, they can be used to frame and support a face, and in a ring shot, they are the most important part of the image.

There are a few things worth considering. If you pose a hand so that either the palm or its back is parallel to the film plane, you will find that the hand appears unnaturally large. If, on the other hand, you place the hand so that its side is to the camera (the little-finger side—thumbs present additional problems), the hand appears to be much more delicate. A slight bend at the wrist and slightly curled fingers will produce an "S" curve, which is pleasing to the eye.

There is one definite no-no. If a hand is peeking over another subject's shoulder, the resulting picture has what appear to be four little foreign dots on the shoulder...not very flattering, and very distracting. If you want to include a subject's hands in your photos, remember to try and catch them from the side, practice in front of a mirror, and if all else fails, crop them out!

Use a Mirror as a Learning Tool

One of my mentors was able to pose a subject's hands in the most creative ways. When I asked where he got his ideas, he told me he used to practice in front of a mirror using himself as the subject. I have found that it is the perfect teaching aid to help with good posing. A full-length mirror is best, but even a small bathroom mirror can help. Find a suitable mirror, put aside your insecurities, and pose yourself as both a bride and a groom. Wear a suit jacket to try male poses and hold a prop for a bouquet to try bridals. Try to analyze what you are doing to see how it affects the feel of the pose. Tilt your head,

In this classical bride-and-groom pose, the bride's back is to the groom's front. Once again both subjects' shoulders are at a 45° angle to the camera. Placing the groom's left hand on the bride's left arm creates a connection between the two bodies, and further, his forearm continues the diagonal line created by her forearm. Notice also that both subjects' upper arms are parallel and create lines that lead toward their faces. Although my model isn't wearing a ring, this pose is great for showing off the groom's shiny, new wedding band.

In this pose the bride and groom are facing each other with their rear shoulders touching. Both subjects have their shoulders at a 45° angle to the camera. By having the groom put his right hand in his pocket, his arm follows the pattern set by the bride's left arm, creating a pleasing symmetry.

turn your body, try to imagine how and where another person would fit into the composition. It can be worth its weight in gold for adding variety to your repertoire.

On a similar note, look critically at magazine images to analyze how the models are posed. Those pages can also add to the variety of poses you use, which can make for fat, profitable wedding albums.

Putting the Bride and Groom Together

Once we accept the concept that the subject's shoulders should be at a 45° angle to the camera, it becomes obvious that there are really only four ways that two bodies can fit together. The subjects can be front to front, his front to her back, his back to her front, and the two of them back to back. Just as there are thousands of

photographers, there are thousands of variations on this theme, but as a rule, when it comes to formal posing, they all boil down to fitting into one of these four categories. Equally true, although I'm using bust-length images as examples, these basic arrangements can be applied to both subjects standing for a full-length pose or one sitting and one standing, or even both sitting (as on different steps of a posing ladder), in addition to the examples I've shown. As an aside, the poses included here can work for more than just the bride and groom. Mom and dad, siblings, friends, and in fact, any couple can be posed this way. These poses work any time you have to photograph two people together. Study some of the variations I've described and then think up some of your own.

To get this pose I had the groom sit on my posing ladder. Notice that I've placed the bride on the side that allows her to show off her wedding ring. Equally as important, her hands are placed one on top of the other without interlocking the fingers. If the fingers interlock, the presentation of the hands becomes confusing and unflattering. A pose such as this can be very effective in a shot of the bride and her father because it has very little sexual connotation.

This pose is usually not included in the standard set of poses a candidman uses, but its difference makes it interesting. Neither wedding ring shows, but the way the bride can snuggle into the small of the groom's back and the way in which she can lean her head on his shoulder makes a connection between them that I find appealing. Notice that her arm position mimics his, making this the perfect pose for a bride and her brother.

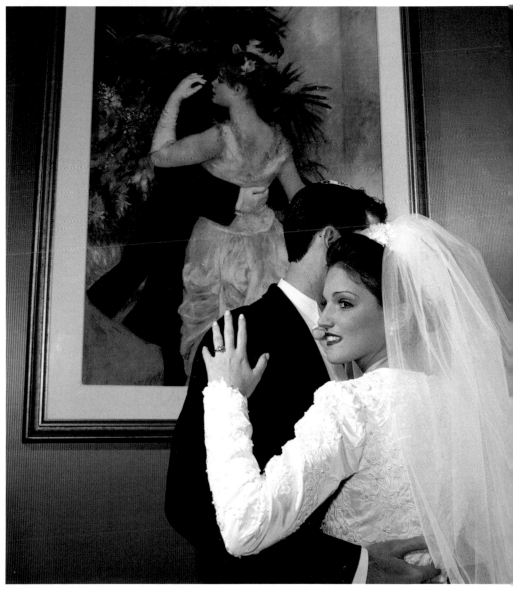

Traditional photographic rules of composition often speak about using repeating patterns for creative effect, and in this case the couple's pose imitates the picture on the wall. To make the picture work, traditional framing rules were left by the wayside and the couple was placed in the lower corner of the frame.
Photo © Jerry Meyer Studio

Each basic pose has three "subposes" that you might want to explore. When you place the subject's shoulders at a 45° angle to the camera, you aren't limited to one view. Throughout a 360° circle there are four positions in which the subjects' shoulders hit a 45° mark; two facing the camera and two facing away.

You can also do a lot by changing the heights of the two subjects. Both can stand, one can sit while the other stands, or both can be seated. Here are four variations on the basic poses I've described that vary by the 45° angle I've chosen and the relative heights of the subjects. But even within the parameters I've set, there are thousands of possibilities. Mix, match, be creative....Find a mirror and a friend and work out some variations that you like!

Here the man is turned 45° so he is facing away from the camera, and his head is in profile, framing the woman's face.

Once again his front is turned away from the camera. His profile frames the woman's face.

They are facing each other, but this time the woman's back is towards the camera.

Her head is higher than his and she's showing her wedding ring. The couple is now front to front, and they both face the camera.

Posing Three People

After you've mastered the two-up, the next group is, you guessed it, the three-up. While the bride and groom are the day's stars, the supporting cast is led by the parents. The bride, her mom, and dad (or the groom and his parents) make three.

For a simple, quick pose of three subjects, it's hard to beat the lineup. Although a lineup is an easy pose to do, you should finish it off by covering the details that make your photograph look more professional. Instead of the "Stand over there and smile" non-pose, remember the basic rules for posing one person—first and foremost, turn the subject's body so that the shoulders are at a 45° angle to the camera. Since this pose usually works best as a horizontal, you might consider having mom place her right hand on the bride's right wrist and dad putting his left hand on the bride's left elbow. The "hands-on" approach I'm suggesting connects the bodies and, what's more important, the arms become

a horizontal holding line that stops the viewer's eyes from falling off the bottom of the picture.

You might question why I put the dad's front to the bride's back as opposed to having the mom's front to the bride's back. Although the dancers I used as subjects are all slim and fit, in the real world, dad's front to the bride's back gives you a perfect place to hide dad's belly...behind the bride's left elbow! Tucking in (and hiding) a belly can turn you into a star photographer in their eyes!

For variations on this theme, look at the other examples shown. If one of the three subjects is a little person, such as a flower girl, ring bearer, or younger sibling, you can arrange the little one in front of the tallest person so the image becomes a vertical composition. If you follow this route, make sure the two heads do not line up exactly one above the other. If you aren't careful, it will look like the tall subject is growing out of the short one...not a pleasing image! You could also arrange

This is another pose that is closed. The two outer subjects sandwich the third, and both outer subjects face the central one. Although it looks very different than the finished, posed three-up shown below (center), it is the same with a few slight changes. In this instance, the entire line was rotated, and one subject was seated on a low stool. Finally, because of the difference in heights, a line drawn through the three faces follows a diagonal line instead of a horizontal one. This makes the composition a vertical instead of a horizontal.

The Three-Up: Compare the "Stand over there and smile" non-pose (left) with the finished, posed composition (right). By turning the bride's back towards her dad's front you have a perfect hiding place for dad's tummy. Notice that one of the three subjects is turned towards the other two. If you can arrange it so that all the subjects face inward the pose has closure, holding the viewer's focus. In the posed picture, both parent models are turned towards the bride (the center). If you had four people (for instance, the bride, groom, and a set of parents), you might turn each couple towards the center of the composition. Although the three-up shown is a lineup, it's not unacceptable because the line is short. Once you have more than five subjects though, it's time to do something different.

A three-up can be made into a vertical composition if you have one tall, one short, and one medium-height subject. With three similarly sized subjects, you can create the same effect by seating one of them in front. Imagine dad seated, with mom and the bride each on opposite sides of him, leaning in on his shoulders.

With a stepladder and three different-sized cases, I can create eight different levels on which to pose subjects. The ladder has three steps, and the three different-height cases make places for the first six subjects. Having some subjects sit or kneel on the floor and having others stand adds variety to the subjects' heights. Cases can be stacked on one another, creating even more possibilities. Look back to the pose of the groom on page 71 for one option.

three faces in a vertical composition by posing the subjects so their faces all fall along a diagonal line. In this instance, I sat the mom on the lowest position (in this case the middle step of my posing ladder) and arranged the young girl and the bride in order of their size. Notice also that the mom's shoulders are at a 45° angle, but her back is towards the camera, and she is facing toward her daughters. By placing her and the bride so they both face in, they contain the viewer's eyes as they sandwich the middle subject.

Once you start doing these variations, you might find that you run out of depth of field. As the posed subjects get deeper and you get closer, it becomes apparent that you can't get everyone in focus because all the faces are on different planes. The obvious remedy is to choose a smaller f/stop, which will increase your depth of field, and focus on a point that is one-third into the depth of the subjects. There is only so much this can do.

The other remedy, one that you should always be aware of, is to create a pose that looks deep but isn't. In the variation of

the three-up on page 75 (bottom right), notice that the tall subject's rear shoulder is behind the bride's rear shoulder. This creates a little pocket for the short subject to fit into, and the pose isn't as deep as one in which the two taller subjects' rear shoulders are on the same plane. On the variation above it, notice that I had the rear-most subject lean in over the middle subject so that once again the pose isn't as deep. If you're posing the subject(s) anyway, you might as well position them so that your technical limitations are minimized.

Carry Posing Tools

One easy way to get variety in the heights of your subjects is to pose some of them seated. For this reason I carry six different-sized chairs with me everywhere I go.

Not really! Though I don't really lug a stack of chairs with me, I do carry a posing ladder. I also use carefully chosen hard cases for my lights instead of today's more popular, soft-sided equipment cases. Each of my three cases, when stood on end, is three inches taller than the next. Inside each case I carry a posing drape that can cover the case, converting it into a seat or perch for a subject to sit or lean on. I also carry a fourth posing drape to cover my stepladder when it's used for posing.

These posing aids all do double duty. The cases are needed anyway to protect my lights as they are lugged around from assignment to assignment, and the posing ladder can serve two purposes by giving me a high vantage point when I shoot over crowds or want to photograph an overall view of the dance floor.

The Large Group

One of the hardest things to do is to make a large group look interesting. If you have no posing tools, you are pretty much stuck with a lineup. In general I will go to great lengths to avoid shooting subjects in a straight line. If there are short people as well as tall people in the family or bridal party you can pose a lineup in which you use the various subjects' heights to make the grouping more pleasing. In the stand-up grouping pictured at right notice that the subjects are placed so that lines connecting the subjects' faces all create diagonal lines that lead into the bride. Also note that the subjects are arranged so that no two faces are one right on top of the other.

In the second picture, pretend that we're in a park and I have my posing ladder with me. Two subjects, in this case the groom and the ring bearer, are seated on the steps of my posing ladder. To create other heights for the pose, I sat two of the

© Jan Press Photomedia

Even though I hate a lineup, sometimes I'm forced to use it. To make the best of a lineup, try to use the subjects' different heights to your advantage.

Just adding a ladder to your arsenal of posing tools opens up new possibilities. Good wedding ladders have a top step (or seat) between 29 and 30 inches high. The one I use is more like a portable mini-staircase than a step-ladder. If you start to use a stepladder for posing, remember to use it to take some high-angle shots at the reception also.

girls down on the floor (er…I mean grass). Some may criticize this pose because the flowers are growing out of the little boy's head, but from sad experience I've found that you're lucky if you can get most little kids to sit still, look at you, and smile for a picture. If he (or she) is still and smiling, I shoot the picture…to heck with the flowers!

For my final group shot I used my posing ladder and two empty camera cases to create multiple tiers. In a real situation, posing drapes and gowns would be covering all the posing tools, but note how all the lines connecting the subjects are diagonal and the grouping looks like a pyramid instead of a lineup.

Creating Your Own Style

Posing is an art form. The photographers I consider to be great take years refining their styles. If your posing doesn't start out at perfection, that's no sin. You should, however, strive not to continually repeat the same mistakes. Your goal is to achieve natural and relaxed poses…poses that don't look stiff and contrived. That is not an easy goal to achieve. I find that beginners tend to plod along on one plateau for a while, and then, in what seems to be overnight, their posing quality makes a quantum leap. Making that first leap requires looking at and critically evaluating your posed pictures. Once you can identify stiff, unnatural poses in your photos, you'll be able to notice stiff, unnatural poses when you are setting up the shot. All that's needed then is the courage to change a pose before you push the shutter button. Once that happens, you'll make your first quantum leap.

Once I add empty camera cases to my posing ladder for group shots I can create many different levels on which to place my subjects. After a short while you begin to be aware of the relative height of the different subjects you're working with and the different height steps and boxes you have available to seat them on. With very little effort your family lineups can be turned into family groupings that are more pleasing to the eye than the "stand 'em up… shoot 'em down" style of posing that many wedding photographers practice.

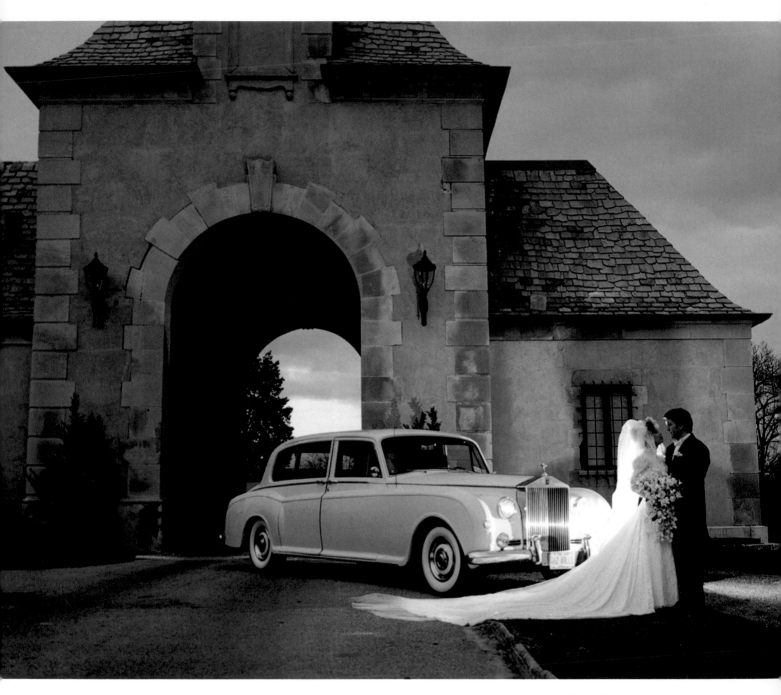

WORKING WITH FLASH

I'm at a posh wedding photographing a big circle dance. As the bride, groom, and both sets of parents go swirling past my camera, the battery pack for my flash unit dies. I call my assistant over and plug my sync cord into his pole-mounted light. I grasp the light pole and my bracket in my left hand, throw his battery pack onto my shoulder, and continue to soldier on shooting with this unwieldy setup. The dance set ends, and the crowd begins to reseat itself, while the second photographer, who has been shooting from the balcony, makes his way over to me. I'm standing there, a battery pack on each shoulder, straining to hold my camera, bracket, light pole, and flash head all in one hand. With my eyes popping out of my head, I say, "Did you see what happened to me during the dance?!" He says, "Yeah, you looked busy....Let's go shoot the tables."

No matter how you look at it, wedding photographers depend on electronic flash. While anyone can extol the virtues of natural (or available) light, the simple truth is that shooting by natural light is very limiting, and nature isn't always cooperative. It pays to remember that the wedding warrior works in dim churches and even dimmer catering halls. Just as important is the fact that while the ceremony might take place in an outdoor setting on a bright afternoon, the party will extend into the dark of night. Although a hobbyist can afford to get one great photograph from a roll of 36 exposures shot while the available light is perfect, a pro, driven by profit, can't afford that luxury. And while the novice might want to use all the lens speed he or she paid for to take pictures, a pro is usually much more comfortable with a smaller f/stop, which can increase depth of field and help cover focusing errors. If you add together a flash unit's power, its action-stopping ability, and the fact that weddings are often covered in "available dark," you can see that a good flash is a wedding photographer's best friend.

There is a battle going on in our industry over which type of flash is best. Should we use automatic flash, or is manual flash unit still king of the hill? From my point of view this is often a tempest in a teacup. Here's why: Most wedding photographs are shot from three specific distances—15, 10, and 6 feet (about 5, 3, and 2 meters). The 15-foot picture can cover full-length shots with a normal lens or group shots with a wide-angle. The 10-foot picture can cover bust shots of singles and two-ups with a telephoto, bust shots of groups from three to six with a normal lens, or full-lengths with a wide-angle. Finally, the 6- to 7-foot picture can cover tight single or two-up head shots with a portrait tele, two- and three-ups with a normal, and intimate candids with a wide. These three distances convert to three different f/stops with a manual flash unit, and even if you add in a fourth f/stop for bounce-lighting effects, you can see that there really aren't many possibilities to remember. Considering that approximately 99.9% of wedding photographs are shot on color negative film, which offers an embarrassment of riches as far as exposure latitude is concerned,

you can see that a manual flash unit is pretty easy to use. If manual flash is your choice, you'll find that within a short time you'll be able to figure out exposure by feel. Soon you'll be able to forget about calculating an f/stop, because with a little practice you'll become an extremely accurate, walking, talking, human flash meter.

However, before you can become a human meter, you'll have to figure out which f/stop to use. That's easy enough. The f/stop you choose for proper exposure with a manual flash is based on the light's distance from the subject. By dividing the flash unit's distance from the subject into the guide number (which is different for every ISO film speed), you get the proper f/stop for correct exposure (at that distance and with that speed film). This is not difficult, so follow along with me as I illustrate this with an example.

If you have a flash unit with a guide number of 80 in feet (24 in meters) for ISO 100 film, and you are 10 feet (3 meters) away from your subject, the f/stop for proper exposure is f/8. To get this I divided 80 (the guide number) by 10 (the distance) and the result, 8, is the f/stop to

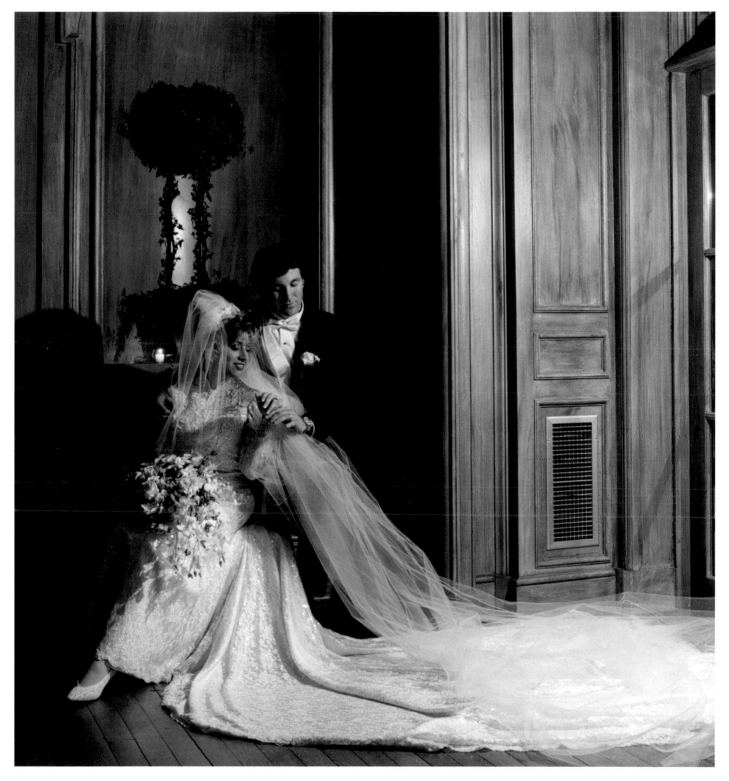

Is it flash or is it available light? Sometimes the look of light coming through a window can be replicated easily with a flash. In this instance the light source is off to the right, and the couple is posed to take advantage of the light's direction. And no, I'm not telling whether the photographer used flash or ambient light for the picture, because either could do the trick! Photo © Franklin Square Photographers, Ltd.

use. This works for metric guide numbers, too, as long as you divide meters by meters. Before you get nervous about making these constant calculations, let me point out the following: In my example, if your distance is 15 feet (4.6 meters), the resulting f/stop is f/5.6, and if you close in to 7-1/2 feet (2.3 meters), the resulting f/stop is f/11. In fact, if your distance is one-half of the 10-foot example (5 feet), you close down two f/stops from the 10-foot exposure, and if your distance is twice the 10-foot example (20 feet), you open up two f/stops from the 10-foot exposure. That means that with a guide number of 80 for an ISO 100 film you would set your f/stop as follows for these distances: 5 feet (1.5 meters) = f/16, 7-1/2 feet (2.3 meters) = f/11, 10 feet (3 meters) = f/8, 15 feet (4.6 meters) = f/5.6, and 20 feet (6 meters) = f/4.

There is one small fly in the ointment. Small white rooms push your guide number up slightly because light from the flash bounces off the walls and ceiling, kicks back onto the subject, and adds to the exposure. On the flip side, big dark rooms, such as banquet halls and cathedrals, suck up some of your light and take away from the exposure. To compensate for this I open up 1/2 stop from the calculation for cavernous dark rooms and close down 1/2 stop from the calculation in tiny white ones.

The term to describe this might be called "Kentucky Windage." During the early years of our country's history, the best sharpshooters were from Kentucky and used long rifles. Their accuracy depended on taking the wind direction and velocity into account as they took aim. Kentucky Windage was the compensation factor the sharpshooters threw into their mental calculations to adjust for the wind's effect. Candidmen do the same thing with regards to room size and color.

Some readers might be concerned about my choice of ISO 100 for my examples when the majority of weddings photographed today are shot on ISO 160 film. Well, for the uninitiated, while it is true that ISO 160 film is the current de facto standard, most shooters rate it at ISO 100 or 125! This is because with ISO 160 color negative film, 1/2-stop overexposure doesn't affect picture quality to any great degree. This is even more true with the roll film (larger than 35mm) that is favored by hard-core users like myself. In any event, an underexposed negative is a thing to avoid like the plague. Furthermore, many of today's manual flash units used by wedding shooters will give you a guide number of 80 or 110 when used at 1/2 power with ISO 100 film. Sometime soon ISO 400 speed films will probably replace the current 160 versions as the favorite wedding fodder. My experience with them so far is that they aren't as forgiving of overexposure as their slower siblings. For the moment, ISO 160 film is the name of the game, and shifting the ISO rating to 100 or 125 is not a problem.

From sheer repetition I find manual flash to be very simple to use, but some may argue that auto flash units are still faster. Although I agree, I often counter that the auto flash unit's "brain" is frequently tricked by a huge white wedding gown or a sea of black tuxedos, or worse still, a huge white wedding gown in front of a sea of black tuxedos. And sometimes the auto flash is faced with a fairly small light subject in the middle of a huge dark room (such as a banquet hall). These situations, which are common in the wedding world, can addle the brain chip in an auto flash unit.

The last argument I'll use on the side of manual flash is the pros' use of pre-visualization. Many photographers think of pre-visualization as the tool of the landscape or view camera photographer, but as a fast-working wedding pro, I rely on it all the time. After watching me work, many assistants have commented that I can work as quickly with a roll-film camera and a manual flash as a novice with a 35mm camera and auto flash. This is possible because I pre-visualize my pictures.

Here's how it works: I decide to shoot a bust-length candid picture of two people. I choose my wide-angle lens. Before I approach them I set the focusing scale on my camera to 6 feet (1.8 meters) and set my f/stop for a 6-foot flash picture. After I've done my camera fiddling, I walk up to my subjects and ask them to look my way and smile. I then backpedal to 6 feet away from them, raise my camera up in front of my face, and push the shutter button. No sawing at the focusing ring or wildly computing an f/stop for me! That's already been done because I've pre-visualized my picture. In fact, the whole thing takes less time to do than to read about.

There's really not much point in discussing all of the pros and cons of manual vs. auto flash because the knowledgeable photographer is more interested in how to exploit whatever lights he or she is using. I prefer manual, but if automatic flash is your cup of tea, more power to you. The real issue is not which hardware to use, but how to use it. What you should be interested in is the phenomenon called "light quality."

Turning Flash into Available Light

When I first started to shoot photographs I worked as an assistant to a busy New York pro. I once told him that I shot only by available light. He told me that if I had an 800 watt-second strobe in the trunk of my car, then it would also be "available." The truth is that I shot by available light then because I didn't own or know how to use flash equipment. Shooting weddings required that I learn flash lighting techniques. Now I don't take out all my lights on every assignment, but when the need arises, at least I know what to do with them—and they're "available!"

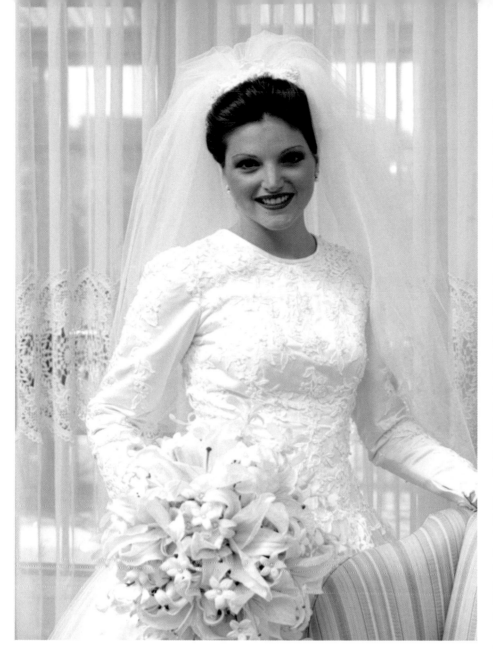

Although bounce flash creates some shadows on the subject's face, it is still a pleasant light source that appears casual and natural, and it minimizes skin imperfections. Many photographers feel that bounce lighting has no sense of direction, but I find if you add a second bounced flash that is stronger than the on-camera bounced flash, you will add dimension to the subject's face.

THE SINGLE LIGHT AND YOU

Ah, quality! If wedding photography is done with flash on-camera, then the light quality often bears a strong resemblance to that provided by a coal miner's helmet light—terrible! However, when working with a single on-camera light, there are a few things that you can do to leave the miner-helmet look behind.

In the "Single Light and You" game, you might remember to keep your eyes open for bounce-lighting situations. Any time you are in a room with white ceilings, bells and whistles should go off in your head shouting, "Bounce, you fool...BOUNCE!" In fact, it is so ingrained in me that the first things I look

at when I enter a room are the ceiling's color and height. The color is very important because a blue ceiling will give you blue pictures if you use ceiling-bounced flash. From personal experience I have found that most white ceilings (from refrigerator to eggshell) will give pleasing results, but bouncing a light off any other color is a definite no-no. The ceiling's height is also very important.

Many years ago one of my mentors gave me an equation for getting the exposure into the ballpark when using ceiling-bounced flash. Just add the distance from the flash to the ceiling to the distance from the ceiling to the subject and that is the distance the light is traveling. This means that if you are in a room with a 10-foot ceiling and you are 6 feet from the subject, and the camera's and subject's height are both about 5 feet, your light is traveling about 12 feet (5 feet straight up and then about 7 feet, diagonally, back down to the subject).

Because bounced flash light travels indirectly, it travels farther than direct flash in order to reach the subject. Therefore, to bounce flash off of high ceilings or to shoot when standing a great distance from your subject, you will need much more flash output than using bounce flash in a low-ceilinged room or shooting close-ups.

As far as the ceiling's color is concerned, from the basic direct-light exposure calculation, which is based on flash-to-subject distance, I open up 1 stop for a clean white ceiling and 1-1/2 stops for a dingy tan-colored one. And because bounce lighting is so soft and full (low contrast), you will find that you can overexpose in a bounce-light situation without much image degradation. Personally, I find bounce lighting has a more casual feel than direct flash, and I find it better suited for home portraits or afternoon affairs than formal evening galas.

When you are deciding to use ceiling-bounced flash, it is important to understand the effect the light will create and what you can do to improve on bounce lighting's fatal flaw—the ceiling becomes the light source. Not only will the light take on the ceiling's color cast (just

Direct Flash

These images show the difference between direct flash and bounce lighting as well as illustrate the limitations of bounce. Bounce flash elminates the shadow on the background, but produces shadows under the subject's chin, nose, cheeks, and in the eye sockets. By using a fill flap (in this case one made by Lumiquest), some of the bounced light is redirected forward into the shadowed areas. Note that bounce lighting with the fill flap appears softer than lighting with direct flash and also reduces shadows on the face and the background.

Bounce Flash

Bounce Flash with Fill Flap

mentioned), but the overall light on your subject will be from above. This creates shadows in your subjects' eye sockets and under their chins.

To get around this, experienced shooters almost always use an accessory called a fill flap to push some light into these shadow areas. A small white plastic or paper card taped, "Velcroed," or rubber-banded to the back of the flash head will redirect some of the upward-traveling bounce light forward to help fill in the unflattering shadows. I've seen one candidman use a white plastic coffee spoon as a fill flap to add a tiny catchlight to his subject's eyes. Some candidmen use 10 x 12-inch fill flaps for a very open effect. While both of these effects are passable, my own preference is to use one about the size of a 4 x 5-inch file card, although the ones I use are made of tough white plastic. I even know one shooter who uses a piece of cardboard covered with aluminum foil—dull side towards the subject—for a more "specular" (his word) effect. As in most things photographic, the size, shape, and reflectivity of the fill flap is a matter of personal taste, so experiment to find your own favorite combination.

Although many photographers think of bounce lighting in relationship to ceilings, a crafty candidman can also exploit white walls for bouncing flash light. Wall bounce can often create pleasing effects that emulate window light. Like ceiling bounce, manual exposure calculation for wall bounce is based on the light's distance from the wall and then back to the subject. From this exposure I again open up 1 stop for white walls and 1-1/2 stops for tannish ones, just like ceiling-bounce lighting. Also, as with ceiling-bounce lighting, the color of the bouncing surface is of the utmost importance. If you bounce light off green walls, you'll get green subjects! I'm sure your customers won't buy many pictures of themselves with a green cast no matter how many times you tell them it's a creative special effect!

When direct, on-camera light becomes the method of operation for a candidman, light quality is still the name of the game, so you must look at the reflector on the flash you elect to use. Flash units get their power from internal capacitors. That power is measured in watt-seconds. Some physically smaller units often have

Some flash brackets, such as those made by Stroboframe, allow you to keep the flash centered above the lens whether you're shooting a vertical or horizontal composition.

smaller capacitors, and to juice up their output, the flash designers create high-output reflectors. Sometimes these "hot" reflectors don't cover the image angle of a wide-angle lens, or they create hot spots in the center of their flash patterns. If your flash unit has an accessory wide-angle diffuser, you might consider using it all the time. In the first place it will cover any misalignment errors between your flash and camera, and it will very often even out the unit's flash pattern. My flash of choice for battery-powered work is a Lumedyne, but I use their accessory wide-angle reflectors instead of the one that comes as standard equipment with the flash. Even though the standard Lumedyne reflector has a wide-angle setting, I prefer the accessory reflector because it is wider still, and the pattern is more even. I made this choice knowing that the accessory reflector costs me one f/stop in power output. But it was worth it to me in my search for improved direct-light quality. While reflector choice is one aspect of light quality, it also pays to invest a lot of thought into how the flash will be mounted to the camera.

For most wedding shooters, the union between their camera and flash is the flash bracket, and that bracket has to perform many functions. Obviously, if you want to be able to bounce the flash off the ceiling or wall, then you must be able to pivot the flash head so that it can be directed towards the bounce surface. While this

seems easy enough, it is also important that the flash bracket positions the flash head so it is directly over the lens when you choose to use direct flash. If the flash is mounted to either side of the lens, it will cast a horrid shadow on the opposite side of the subject. Designing a flash bracket for square-format cameras is easy because these cameras are oriented the same way for either vertical or horizontal compositions. However, rectangular-format cameras (such as 6 x 4.5cm and 35mm) have to be rotated 90° to change from vertical to horizontal format (or vice versa), which changes the relative position of the flash and creates flash bracket dilemmas.

There are only two ways to solve this. One is for the flash to swing so that it can be positioned over the lens for either vertical or horizontal pictures. The second is for the camera to rotate within the flash bracket so that the flash remains over the lens for both verticals and horizontals. For more specific information on flash brackets, see the Equipment chapter, but for the time being, let's get back to light quality.

While a good flash bracket will position the flash head directly over the lens, the question begging to be answered is, just how high over the lens should the flash head be? As with many things in wedding photography, the distance between the flash and the lens is based on a series of compromises.

Flash-rotating bracket

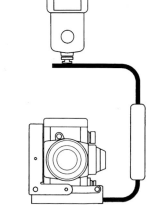

Camera-rotating bracket

The Extended Approach

In the real world, natural light comes from above us, so some might think that the greater the distance between the flash tube and the lens, the better. However, to move quickly through crowds (not to mention doorways) with the flash head attached to a thin metal arm some 6 or 7 feet above the lens is impractical. Furthermore, the weight of a flash head that far away from the camera exerts substantial strain on a photographer's wrists, so trying to keep the whole rig under control is a difficult task. Some readers may think that I'm wasting time talking about this admittedly bizarre approach, but I have actually seen shooters working with their flash units on extendible flash arms that can (and do) place the flash 6 or so feet above the camera!

While 6 feet between the flash and lens is one end of the spectrum, there are photographers who like their candid rig to be as compact as possible. They enjoy the feel of a small package, and on some rigs I've seen flash heads 3 to 4 inches above the lens. The problem is, the closer the flash head gets to the lens, the more chance there is for red-eye.

The Compact Approach

In addition to achieving better balance and reducing wrist fatigue, another advantage to using a compact bracket becomes evident when you are shooting pictures of people who are close to a wall. In this scenario, any shadow the flash creates falls almost directly behind the subject and therefore doesn't detract from your image.

However, once the flash head reaches a height of about 12 to 14 inches (30 to 36 cm) above the lens, the shadow cast by the subject's head onto a wall, drape, or a person behind him looks like a dark blob behind his neck. While this blob may seem to be an acceptable compromise, raising the flash unit this high can create other problems. Specifically, it can make it very difficult to shoot pictures through small openings, such as limousine windows, which are often bestsellers.

Over my years of experience as a candidman I have had a variety of brackets that have placed the flash head between 3 and 14 inches from the camera's lens. I've finally settled on a bracket that lets me move my flash head between 4 and 7 inches from my lens. For tight places I push the flash head close to the lens, but for general shooting I prefer to extend the flash head farther out to about 7 inches from the lens. If you are serious about wedding photography, you'll find yourself constantly chasing after the perfect distance between the flash and the lens. Sadly, the perfect distance doesn't exist, but nevertheless, you can (and will) spend years searching for it!

So Which One's Best?

Each distance between flash and lens has advantages and limitations, so your best bet is to do some tests of your own. Attach your flash unit to a light stand and hold the camera against the stand at different distances from the light. Remember to place the subject at different distances from a plain wall so you can discover not only how close the flash is to the lens when it finally causes the dreaded red-eye, but also how the distance affects the shadow cast by the subject's head. You will find that, in addition to the flash-to-lens distance, the subject's distance from the wall and the lens in use also affect how the shadow appears behind the subject.

Finally, when deciding on a flash bracket and determining the distance between the flash head and lens, take into account the weight of the flash unit you are using. Most self-contained flash units with enough battery capacity to satisfy a serious wedding pro weigh so much that every extra inch of distance between the flash and lens adds pounds of extra torque on your wrists as you try to whip the camera around for a shot. While you could work out to increase your wrist strength, lighter-weight flash heads with separate, shoulder-hung battery packs go a long way towards keeping your wedding rig from becoming top-heavy. (See the Equipment chapter for more information.)

Flash in the Great Outdoors

Most photographers know that midday light is awful. A big, beautiful sun beating down on subjects from directly overhead creates inky black shadows under noses and chins and makes eyes recede into dark sockets under the shadow of the brow. Very often, such beautiful days (though they are what every couple hopes for) don't lend themselves to making beautiful portraits. But whether faced with soft light or glaring light, the wedding photographer must prevail! Every bride wants outdoor pictures whether the light is cooperative or not. Against all odds, with only a flash unit at one's side, a candidman can use flash successfully outdoors to create beautiful pictures. The trouble is, every novice photographer is afraid to.

To a novice, mixing ambient light and flash is voodoo, but there really is no alchemy involved. You are just mixing two ingredients, and there are recipes you

Red-Eye — What It Is and How to Eliminate It

Red-eye is caused by light shining into the eye, bouncing off the retina, and back into the lens. So you see, red-eye is a reflection problem, and the old rule that states "the angle of incidence equals angle of reflection" applies. Therefore, one good way to eliminate red-eye is to increase the distance between the flash and the lens. Do some testing on your own with a blue-eyed friend (the worst red-eye offender) to determine just how far apart the flash and lens need to be for your setup to eliminate red-eye.

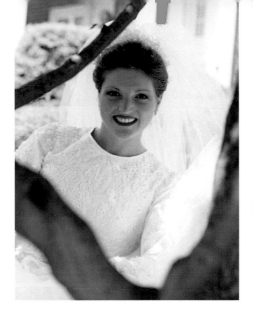

Working outside under bright sunlight can be a challenge, but crafty photographers know to move the subject into the shade, even if it is only under the leaves of a tiny tree! Although the shade from the tree softens the light on the bride's face, the background lit by direct sunlight is overexposed, and the resulting image is high key.

In this second photo the photographer used a single flash off-camera to the right to light the bride, which accomplishes a few things: 1) The background is no longer overexposed; 2) The picture appears crisper; and 3) The picture has a very different feel than those shot with available light, which adds variety to the customer's choices.

It may go against your instincts to add more light to a brightly lit scene, but bright sunlight causes harsh shadows. Illuminating the shadow areas with fill flash reduces contrast to a range that can be recorded by the film. By adding a little fill, the photographer captured the beautiful ambient light rimming them while preventing them from being hopelessly underexposed.
Photo © Phil Cantor Photography

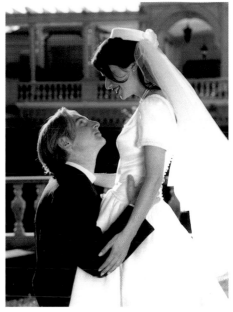

can follow. By understanding how the ingredients work, you can control how much of each ingredient to use in your recipe. Ingredient number one is ambient light (you can substitute the word daylight, sunlight, skylight, available light, or moonlight here), which is a *continuous* light source. You can control the ambient light's exposure on film by changing either the aperture or the shutter speed. The second ingredient is the burst from your flash, which is an *instantaneous* light source. You can control flash exposure on film by changing the flash's distance from the subject, its power output, or the lens aperture. Flash exposure, for the most part, is unaffected by your choice of shutter speed (as long as the shutter speed allows flash synchronization). This means that by changing the shutter speed you can affect the ambient light part of the recipe without changing the flash ingredient. Also, by adjusting the flash unit's output or by changing its distance from the subject you can affect the flash part of the recipe without changing the ambient light ingredient. Here is where leaf (also called between-the-lens) shutter camera designs really come into their own. When you

realize that leaf shutter cameras can synchronize flash at any shutter speed, you'll understand why they are a strong favorite for wedding work. Digest that thought for a minute, and then let's look at a another choice you have to make.

With flash and ambient light as your two light sources, you must decide if you want one light to be the primary source (and if so, which one), or if you want the two sources to have equal value. Once you've made that choice, getting the two light sources to complement each other is the name of the game. The best way to understand this is by walking through a hypothetical scenario for each possibility.

In the first scenario we'll make the ambient light the main light and the flash the fill light. You are outside, it's 1:00 p.m., and you're looking at a beautiful bride with black shadows under her brow, nose, and chin. You are in the middle of a field, and there isn't a tree in sight. I mention the barren field because given a shade tree, I might try to work in its shade. But the scenario I'm painting includes harsh sun and no shade, so you must make do. An incident meter reading of the ambient light falling on the subject calls for an

exposure of 1/125 second at between f/11 and f/16. Set your camera to these settings. The next step is deciding how much light you want to use to fill in the shadows.

From hard-earned experience I've found that a fill-light exposure that is about 1-1/2 stops less intense than the main light results in a pleasing amount of light in the shadows. That means that the flash has to be far enough away and put out enough power to create an exposure of f/8 for the subject. (Why f/8 you ask? Because it creates an exposure that's 1-1/2 stops less than the ambient exposure of 1/125 second at between f/11 and f/16!) I know that if my manual flash unit is set on 1/2 power and it is 10 feet from a subject, the intensity of the light it puts out is f/8. Perfect. So, using a long sync cord I can position the flash so that it is 10 feet from my subject, and voilà—I have a fill

light 1-1/2 stops under the sunlit ambient exposure. Of course, you could dial the flash unit's power down as well. There is always more than one way to skin a cat.

Although this scenario may seem easy, maybe the ambient light intensity is something a little unusual, like 1/500 second at f/5.6. What do you do then? Well, first remember that flash exposure is unaffected by a change of shutter speed. Then, remember that 1/125 at f/5.6 is equivalent to 1/60 at f/8, which is equivalent to 1/30 at f/11. I could shoot at 1/30 at f/11. I know that at 1/2 power my manual flash puts out f/8 at 10 feet. I also know that when the flash unit is 15 feet from the subject it calls for f/5.6 (see the guide number explanation on page 80). So put the light approximately 12 feet from the subject, and once again the fill light will be 1-1/2 stops below the exposure you're using for the ambient light. Just for the record, if you were to decide to expose at 1/60 second at f/8, you could leave the flash about 12 feet from the subject and drop it to 1/4 power so it would put out enough light for an exposure between f/4 and f/5.6.

Now let's look at a scenario in which you want the light from the flash to overpower the ambient light falling on the subject. This might come up in a situation where the subject is in the shade of a tree but the background is a sunlit sky. If you expose for the light falling on the subject's face, which is in the shade, the sky in all its azure glory will be overexposed to a bland white. In this example an incident reading of the subject might call for an exposure of 1/30 second at f/5.6 while a reflected reading of the sky might call for an exposure of 1/125 second at f/11. What do you do? Because you want the sky to register as deep blue, set the camera to 1/125 second at f/16, and then move the flash unit in until it is about 5 feet away from the subject. You already know that your flash exposure at 1/2 power and 5 feet away calls for an f/16 exposure, so you're ready to shoot the portrait.

This picture will indeed produce a deep blue sky, but you might want to take a second photograph without the flash, with the camera set to 1/30 second at f/5.6

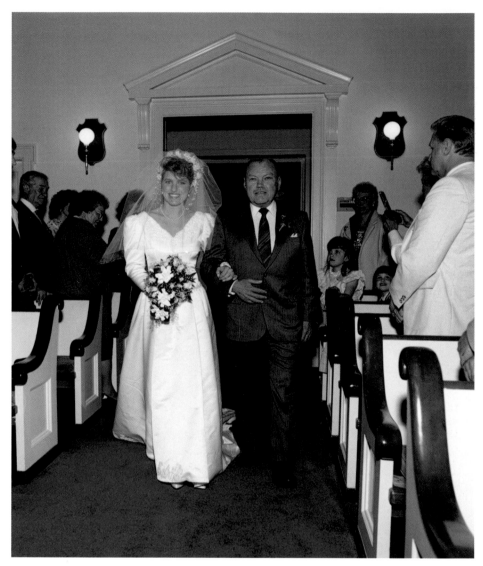

Capturing a photograph of the bride and her dad walking down the aisle is a must at any wedding. Even if there is no time to set up room lights to illuminate the background of the church, you can often pick up some of the ambiance in the church by dropping to a slower shutter speed so that the wall sconces in the rear of the church become more prominent.

(meter for an incident light exposure of the subject in the shade). The two pictures will appear wildly different, and you might get two sales from these two frames of film. One (with flash) will be richly colored, while the other (no flash, ambient light only) will appear high key and airy.

Even under conditions that many photographers consider perfect, such as an overcast sky, you might want to use a small puff of light to brighten up the subject's eye sockets. For these situations I carry a clean white handkerchief and drape it over my flash head. The white

cotton cloth cuts the flash output by about 1 stop. I use this technique when the ambient light intensity is low so that light from the flash is not unnaturally harsh.

The mixing of flash and ambient light is not limited to use out of doors. Many shooters, in reception halls with great crystal chandeliers and wall sconces, shoot their dance-floor images at 1/30 second (instead of 1/60 or 1/125) to pick up some of the "flavor" of the room. Just remember not to do this when working under strong video lights or the images will have a yellow cast.

THE DOUBLE LIGHT AND YOU

After you've mastered how to use a single light, the next step in portable flash work is called "double lighting." In this style of wedding shooting, in addition to the camera-mounted flash unit, the photographer uses a second light, equipped with a flash slave, on a pole. To get the most out of a portable second light, you need a good assistant to hold and aim it.

First Thing's First: Get a Good Assistant

A good assistant is one of the most valuable tools in a wedding photographer's arsenal. Many photographers feel that they can work most effectively alone, but when it comes to weddings, I disagree. A photographer and a good assistant become a team. It has been said that the best assistants are other photographers because they know what the photographer is trying to accomplish and, therefore, they can act to achieve that goal.

Some might feel that they work more quickly when working alone, and others who have been reared in a photojournalistic tradition feel that an assistant makes them too conspicuous. Let's think about this for a second! Imagine you are standing at the foot of the aisle, with 300 people sitting in the pews. Both you and the 300 people are waiting for the bride to enter the church. The 300 pairs of eyes aren't all turned to the back of the church. Most guests are looking towards the alter, and there, standing right in front of them is YOU! Wedding photographers, by the very nature of their jobs, are conspicuous. Everyone's eyes are always riveted on the bride and groom, watching their every move, and you are always right in the middle of the action. If you expect to be a fly on the wall, you won't be getting many great photographs. In fact, most brides and grooms expect you to be there, right next to them. So much for being inconspicuous.

Finding a good assistant is not easy, but there are some likely places to look. Trade schools and your local high school or college photography department are obvious sources. Some schools offer job-hunting assistance to young people, and it might pay to look into those programs. If you live in a big city with multiple-room catering halls, your next assistant could be working for the photographer at the other reception! Also, keep your ears open for members of the bridal party who are interested in photography. Finally, you might look for a young person in your neighborhood who's interested in photography or just wants to earn a few extra bucks.

A good assistant is to be treasured. I've heard some candidmen call their assistants "light poles with legs." I pity these photographers because they aren't exploiting their assistant's full potential. After a short time an assistant can help organize the families and even touch up a pose. A good assistant can load magazines, hand you filters, even shoot another view from the choir loft of the church while you are working on the lower level.

To get this kind of performance from an assistant requires that you communicate what you want and say it in a way that is understandable. I try never to criticize an assistant in front of a customer, but many times on the way home from an assignment my assistant and I discuss how things could be improved. If you listen carefully, you might also get ideas on how you can improve your own work, but what's more important is that the assistant feels like a teammate and is willing to work harder. Getting the most from an assistant requires that you have good people skills, and since you need those skills for working with the bride and groom as well, practicing on your assistant has many benefits in addition to making him or her better at the job. It pays to remember that as you become more successful, your number one assistant can become a photographer in his or her own right and cover a second assignment for you.

Many times I teach by example. If you want your assistant to get you a cold drink during a break, first offer to get him one yourself. Ask how he is doing, listen when he speaks, be polite to him, and in general, treat him like you would like to be treated yourself. I make it a point to throw my assistants a few extra bucks after a heavy June season and around Christmastime, and usually I give them a share of any tips I get. It's amazing what kind of loyalty and effort you can get out of assistants when you treat them well. You are trying to establish a team, and a good team usually means better pictures and a smoother assignment.

Candids on the dance floor often give the impression that the main subject is standing in a black hole. It gets worse when catering hall designers paint the walls or ceilings black or midnight blue to make the room more mysterious and romantic. By dragging your shutter a little (using a longish shutter speed) you expose the background and add a sense of motion to a scene in which activity is important. Alternatively, you could add a second or third light to such scenes, which would help open up the background a bit, making the subjects appear more three dimensional. Photo © Three Star Photography

Mixing flash and ambient light can add drama to a scene that contains ambient light sources. In this instance the photographer placed a flash behind the couple and under-exposed the ambient light slightly, creating a beautiful semi-silhouette. Photo © Franklin Square Photographers, Ltd.

Remote Flash Triggers

To make your second light fire in synchronization with your camera light, you need a piece of equipment called a remote trigger or flash slave. These devices are used to trigger a remote flash in sync with the camera's main flash. There are three categories of remote triggers, classified by their actuation method: light (from a flash unit), radio signal, or infrared pulse. Before we get into where to aim your second light, let's look at the three types of remote triggers available.

Light-Actuated Remote Flash Triggers

Light-actuated slaves are the simplest and probably the most reliable of the three. They react to a burst of light (your on-camera flash) and trigger the second light to fire. They have no moving parts and, in general, require no power supply, although some contain battery-powered amplification circuits. Their Achilles' heel is that light from any flash unit will cause them to fire. While this may not seem like a problem, just think for a moment of all the point-and-shoot cameras at the average wedding that will be

using up the battery supply that powers your second light! To make matters worse, if you base your exposure on that second light firing when you need it, and it is recycling after being tripped by Uncle Otto's Wonder Blatz, you (and your picture) are out of luck.

In today's wedding photography world, the other problem a light-actuated remote trigger user faces is that video lights can often blind a light-actuated trigger, making it useless. I have often defeated this bugaboo by covering my remote trigger's receiver with translucent strapping tape, which reduces the amount of ambient light falling on it. Even considering this, light-actuated slaves are reliable, lightweight, relatively inexpensive, and easy to use.

Radio Remote Flash Triggers

Radio remote triggers use the same basic technology as electric garage door openers. The transmitter sends out a radio signal. The dedicated receiver picks up the signal and fires the remote flash unit it is attached to. They are preferable to light-actuated flash slaves for shooting weddings because they don't react to every point-and-shoot flash camera. However, they aren't perfect either. Most require two cords on the transmitter, which is mounted on the camera: one sync cord from the camera to the transmitter and a second cord from the transmitter to the on-camera flash. Some radio slave transmitters come equipped with a foot that allows them to be mounted to the hot shoe of a 35mm camera. This eliminates the need to have a cord between the radio slave transmitter and the camera. Also, a third sync cord is needed between the receiver box and the second light, which is mounted on the pole. To further complicate things, radio remote triggers require batteries in both the transmitter and receiver. The transmitter box draws power only when you fire the camera, so its power supply seems to last forever. The receiver, on the other hand, must always be in a state of readiness to receive the transmitter's signal. Because its circuitry is always up and running, it eats batteries for breakfast, lunch, and dinner! While

the newest radio remote triggers have really cut back on their power-hungry ways with improved circuitry, they still require frequent battery replacement.

Infrared Remote Flash Triggers

Instead of responding to a radio signal, infrared receivers are triggered by a coded pulse of infrared light from a transmitter, so they too are unaffected by flash-happy point-and-shooters. The transmitter is battery dependent, but the receivers require no batteries. More important, the transmitter must recycle between pictures, and as the transmitter's batteries near the end of their useful lives, the transmitter's recycling time gets longer. On the plus side (and it is a big plus), many of today's AC (studio-type, plug-into-the-wall) strobes come equipped with infrared receivers, so all you'll need is a compatible transmitter.

Using the Second Light

Currently I use radio remote triggers, but my gear cases include multiple replacement sync cords, multiple spare batteries, and multiple back-up light-actuated slaves for use when everything else fails. Once again, like the manual vs. auto flash controversy, the type of remote trigger you use is not the real issue. What you can do with a second light and how you use it are much more important than simple hardware preferences. That's what makes a difference in your photographs, and that's what can increase your potential picture sales.

In my opinion there are four different ways a candidman can use a second light on a pole. Actually, there is a fifth, but it is really a combination of two of the first four.

1. You can use a second light as the main light to illuminate the primary subject you are shooting.

2. You can use a second light as a hair light to separate the primary subjects from the background.

Seeing all these point-and-shoots is the best advertisement I can think of for using radio or infrared slaves! Though a posed photograph of the bride with her attendants is a surefire seller, sometimes an "arranged candid" can give the whole album a different, fun look. While some might balk at the idea of arranging a candid, a situation like this begs for the photographer's direction. Any single bridesmaid with her camera would make an interesting image but it would rarely sell. However, squeeze them all into one frame, and it'll probably make the album! If you add into the mix the modeling created by two flash units (with the main light off-camera), you can greatly increase your chances for a sale. Photo © Franklin Square Photographers, Ltd.

3. You can use a second light to light up the background, which won't improve the lighting quality on your primary subjects but will get rid of the light-in-a-tunnel, dark-background look.

4. You can use a second light to create a special effect for a highly salable picture.

5. As a last effort, and with the help of a good assistant, you can use a second light to provide a hair light and light up the background at the same time.

By placing a second light closer to the subject than the camera-mounted light, at an angle 45° to 60° to the lens axis, and 2 or 3 feet above the subject, a photographer can make the subject appear three-dimensional. In this technique, the second light (on the light pole) becomes the main light, and the flash on the camera becomes the fill light. Making the second light the main light means that it is stronger than the on-camera light. This diminishes the coal miner's helmet-light look.

I have heard some photographers claim that when they are double lighting they make the camera light the main light and the second, pole-mounted light the fill. Without meaning any disrespect to my colleagues, I think they are wrong! If you think about this supposed technique for a moment, you will realize that it is impossible. If the camera light is the main light in the traditional miner's-helmet

style (coming directly from the camera lens axis), what shadows does it create? There are no shadows to fill in!

I think a much more interesting question is, how strong should the second (main) light be in comparison to the camera-mounted fill light? Although I might answer the question by saying, it depends (actually, it does!), many readers would like to know if there is a simple rule that could be followed in most situations. I have found that if the main light is twice as strong as the fill light (that, by the way, is 1 f/stop), the resulting pictures feature shadows that are "open." The idea isn't to make all the pictures overly dramatic by creating inky black shadows, but instead a good candidman is trying to create well-lit three-dimensional looking images. Here's the trick: If you are working with two flash units of equal power and the fill light is mounted on the camera, then the main light should be located two-thirds the distance from the subject as compared to the camera-mounted fill. If you do the guide number math, you will find that the two-thirds rule equals about a 1-stop difference in exposure between the two flash units. If I'm taking my photograph 10 feet (3 meters) from the subject, then the main light should be about 7 feet (2 meters) away from the subject. If I'm 15 feet (4.6 meters) from the subject, the main light is 1 stop "hotter" if it is 10 feet away from the subject. This rule always holds true!

The next question that must be asked is, how does one expose for this type of two-light setup? Some might think that you should expose for the main light and let the shadows fall where they may, but I disagree. The problem with following that rule is that you cannot be 100% certain that the second light will fire. You can test your slaved flash a thousand times, but when you need it most, it may not work. The radio or infrared slave's batteries may be too pooped to pop, the light-actuated slave might be blinded by a video light, the batteries that power the flash itself may decide to be exhausted at that moment, or someone else's flash may trip your slaved unit a nanosecond before you shoot,...or,...or,...or,...ad nauseam.

Being aware of Murphy's Law comes with a candidman's territory!

Considering the fact that underexposing by 1 stop will not yield good photographs, I split the difference between the exposure required for each individual light. Therefore, if my main light calls for f/11 and my fill light calls for f/8, I set my aperture scale between f/11 and f/8. That way, when the second light doesn't fire (and it won't sometimes), I end up with a negative that is only 1/2-stop underexposed. When my second light does fire, the highlights on my negative are a little "hot," but with the latitude that's built into color negative film, it is a situation that both I and my printer can live with.

With the help of a good assistant you can place a second light above your subjects so that the beam skims the tops of their heads. This separates the subject from the background. This may not seem important, but in the dark murkiness of a catering hall with dark-haired people wearing dark suits, the edges of your subject can sometimes disappear as they merge with the unlit background. However, there are a few notes of caution worth considering. If the light above the subject hits the face, it will illuminate the top of the nose, which I can say from sad experience is very unattractive. Also, in the same vein, if your subject has thinning

hair (or is just plain bald) and you accentuate that feature for the whole world to see, you could have a very unhappy customer. Worse still, often the cue ball you've exposed is the person who's paying your bill, and that is definitely not a pleasant situation to be in!

Many photographers work alone, and although I'm not often in that situation (anymore), when necessary, I put my second light on a light stand equipped with wheels. To stabilize the rig, I hang the flash unit's battery pack from a lower section of the light stand so that it is less apt to tip over. Working with two lights in this fashion isn't easy, and because of that I change my plan of attack. I do not use my second light as a main light or as a hair light on my primary subject. Instead, I place it so that it illuminates the area

An Important Hardware Note

If you decide to work with two lights, one of the most important accessories you can own is a pair of Wein TeleFlash Monitors. These little boxes (about 1 x 1/2 x 2 inches) sense the electromagnetic pulse that's emitted when your flash goes off and they blink red to confirm that the flash has fired. I have one mounted on each of my on- and off-camera flash heads with a piece of Velcro. If you use radio or infrared slaves, it is all too easy to accidentally throw a sliding switch in the heat of battle and shut off your assistant's flash (or even worse, your on-camera flash). I train my assistants to constantly glance at both sensors to make sure everything is working as planned. And even though my assistants are checking the sensors, I check them too. It's that important.

behind my subject. This is called lighting the background, and although my prime subject is bathed in miner's helmet light once again, now it's acceptable because the background isn't unbearably dark. I have watched couples add pictures to their album at the proof return because they could see Uncle Louie in the background of a photograph...lit by my background light.

Placing a portable light behind the subject creates a silhouetted look. In this instance, the photographer chose a setting (a little backlit balcony) that accentuated the effect.
Photo © Franklin Square Photographers, Ltd.

Special Effects with Two Lights

Using a second light to create a special effect is really unlimited in its scope. If a subject has a winning profile, simply putting the second light on the floor behind him or her and aiming it at the wall behind the subject can create a silhouette. If you decide to go this route, you must block most of the light from the camera-mounted flash so that the front of the subject remains dark (unlit). This can be achieved by bouncing the on-camera light or by blocking most of its reflector with your hand. If you are using a radio or infrared slave, there is usually a provision for shutting off the light mounted on the camera. If that's your plan of attack however, you MUST remember to turn the camera-mounted light back on after you've made your magic. You Must! You MUST! YOU MUST!

A second flash can also be used to rim-light a kiss. Instead of aiming the second flash unit at the wall behind the subject (as you would for a silhouette), you can turn it around towards your subject for a beautiful, glowing effect. Trying this is often a hit-or-miss proposition, but sometimes even the mistakes are outstanding.

Your imagination is the only limit to the different ways you can use a second light for a special photograph—a sure-seller. Many candidmen I know put their cameras on a tripod and make time exposures with a second light fired into the background. You might try placing your second light up a stairway and aim it down at the bride's and groom's faces as they climb "the ladder of success" (a little hokey, to be sure, but pretty nonetheless). I knew a photographer who always carried a small piece of reddish-orange gel with him. Whenever he saw an unlit fireplace, in went his gelled second light. Brides and grooms appeared to gaze longingly at the roaring fire, when actually they were only looking at a 50 watt-second pop!

Another situation in which a background light is worth its weight in gold is during the bouquet and garter toss. I use it to illuminate the crowd diving for the bouquet or garter as it is frozen in mid-air by my on-camera flash, I almost always have a winner. Although you might not like these pagan rituals yourself, they almost always find their way into a wedding album, and your job is to create photographs that sell, not to make value judgments about a client's tastes.

ADDING A THIRD, FOURTH, OR MORE TO THE MIX

If you want to use your portable double lights to illuminate the main subject (which I feel is the most flattering method), the backgrounds go dark. This means that the whole background melange of the wedding goes unrecorded. And guests, flowers, decor, even ambiance in your photographs can often lead to more sales. A third (or fourth) flash unit lighting the background can open up new possibilities. To some candidmen these lights are called room lights, and most often they are slaved 1,000 watt-second AC strobes on 10-foot stands, bouncing off or skimming the ceiling. They aren't aimed at the crowd on the dance floor, but instead they flood the background jumble with light. If the room is large enough to require room lights, I try to place them inconspicuously (if 1,000 watt-seconds can ever be considered inconspicuous!) along the sides of a room. Near an electrical outlet and away from waiter and guest traffic is a perfect location.

If you decide to set up a room light, you have to be aware of where it is placed, and you must position yourself in such a way that the room light doesn't appear in your picture or flash into your lens. Most importantly, you and the room light must be placed so that the room light is lighting the background of the picture you are taking. When I explain this to green assistants (or photographers not used to exploiting room lights) I draw the analogy of a pick set in a basketball game. The pick (the room light) remains stationary, and the play develops around its position.

Many times at multiple-photographer weddings, another crew is responsible for setting up the room lights. After taking portraits in another room you may find yourself dashing into the ballroom (or ceremony room) with just a few seconds to orient yourself and discover where the room lights are positioned and aimed. When I'm faced with this situation, just

Winter weddings and weddings on rainy days push a photographer's flash technique to the limit. After the main and fill lights are placed to illuminate the subject, some photographers run out of gas when it comes to using a third light. In both these examples a boom-mounted light with a 20° grid is positioned behind the subjects.

In the photo at left, the light is directed toward the models' heads, and the resulting hair light separates their heads from the background. Alternatively, you can forgo the hair light and position the third light so that it illuminates the background as was done in the photo at right.

moments before the action starts as I enter the room I'll pop the room lights with my remote trigger just to see where they are. Once I see them, I choose my position. This may seem far-fetched if you are used to smallish weddings with 100 to 200 guests. However if you are photographing in the New York Hilton's grand ballroom (which is the size of a football field, has 40-foot ceilings, and a wrap-around balcony) with 700 guests milling about, finding the room lights is no easy task.

In the New York area some banquet halls have balconies that are off-limits to the reception guests, but available to photographers. If I have two (or three, or four!) 1,000 watt-second room lights in the balcony giving me an f/8 exposure anywhere in the ballroom, I'm in heaven!

Special Effects with a Third Light

A third light, like the second light, can be used to create interesting effects. If used as a carefully placed room light, a third light can make a simple church look like a cathedral. And you can use it not only to open up backgrounds at the reception, but to open them up for formal portraits as well. This frees you from having to work against a wall or a drape. If you use a third light as a room light, you can set up a portrait location in the middle of a fairly large room without fear that a dark background will detract from your image. Another advantage to using a third light is that the background lit by it will be quite far away from your subject and will be slightly out of focus. It's another way to make your subject "pop" off the page.

But for more formal portraiture, if an artificial background is required, a third light opens up all sorts of possibilities. Whenever the background comes out of

its bag, my third light really starts to shine. I place the stand behind the background, with the flash head peeking over the top. When I put a 20° honeycomb grid over the head, it becomes a studio-type hair light.

One thing that usually sets studio portraiture apart from wedding portraits is the use of a hair light. With a background and a 20° grid I can make my location portraiture look more like studio work. Many shooters set the hair light's output so it is 1/2 stop more powerful than the foreground lights. Personally, I've found that a hair light exposure equal to the foreground exposure is about right, but this is a matter of taste and also depends on the subject's hair color. With black-haired subjects, the hair light can be 1 stop stronger than the foreground exposure, with lighter brown-haired subjects I set my hair light 1/2 stop stronger than my main light exposure, and with blond or white-haired subjects I make the hair light of equal intensity to the main lights.

If you are going to use a hair light, here are a few suggestions:

1. Put a small piece of tape on the floor where your subject has to stand to be bathed in the hair light. That way, you'll know that the subject is the proper distance from the hair light, ensuring proper exposure.

2. Hair lights are notorious for causing lens flare. If you use a hair light, investigate purchasing a compendium lens hood for your portrait lens. Short hoods will not do the job!

3. If your subject has thinning hair or is bald, turn the hair light off. This is a feature most subjects don't want you to accentuate.

Sometimes in rooms with a low ceiling I will give up on the idea of using a hair light because the possibility of lens flare isn't worth trifling with. It's better to have no hair light than lens flare. In that case I carry a special short light stand and put my third light (complete with 20° grid) behind my subject and aim it at the muslin. Nothing makes a subject appear angelic like a gridded background light.

When I first started to shoot wedding photographs I carried two battery-powered flash units. Today, counting backup equipment, I carry three or four battery-powered flash units and three or four AC-powered studio strobes. I have also added an assistant to my list of essentials. If you think this is the antithesis of reportage wedding coverage, I agree. But I have seen what *National Geographic* and *LIFE* photographers include in their kits in order to be prepared for anything. In the world of wedding photography, the real players (i.e., the busiest candidmen) are always willing to go the extra step and carry an extra light.

Grids can be used to narrow a light's angle of coverage.

The Balcony from Heaven

As an aside, whenever you look up at a ceiling to decide if you can use bounce lighting, also look for high vantage points. Choir lofts, projection booths, and balconies offer many creative possibilities. Not only can you place lights up there, but from there you can also make gorgeous photographs! Just remember that, like fine perfume, a little goes a long way. Customers will always buy one or two unique views, but rarely will they buy two dozen. A few frames are all that's required.

I finally scraped together enough money to get my first wedding camera...an old (but beautiful) baby Linhof Technika. It was gorgeous! I brought the camera to my mentor Joe's studio to show off. His response was, "Get insurance." I told him it would take awhile to save the money for that and shifted the conversation to my real purpose. Could I bring my camera to next weekend's job? Could I shoot a few pictures? The answer was yes!

EQUIPMENT

The following Sunday I set up my camera, put it aside, and started to assist. Two hours later Joe told me to pose one of the last family pictures. When I was finished with my pose he told me to go shoot some photographs of the buffet table while he finished the family groups. Oh joy! Oh rapture unbounded! I was going to shoot! I ran to where I had left my camera and...it wasn't there! I ran back to Joe who was posing the last group. "Joe, my camera is gone," I said. Without skipping a beat he replied, "Not now, I've got to finish this family group."

I searched and searched and still couldn't find my camera. My heart was fluttering...I felt dizzy. I had put all my money into that Linhof, and now it was gone. For two hours I was a miserable lump of human flesh. Finally, when my misery became unbearable, Joe took pity on me and gave me back my Linhof. He had hidden it in his camera case. I was livid...absolutely crazed! Joe just looked at me deadpan and said, "Get insurance!" Monday morning I called an insurance agent.

Writing about which equipment a photographer should use for shooting weddings can be a nightmare. Every photographer has favorite brands, and battles rage about which camera or strobe to use. Every time a name photographer endorses a specific brand other photographers rush to buy it. This is the same in many fields, from sports to sports cars, and it is what drives the endorsement game.

Although I offer very specific recommendations in this chapter, I also include the general features you might be interested in. Keep in mind that no matter what suggestions I make, another photographer will disagree. In the end it is the images that are important, not the equipment that's used to make them. On the flip side, we may encounter customers who have been "educated" by advertising, and using a well-known brand that has a sterling reputation can add to your credibility.

THE CAMERA

Almost every photographer thinks that, of all the equipment they must select to buy, their choice of camera is the most important. Although I think that the choice of lighting equipment has equal if not greater importance, in deference to all the camera-lovers in the world, I will start here. Today, for candid wedding coverage, there are two film formats that you could use—35mm and 120/220 roll film (medium-format).

I believe the roll-film format is superior to 35mm for wedding coverage. There are many reasons that support my opinion; some are based on practical, mechanical concerns, and others are based on customer perceptions. Both are valid. Here's the real nitty gritty of it: Over the years 35mm has made great inroads into the field of professional photography. We've all seen nature and sports photographers toting humongous telephoto lenses attached to Nikon or Canon bodies. We've all seen news shooters covering war zones festooned with 35mm cameras. Before we assume that these cameras are equally suited to wedding work, we must realize three things: 1) Weddings are shot on color negative film; 2) The images are going to be viewed as original prints, not two generations removed after going through the printing press; and 3) It is more profitable to sell large prints than small ones.

Although 35mm truly has become the "everything" format, its main weakness is in the area of color prints. I know, I know. You can get excellent results from 35mm color negative films. I agree with this statement until someone tries to tell me that they can *consistently* pull large prints (i.e., 8 x 10 and larger) with saturated color, creamy smooth skin tones, and excellent sharpness from 35mm color negs. The simple fact is that when a 24 x 36mm negative (i.e., 35mm format) is enlarged to an 8 x 10-inch print, only a 24 x 30mm section is used. The negative can become even smaller if the client asks you to crop out "the lady in the red dress" or asks that the final print be a vertical instead of a horizontal. In the greater New York area 5 x 7-inch prints are sold for $10 to $20, 8 x 10s bring $15 to $40,

11 x 14s are priced from $50 to $150, and 16 x 20s can run the gamut from $75 to $300. For larger prints the prices are even higher. When these prints are produced by a wedding lab, the price difference between them (to the photographer) is minimal. You can't afford not to provide them to your customers! If the size of your negative doesn't allow it to be blown up to a 16 x 20 print, you are losing the highest-profit items from your price list.

Still, there are photographers who swear by 35mm, and in fact, I have more than a few Nikons in my equipment locker. However, I don't use them for color negative wedding photography. There will be photographers who will tell you that the quality of 35mm is equal to that of medium-format, but I find that that's not exactly true. Usually I've found that the photographers who say that either:

1. Don't want to carry the weight of a roll-film camera;

2. Have a 35mm system and don't have the funds to start building a roll-film system;

3. Use the automated systems available in 35mm as a crutch and don't have the technical knowledge to cope with the demands that roll film places on a photographer;

4. Think that what they can accomplish in 35mm cannot be done in medium-format; or

5. Are intimidated by manual, large-sized cameras.

The public's perceptions of the differences between roll-film and 35mm cameras are also worth considering. If you shoot a wedding with a 35mm camera, chances are good that some guest at the wedding will have a camera that is equal to or "better" than yours. Professionals know that it is the person behind the camera that makes the picture and not the camera, but if Uncle Louie has the latest Whizflex G5, and you are shooting with the Whizflex G4, your abilities may be questioned. It doesn't matter that Uncle Louie's pictures never come out. He has a better camera, and therefore to the casual observer he is a better photographer. By extension, their perception is that if his pictures don't come out *and* he has a better camera than you, then... well...you couldn't possibly be very good!

On the other hand, if you are shooting with a Hasselblad (for example), most people who are into photography will be in awe of your equipment. They've heard of your camera...maybe even seen one at a dealer or photo show. But you actually have one (or two)! After many years in this game, I find that I can get more mileage from my camera's reputation by downplaying the whole thing. When someone starts to drool over my camera and asks me how good it is, I say, "It doesn't break often," or "Well, the lenses are very sharp." Sometimes this kind of understatement is fun. The truth is, any roll-film camera will command respect. Photography teachers often talk about the camera's "presence," and the more professional your equipment's "presence" is, the more professional you look. This isn't necessarily true of course, but if you're just starting out in the wedding business, every little thing that can add credence to your professionalism is helpful.

In William Golding's book *Lord of the Flies*, a group of school boys becomes stranded on a desert island with no adult supervision. They set up a rudimentary form of government that revolves around a conch shell. Only the boy who holds the conch shell can speak; without it, they must listen. A roll-film camera is the wedding photographer's conch shell. If you shoot 35mm there is a good chance that there will be more than one "conch shell" at the wedding. With these thoughts in mind, let's start the section about cameras by looking at the professional wedding mainstay: roll-film cameras.

120/220 Roll-Film Cameras

Thirty years ago, roll film was in its infancy in the wedding world. Without getting into an extensive wedding photography equipment timeline, I'll explain. Two important developments for wedding photographers were that sheet film was replaced by film packaged in rolls, and black-and-white was replaced by color. Both roll film and color wedding coverage were beginning to come of age in the early 1960s. As the move away from the 4 x 5-inch format progressed, cameras such as the 6 x 7cm Koni Omega, Graflex XL, and Mamiya Press came into production. This resulted in the end of folding, bellows-equipped press cameras being used for wedding work. In addition, as film quality improved, the 6 x 6cm camera, in both twin-lens-reflex (TLR) and single-lens-reflex (SLR) designs, started to come into favor. Finally, the smallest of the roll-film formats, 6 x 4.5cm, was introduced in the mid-1970s.

Today the roll-film arena is a confusing place in which to make your choices because there are three formats to look at and three camera types from which to choose. This equation becomes more complicated because there are also two different types of shutter designs that must be considered. Since some cameras can produce multiple formats by using interchangeable magazines and others feature both types of shutter, let's look at the two shutter types first. Shutters first, cameras second, formats last.

Leaf vs. Focal Plane Shutters
Shutters come in two types. The first, the leaf shutter, is located between the elements of a lens. The second is the focal plane shutter. It's positioned in the camera body, right in front of the film (approximately at the focal plane).

The lens on the left is a 50mm f/4 optic, which has a leaf shutter between the elements. On the right is a 55mm f/2.8 lens designed for use with a focal plane shutter camera. The leaf shutter lens has a greater advantage over the focal plane lens when it comes to using flash, however the focal plane lens, lacking a shutter within, is smaller and 1 stop faster.

Leaf shutters

Leaf shutters consist of a group of overlapping blades that are attached to pivot points on a ring that is located between the lens elements. When the shutter is released, the blades pivot out of the way, opening the shutter, and then at the end of the exposure they swing back into the overlapped position, blocking any more light from entering the camera. This operation is the crux of the leaf shutter's biggest strength and weakness.

Because the shutter opens fully at every shutter speed, flash can be synchronized with the shutter's operation at any shutter speed, which is a big plus. On the downside, a leaf shutter's construction limits its shutter speed potential. The spring or motor that powers the shutter must accelerate the mass of the shutter blades from their closed, at-rest position, and then stop the blades' motion when the shutter is fully open. Once the exposure is complete, the blades' mass must again be accelerated to close the shutter. No easy task in a fraction of a second! The open-stop-close action that's required of the blades means that there are a lot of parts moving around, and their mass usually limits a roll-film camera to

a top speed of approximately 1/500 second. Furthermore, because blade mass is so important to leaf shutter performance, most leaf shutter lenses are not very fast, meaning they have relatively small maximum apertures. That is why the Hasselblad 100mm Planar lens with a leaf shutter has a maximum aperture of only f/3.5, while the Hasselblad 110mm Planar lens designed for Hasselblad's focal plane shutter camera has a maximum aperture of f/2.

Rollei produces some leaf shutter lenses for their roll-film SLRs that have shutter blades made of layered carbon fiber. This lighter, stronger material has allowed Rollei to achieve shutter speeds of 1/1000 second with some of their lenses (1/500 second with larger maximum aperture lenses), but carbon fiber blades are currently unique to Rollei. Still, even accepting the limited maximum apertures and relatively slow top shutter speed, leaf shutters are the way to go for flash photography. Leaf shutters offer such an advantage for flash photography that some focal plane shutter camera systems, such as the Mamiya 645, offer leaf shutter lenses as accessories.

A few other disadvantages associated with leaf shutter lenses should be noted. Because each lens has its own shutter, every leaf shutter lens is more complicated than a lens used on a focal plane shutter camera. Each lens is almost a camera unto itself. This adds to the cost of the lens, and because every shutter is slightly different, sometimes there are slight differences between the accuracy of the shutter speeds from lens to lens. Some manufacturers, such as Bronica, have tried to eliminate shutter speed variations from lens to lens by placing the electronic timing mechanism for the lens within the camera body. In this way one mechanism is handling the timing for all the leaf shutter equipped lenses...a good and noble idea.

As with everything, there are pros and cons to every tool that's ever been created. Still, I prefer a leaf shutter for general flash photography (see page 25 for how to check your flash sync with leaf-shutter cameras).

Focal plane shutters

Focal plane shutters work very differently than leaf shutters. They are usually designed with two curtains, one following the other across the film gate. Curtain number one opens, the film is exposed, curtain number two closes.

Traveling shutter curtains have more mass than thin leaf shutter blades, so the components travel more slowly. But a funny thing happens with focal plane shutters. At fast shutter speeds, before the first curtain completely exposes the film frame, the second curtain starts to close. Thus you end up with an open slit traveling across the film gate exposing the film as it goes. With a narrow slit, focal plane shutters can reach speeds of up to 1/8000 second.

A limitation of this type of shutter is revealed when flash is used. Flash is an instantaneous burst of light, and if the shutter is exposing only a narrow band of film at any given instant, then the flash exposes only that narrow band of the frame. Therefore, to synchronize a focal plane shutter with flash you must use a shutter speed that is slow enough for the first curtain to be fully open (exposing the entire frame) before the second curtain starts to close. The first curtain opens fully, the flash fires, the second curtain starts to close.

If the sync speed is too slow, you will encounter another problem called ghosting. This can occur with any type of shutter but may be unavoidable with the slow sync speeds required by a focal plane shutter. If the shutter syncs at 1/30 second (for example) and there is a lot of ambient light (such as the amount produced by video lights), two images may be recorded on the frame, one exposed by the flash and one exposed by the ambient light. Although the flash freezes the action as it fires, the slow sync speed combined with ample ambient light allows a second, ghost image to register on top of the flash-exposed image. This is not always the effect you're after.

Focal plane shutters on medium-format, roll-film cameras have more mass than their 35mm cousins and therefore move more slowly. Because the film gate

is larger it takes longer for the curtain to uncover the film. This results in roll-film cameras having slower maximum sync speeds than 35mm focal plane shutters can achieve. (For information on 35mm focal plane shutters, see page 112.)

Now that we have a basic understanding about how shutters work and the pros and cons of different designs, let's look at the cameras that are built around them.

The Big Three Camera Types
The twin-lens reflex
Current and Recent Production
Mamiya C330
Rolleiflex

Available Used at (Somewhat) Less-Expensive Prices
Mamiya
Rolleiflex
Minolta Autocord
YashicaMat 124G

One of the oldest styles of roll-film camera is the twin lens reflex (TLR). This camera design has two lenses arranged one above the other, and the camera body is divided into two separate boxes, one above the other. Viewing is done through the upper lens, and picture taking occurs through the lower lens. Today the twin-lens reflex has fallen into disfavor because

Mamiya C330

of the many advantages inherent in the single-lens-reflex (SLR) design.

But there are TLRs that make good wedding material, namely the 6 x 6cm cameras that make 12 exposures on 120 film and 24 exposures on the longer 220 rolls. Because these cameras are no longer the rage, a novice (or economically challenged) photographer can get great buys on the used-camera market. Even though the TLR is limited when compared to an SLR with its interchangeable lenses and magazines, it is still a powerful picture-taking tool...and many can be owned for pennies (a slight exaggeration). For the record, when I started to shoot weddings, I used a 6 x 7 Linhof press camera with an 80mm lens. My spare camera was a beat-up Yashica A, a twin-lens-reflex design with non-coupled film advance and non-coupled shutter cocking. It's held its value amazingly well; in 1968 I bought it used for $30, which is about what it would cost today! The Linhof is history, but I still have that used and abused TLR, and it still takes sharp pictures. There are huge disadvantages and advantages inherent in the TLR design, and both are worth noting.

1. Non-Interchangeable Magazines: Thumbs Down
Not one of the TLR designs offers interchangeable film magazines (backs), and this can really slow you down during continuous shooting. Roll film comes wrapped around a spool, and as it is exposed, it travels through the camera onto another spool called the take-up spool. Replacing the exposed roll with a new one requires the photographer must wind the tail end of the leader through the camera, remove and seal the exposed roll, move the take-up spool from one chamber to the other, put in a new roll of film, attach the leader from the new roll to the take-up spool, close the film

chamber, and advance the film to frame one. That's a lot to do as the bride and her father are walking down the aisle!

With practice, a sharp candidman can do this very quickly. I once participated in a friendly race with one of these sharpies. He loaded a Rollei, and I changed magazines on a Hasselblad. Repetition had made us both smooth as glass and blindingly fast. The outcome was close, but he had to hang the Rollei and flash over his arm while he sealed his exposed roll, and I could change my magazine while walking backwards, making progress in preparing for the next shot.

Please note, many photographers sidestep this issue altogether and work with multiple cameras when they use bodies with non-interchangeable magazines. If you want to shoot with older Yashica-Mats, for example, you can find and buy three identical cameras. By mounting a quick-release coupling between the camera and the flash bracket, you can just switch cameras instead of switching magazines! There is another hidden advantage to using this technique. If your exposed film is spread over three cameras and one camera breaks (as they all do eventually), you lose only one-third of your images. This idea of rotating equipment to cut down on film loss due to equipment failure is worthwhile with other camera types as well.

2. Non-Interchangeable Lens: Thumbs Down
In general, except for the Mamiya TLRs (any vintage), which feature interchangeable lenses, TLRs have one fixed focal length lens. Depending on which manufacturer's effort you look at, the normal lens for these 6 x 6cm cameras is either a 75 or an 80mm. Franke & Heidecke, makers of Rolleiflex cameras, understood the limitations of this and came up with various solutions to the problem without

going to a true, interchangeable lens design. At one time they offered a Wide-Angle Rolleiflex TLR with a pair of 55mm lenses for viewing and picture taking. In the same vein, there once was a Tele Rolleiflex TLR, which used a pair of portrait focal length lenses (135mm) instead of the normal 75 or 80mm focal lengths normally associated with these cameras. Both of these fine cameras are now collectibles, and most reside on collectors' shelves.

Mamiya's TLR interchangeable-lens design features a light-tight, felt-covered metal flap that must be flipped forward by the photographer before the lenses are changed. This flap seals the taking lens opening from light, and because of a lens release interlock, this must be done before the lens pair can be removed. This design prevents film in the lower picture-taking chamber from becoming fogged when the lens is removed.

Before we dismiss most of this class of camera because of the single focal length, let me point out that most images a wedding shooter takes can be made with a normal lens. If your back is to the wall, you still need a wide-angle lens; if you want to throw a background out of focus and compress a nose, you still need a tele; but great, salable images have been made for years with normal lenses, and there is no reason why you can't make great images with a normal lens today.

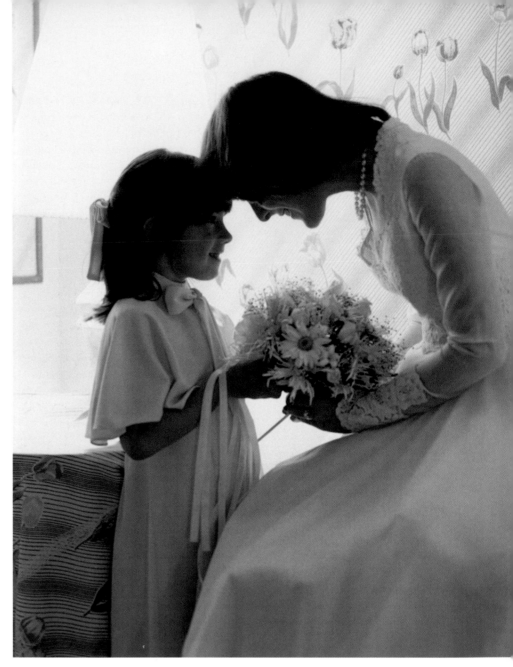

3. Viewfinder Parallax:
Thumbs Down
Since the viewing lens and the taking lens on a TLR are positioned one above the other, they each offer a slightly different view of the subject. The difference between what the viewing lens sees and what the taking lens sees is called parallax. This means that sometimes, especially in close-ups, you might misframe your subject. While some novices might think this problem is minor, I must point out that shooting through cake decorations, floral arrangements, and car windows can all yield stunning photos that are an easy sale. Sadly, all three of these situations bring TLR cameras to their knees. Trying to do a close-up of the bride's ring

and her invitation or bouquet can give a TLR shooter a huge headache. In today's TLRs, manufacturers have devised different ways to overcome the parallax problem, but none are perfect or fast or easy to use.

4. Waist-Level Viewing:
Thumbs Down & Up
Just one look through most waist-level viewing hoods makes you realize just how poor waist-level viewing is for wedding work! That's because in every waist-level viewfinder the image on the ground glass is reversed from the actual scene. As the subject moves to the right it appears to move towards the left...just the thing you need when covering fast-breaking action!

When you're shooting children it is important to remember to get down to their eye level. One easy way is to use a waist-level finder (which also saves wear and tear on your knees), but even if your camera is equipped with an eye-level viewfinder, it is still necessary to get down to your subject's eye level.

Following action with a waist-level finder is so hard that every TLR has a non-optical sports finder built into its focusing hood. This peep-sight eyepiece and frame is only for viewing. However you still have to focus on the ground glass, and the image is still flopped left for right. This effect is so distracting that using waist-level viewing for people pictures is almost worthless, except for one thing. If you want to get down to the eye level of a child, waist-level viewfinders make it easy on your knee joints. And, in the same vein, if you want to take a picture from ground level, you don't have to eat the dirt as you look through the eyepiece.

To combat this dilemma (which is also an issue with roll-film SLRs), many manufacturers offer eye-level prisms for their cameras. One of the brightest and easiest to use is made for the Rolleiflex TLR. This particular prism is so good that one friend of mine even had a Rollei prism grafted onto his Hasselblad! I don't know if I would go that far, but if you want to use a TLR, there are ways out of the waist-level viewing and focusing box.

5. Continuous Viewing: A Big Thumbs Up

The mirror for reflex viewing in a TLR is stationary. It doesn't move when you release the shutter. Because the mirror doesn't have to move out of the way to let the light pass through to the film, the image on the camera's ground glass never blacks out when the shutter is released as it does on an SLR. With a small amount of practice, a candidman can learn to see expressions (and blinks) during the actual exposure. It is even easier to do this in dim light because when the subject gets hit by the flash, the image on the ground glass seems to pop out at the photographer.

6. Simple Construction, Quiet Operation: Thumbs Up

TLR cameras have far fewer moving parts than SLR cameras. The reflex viewing mirror in the upper chamber of the camera doesn't have to flip out of the way during exposure, and therefore it can be fixed rigidly in place. This contributes to the camera's optical accuracy and sturdy construction. While there is still a shutter mechanism, there is no need for an automatic diaphragm mechanism to keep the taking lens wide open for viewing and to close it down for exposure. There is another advantage to having fewer moving parts: The camera is much quieter—just the thing for a sacred ceremony.

7. Short Time Parallax: Thumbs Up

With all cameras, there is a time lapse between the time you push the button and the time the picture is taken. The less complicated the camera's mechanism is, the fewer things need to happen between the time the shutter button is pushed and the film is exposed. The result is a shorter time parallax. When a camera has a long time parallax, the subject's expression has time to change...the subject has time to blink...a smile can fade. In the TLR design the time parallax is minimal. No mirror to move, no diaphragm to close down, no shutter to close, no autofocus to lock on. It's a simple design. Push the button and the picture happens NOW!

The rangefinder
Current and Recent Production
Fuji GA645, GA645W, GA645Zi
Mamiya 6, 7

Available Used at Inexpensive Prices
Graflex XL
Koni Omega
Mamiya Press, Super 23

With today's interest in the sexy SLR, one might think that the rangefinder camera is dead, but that just isn't the case. As I mentioned before, the once-popular 4 x 5 press camera included a coupled rangefinder, and the second generation of wedding cameras were all rangefinder cameras. Why? Because the human eye can align coincident images twice as well as it can discern sharpness on a ground glass. This is especially true with a wide-angle lens...a favorite focal length of the candidman. Today there are only five cameras competing for rangefinder users' dollars, and they span three of the formats used with roll film (6 x 4.5, 6 x 6, 6 x 7cm).

On the used market the choice is greater, and with a little searching you might find an older tool that can really cut the mustard. Some, such as the Graflex XL, Koni Omega, Mamiya Press, and Mamiya Super 23 were basically 6 x 7 or 6 x 9cm cameras designed with the wedding pro in mind. The Koni was designed for wedding and press work and featured a push-pull lever for film advance and shutter cocking. It is also blessed with an intermittent pressure plate. When you pull on the advance knob, the pressure plate moves away from the film. As you shove the lever home, the pressure plate makes contact with the film once again....you never have a scratched roll of film with a Koni. It was a neat idea.

Today's rangefinders include the Mamiya 6 and 7, which shoot 6 x 6cm and 6 x 7cm negatives respectively, and the Fuji GA645, a 6 x 4.5cm autofocus camera that has a fixed 60mm lens. Another incarnation of the Fuji camera is the GA645W, which is the same as the GA645 except the lens is a 45mm wide-angle optic. Although these two Fujis lack a few professional features such as a

Mamiya 7

PC outlet (they have a hot shoe), Fuji has recently introduced the GA645Zi, which features a PC socket and a 55-90mm (f/4.5-6.9) zoom lens. This titanium-bodied wonder looks like a 35mm point-and-shoot camera on steroids and includes three modes of exposure control (programmed AE, aperture-priority AE, and manual exposure). This camera's PC socket and its manual exposure mode bode well for flash-toting pros. It offers the same Fujifilm barcode reading system introduced in the wide-angle GA incarnation, automatically adjusting the camera's pressure plate for 120 or 220 film and setting the film's ISO in the metering system. For non-barcoded film, or pros with their own opinions, manual override is possible. A pop-up flash, eyesight compensation, and a lens cap sensor (which tells you when you left the lens cap on) complete the package.

As we did with the TLR, let's look at the pros and cons that a rangefinder camera has to offer.

1. Non-Interchangeable Film Magazines with Current Models: Thumbs Down

None of today's rangefinder cameras have interchangeable film magazines. This problem is compounded by the high price of today's offerings, which makes it more expensive to own multiple units for use as if they were interchangeable magazines. However, all three of the older rangefinder cameras mentioned above do have interchangeable magazines.

2. Seeing beyond the Edge of the Frame: Thumbs Up

With your eye stuck to the viewfinder of an SLR or TLR you can't see if anyone is walking into your frame until they are there. Rangefinder cameras' viewfinders show lines that surround the image you'll capture on the film...AND a little bit extra. That little bit extra can give you the time to decide not to push the button until the waiter passes through the frame.

3. Difficult to Visualize the Exact Image with Long Lenses: Thumbs Down

A portrait lens is a very powerful tool, but when used with a rangefinder camera it can be hard to get the exact framing you want because viewing is not done through the lens. The viewfinder has a fixed magnification and is inscribed with frame lines to indicate the viewing area. For a wide-angle optic, the area is relatively large, but for a telephoto, with its narrower angle of view, the area is a bit small for easy viewing.

While it is true that focusing is more accurate with a rangefinder and a wide-angle lens, when you shoot with a reflex camera and a telephoto, the playing field levels. With a rangefinder camera the accuracy of the focusing system is based on mechanical limitations. With an SLR or TLR the magnification of the image on the ground glass and the limited depth of field of the tele make them easier to focus than their rangefinder counterparts. With a reflex camera, the long lens' magnification improves the eye's ability to discern sharpness. Score one for reflex viewing if you use a tele. But if you are using a wide-angle, the rangefinder wins in a walk.

4. Viewfinder Parallax: Thumbs Down

Like the TLR, a rangefinder camera also has viewfinder parallax. However, in the case of some rangefinder cameras the viewfinder window is not only above the lens, it is also offset to one side of the camera. As with the TLR, exact framing is not always the easiest thing with a rangefinder. Before you discount the abilities of a rangefinder (or a TLR for that matter) please remember that parallax becomes a problem only in close-ups or when you shoot through a confined area such as a car window. For general wedding photography, though, it works fine.

5. Rangefinder Focusing: Thumbs Up

In the available dark of the wedding hall, a rangefinder camera can be a blessing. Rangefinders work best on contrasty straight lines. The perfect example is a suit or tuxedo's dark lapel against a crisp white shirt. For every candidman that is familiar territory. As I've already mentioned, you can focus the coincident images a rangefinder creates far better than the human eye can discern sharpness on a ground glass. For exact focus when using wide-angle lenses, the rangefinder is the thing to use.

6 & 7. Quiet Operation and Short Time Parallax: Thumbs Up

Like the TLR, this camera also does not have a mirror flapping around in the body. In addition, because you are not viewing the subject through the taking lens, there is no need for an automatic diaphragm, and the shutter can remain closed until the picture is taken. All this adds up to a short time parallax and quiet operation—features that are important to the candidman.

The single-lens reflex
Current and Recent Production
Bronica SQ-, GR-, and ETR-series
Hasselblad 503CX, 503CXi, 2000FC (focal plane shutter)
Mamiya RB/RZ, 645 PRO, 645 PRO TL
Pentax 67, 645
Rollei SLX

Available Used at Slightly Less-Expensive Prices
Hasselblad 500C, 500C/M
Mamiya RB/RZ, 645
Pentax 6 x 7
Rollei, various

The single-lens reflex is the only 35mm or roll-film camera design that lets you see what the lens sees. Many of the problems I've outlined with the other two roll-film camera designs are conquered by the SLR. Although both the TLR and rangefinder designs have unique attributes, for professional use, the SLR is today's most popular design. Once again let's look at the pros and cons.

1. Interchangeable Film Magazines: Thumbs Up

Most of today's medium-format roll-film SLRs (an exception is the Pentax 67) are designed to take an interchangeable magazine or interchangeable film insert. Both the film magazine and the film insert can be preloaded so that starting a new roll of film is almost instantaneous. Fully interchangeable magazines protect the new roll before it is placed in the camera. Interchangeable inserts are less expensive because of their simpler construction (they have no housing), but the roll of film can become contaminated with debris or become loose on the spool. Don't laugh, I've seen it happen. Lint, film wrappers, shreds of tobacco, gum, or anything else that might be hiding in your pocket or camera case can ruin the film. Although I do prefer the complete magazine concept, both solutions offer quick film change, which is a big plus.

Another advantage of the interchangeable magazine is revealed when you want to make creative double exposures. With an interchangeable magazine a candidman can shoot one-half of a double and remove the back from the camera. Sometime later the magazine can be put back on the camera and the second exposure can be made.

Mamiya 645 Pro

Here is a roll-film magazine with its interchangeable insert removed. Some cameras are designed only with removable inserts, which simplifies construction but does not allow you to change film mid-roll (when shooting consecutive portraits in black and white and color) or to save the first half of a double exposure for the second exposure.

2. Interchangeable Lenses: Thumbs Up

When your back is to the wall there is nothing like a wide-angle lens. And, when you're sweating in the church choir loft, nothing will bring the alter in like a moderate tele. Even though most wedding photographs can be accomplished with a normal lens, there are situations when you need another focal length. When you're stuck with a bride and twelve bridesmaids in a 10 by 12-foot living room, you just can't pull off a full-length group shot with a normal lens, no matter how good you are. Of course a crafty candidman equipped with only a normal lens will take the group outside, or shoot it later on the church alter, or make the living room work by arranging the bridesmaids into a bust-length composition. Personally, I'd rather switch to a wide-angle lens! In today's visually literate world, I feel that interchangeable lenses are a must.

3. Viewing through the Taking Lens: Thumbs Up & Down

All of the viewing limitations I mentioned with the TLR and rangefinder cameras are conquered with the SLR design. Close-ups are a piece of cake. Shooting through things (doorways, limo windows, cake decorations, etc.) is easy with an SLR.

As an added attraction, SLRs let the photographer preview the depth of field at the taking aperture. By putting the stop-down lever to use, a practiced eye can tell how much depth of field is available. This really helps when you want to do a selective focus image or if you want to know just how sharp an out-of-focus background will appear.

There is one aspect of the SLR design that I find disturbing. You don't get to see the subject at the exact moment of exposure. When the shutter release is pressed, the reflex mirror behind the lens flips up out of the path of the incoming light, which exposes the film. Whether the SLR has an instant-return mirror like a Bronica or a mirror that doesn't reset itself until the camera is recocked like early Hasselblads doesn't really matter. At the moment the flash fires, the instant the film is exposed, the eyepiece view is a black hole. Because wedding photographers depend on flash, they want to see it fire; they should want to see it hit their subjects. With an SLR you can't see the subject when you need to. However, there is a way around this:

Don't look through the camera! SLR cameras with normal (or close to it) lenses are possibly the second-best way to view a scene being photographed. I say second-best because people are the squirmiest, wiggliest, blinkingest things

the universe has to offer. Therefore, under most "people-picture" circumstances, the "best" way to shoot pictures is by viewing the moment of exposure with your naked eye, without a camera in the way. When you're shooting a formal pose with the camera mounted firmly on a tripod, this technique is easy. The camera is held firmly in place; it isn't going anywhere. When you're working hand-held shooting flash, it's not as easy. The easiest way to explain it is to say I feel like a turtle. It's like this: I view through the camera and frame my picture. I freeze my arms and body still. Then, without moving my body, I crane my neck and peer over the eyepiece of the camera. I view the real scene as I push the button. The first advantage is obvious. You can see if your flash fired! But with a little practice you can see blinks, smiles that died or crested perfectly, and a zillion other little details that are frozen by the flash.

If you use wide-angle lenses (in 35mm format: 20, 24, 28, or 35mm; or in 2-1/4: 40, 50, or 60mm) regularly, the body-freezing trick is even less critical if you frame your photograph with a little "air." When you use normal and longer lenses your framing accuracy becomes more important, so you have to be very careful about holding everything still while you do your craning. Still, if you do weddings and use flash, this is the way to go!

4. Difficulty Focusing Wide-Angle Lenses: Thumbs Down

Wide-angle lenses "minify" the image on an SLR ground glass. This means that the details you want to focus on are smaller and harder to see. The wider the lens, the worse it gets. For most of my work with wide-angle lenses on an SLR, I focus by guesstimation. As a test, in a dim catering hall, I used a 50mm lens on a 6 x 6cm camera and focused three times on the same subject. Each time the distance scale ended up at a different setting. With a wide-angle lens I have found that the best chance for focusing success is to estimate my distance from the subject, set my distance scale accordingly, and shoot away. Estimating distances accurately takes practice, but it is a very worthwhile skill for a candidman to master. From experience I have become good at estimating distances between 6 and 15 feet. Shorter and longer distances give me much more difficulty. If I'm shooting a large group with my wide-angle lens, I even go so far as to bracket my focusing. If I think the group is 20 feet from me, I shoot a frame with my distance scale set to 15 feet, another frame with the scale set at 20 feet, and a third frame with it set to 25 feet, just to be sure. A candidman I know once watched me shoot a wide-angle group shot. After I was done, he came over to me and told me he did it just like I did. First he focused his camera, then he looked at his distance scale, then he reset the distance scale to what he estimated the distance to be, then he shot. In other words, he didn't trust his distance scale either! And we both ended up with sharp images.

5. Long Time Parallax: Thumbs Down

Sadly, SLRs have a long time parallax. When you push the shutter release on a leaf shutter SLR the following things happen: The lens stops down to the taking aperture; the leaf shutter closes; the mirror flips up out of the way; and finally, the shutter fires. Although this takes only a fraction of a second, it can seem like forever. If you're shooting with a leaf shutter Hasselblad, there is also a second auxiliary back shutter that must open. If you're shooting with a Mamiya RB or RZ, or a Pentax 67 (although it has a focal plane shutter), the mass of the mirror makes the flip-up procedure agonizingly slow. Many times, blinky subjects react to the sound of the mirror flipping up, and they inadvertently time their blink to coincide perfectly with the flash. Often the motion of the shutter stopping down alone is enough to make subjects react with a blink.

Some of you are saying, "So what?" The time parallax is only a tenth of a second." It just so happens that one of the fastest human reflexes is the blink. It protects the eyes from dust and other stuff (like flying bugs), and its speed can create havoc for photographers. You end up with a set of wedding pictures no pro wants to show. But there are a few solutions.

As a first line of defense, many cameras have a way of pre-releasing the mirror. This feature also closes the shutter and stops the lens down. Once all this happens, the SLR's time parallax shortens dramatically. It should, because once you've released the mirror you no longer are using an SLR, therefore this solution works best when your camera is tripod mounted. Another trick is to cover the finger resting on the shutter release with your free hand. Some subjects react to your finger's movement. In the worst cases, you can ask your subject to close his or her eyes and open them when you count to three. At the exact same instant, on three, you push the shutter release. Sometimes none of the above solutions work and you are just out of luck. It happens. If you find yourself in this situation, shoot a lot of extra film and hope

that something works. Most times it does. But even when it doesn't, at least you can say you tried your best.

6. Complex Construction: Thumbs Down

With all the things moving around in an SLR, something's bound to break sometime. Last year I completed about 100 wedding assignments, shooting approximately 20 rolls for each one. Every roll had 24 images on it, meaning that last year my cameras made approximately 50,000 exposures. Camera mechanisms are only metal, and metal eventually breaks (but it takes longer than plastic!). The complexity of the SLR exacerbates this situation as does the knockabout way wedding cameras are used. One solution is to have a few spares in your equipment locker (not counting the two you carry with you) and rotate your equipment. Keep records on each camera, and have your repairman perform CLAs on them regularly. CLA stands for Clean, Lubricate, and Adjust. Even when you do this religiously, they'll still break. When it happens, don't fret. Just change to your spare and keep going. By the way, check your spare cameras regularly to make sure they're working correctly.

7. Noisy Operation: Thumbs Down

Another downside to having so many things moving around in an SLR is that they can sometimes be a bit noisy. On the dance floor with the orchestra playing, nobody notices the "thwuck" or "clang" your camera makes every time you release the shutter. But that same thwuck or clang becomes very loud during the hush of a nuptial mass. You can't do much about it.

Even considering these shortcomings and after careful consideration, my choice is still the SLR.

And now...a commercial for used equipment

Sometimes a used camera can serve you just as well as a new one. Sometimes the latest incarnation of a specific camera has additional features that are of no real interest to you. The latest Hasselblads, for example, all offer TTL auto flash, and if manual flash is your cup of tea (as it is mine) then spending extra bucks on electronics you won't use is not cost effective. Even Hasselblad is aware of this, and they have reintroduced earlier designs. In the roll-film camera arena, old is not necessarily bad.

If you decide on an older camera...and these tools can still produce great results...you might find yourself searching high and low for a source of used bodies, magazines, or lenses that fit your brand. You might begin your search by scouring the ads in photographic magazines. *Shutterbug*, for one, runs a tremendous number of ads from dealers who specialize in the older equipment you might be interested in.

Retailers that specialize in used equipment often use a rating system. For example, one used equipment mail-order advertiser rates their equipment as NEW (self-explanatory) through various classes such as LN (like new) and UG (ugly). UG cameras are in rough shape. They may exhibit dents, dings, mars, and brassing on the camera body. UG lenses have surface wear and may have damage to optical glass that will affect the image. Up one notch from UG is BGN (bargain). Bargain equipment is rated as 70–79% of its original condition with more than average wear. Bargain equipment will probably have surface scars, but will still be in useful condition. Lenses may have more than average wear, but picture quality is not affected. While I stay away from UG equipment, I don't have anything against "more than average wear." If you feel your camera is a reflection of your ego and need the latest on the market, that's fine, but if the flaws on a used piece are just cosmetic and won't affect picture quality, I don't care. If you love (and must have) new equipment, consider buying a new first camera and find used models for back-ups. It's just a thought for budget-conscious shoppers.

If you are fortunate to have a photo shop in your area that specializes in pro equipment, by all means, check out the used equipment that is available. Wherever you shop, if you see something you need, do not waste time. Jump on it. Who knows...you might decide to trade in something I have been looking for!

The Big Three Roll-Film Formats

Given the dimensions of 120 and 220 rolls of film, camera designers decide how to break up the roll film's length into frames or exposures per roll. The 6 x 7cm (2-1/4 x 2-3/4 inch) format divides a 120 roll into 10 frames (20 on a 220 roll). The 6 x 6cm (2-1/4 inches square) format lets the camera designer fit 12 frames onto a 120 roll and 24 onto a roll of 220. The newest roll-film format, 6 x 4.5 cm (2-1/4 x 1-5/8 inches), squeezes 15 frames onto a 120 roll and 30 exposures onto a 220 roll. It would seem that the obvious choice, from a cost perspective only, would be the smallest format. Because there are other considerations involved, the other two formats are also popular. Let's look at each format, which cameras are available for them, and what pros and cons should be considered.

Bronica ETRSi

6 x 7cm

The largest format that is applicable to wedding photography is 6 x 7cm. This 2-1/4 x 2-3/4-inch negative offers some advantages but even more disadvantages. It has the so-called "ideal" proportions, so it can be enlarged to the standard sizes of photographic paper (4 x 5", 5 x 7", 8 x 10", 11 x 14", and 16 x 20") with only a tiny amount of the negative being wasted by cropping. It is interesting to note that if a negative enlarges directly to 4 x 5 inches (or 8 x 10, or 16 x 20) it doesn't enlarge directly to 5 x 7 inches (or 11 x 14). So "ideal format" can apply to only one set of print sizes at a time.

The 6 x 7cm format requires a large camera, and because it is a rectangle, the photographer must decide beforehand whether the final photograph is a vertical or horizontal. There are three cameras available today in the 6 x 7cm format. They are the Mamiya RB/RZ series, which are two different cameras but one basic design; the Pentax 67, which looks like a bulked-up 35mm camera; and the new kid on the block, the Bronica GS-1.

The cameras in the Mamiya RB/RZ series are 6 x 7 SLRs that feature rotating backs. The camera is always held one way, and the back or magazine is turned 90° for vertical or horizontal compositions. The RB/RZ cameras have leaf shutters. The revolving back means the reflex mirror has to be 2-3/4 inches square to cover both composition possibilities. This creates a larger mirror box, which therefore requires the camera to be larger. Also, the time required to flip up the mirror is greater, and the time parallax is longer. While these are great portrait or studio cameras, I find them a bit bulky for wedding work.

The Pentax 67 is a 35mm SLR camera on steroids. Making a small design bigger (as is the case here) results in some interesting problems. Because the Pentax uses a focal plane shutter and the format is so large, the flash sync speed is only 1/30 second. In addition, an eye-level pentaprism big enough to cover the entire frame would be huge, so Pentax compromised by designing a pentaprism that shows only 88% of the ground glass.

Pentax 67

Finally, because of its "35mm" shape, the camera isn't designed to take interchangeable magazines. Interchangeable magazines are even more important in the 6 x 7 format because the rolls of film (either 120 or 220) have fewer exposures per roll, making the ability to change rolls fast incredibly important.

The Bronica GS-1 is shaped like a traditional 6 x 6 SLR, except the format is 6 x 7, and when the camera is held normally the composition is horizontal. Featuring a leaf shutter and interchangeable magazines the GS-1 doesn't have a revolving back like the Mamiya RB/RZ. This has pros and cons. The non-revolving back design allows a smaller mirror (which means less mirror mass...which means faster mirror flip up...which means shorter time parallax [than the RB/RZ]), but it also means the entire camera must be flipped for a vertical composition. So you'll need a sturdy tripod and tripod head and a flash bracket design that includes a flipping feature.

On the used market there are a few rangefinder cameras available in the 6 x 7 format that were originally designed for wedding work. These cameras, with no reflex mirror to move, operate much faster than the current SLR designs. Although 6 x 7 is certainly an impressive negative size, with today's film quality, I feel it is better left for studio and portrait work.

6 x 6cm

Square-format roll-film cameras have been available for decades. From ancient TLR Rolleis to Victor's original

Hasselblad, the square format is well established. Today, cameras in this format are available in SLR, TLR, and rangefinder incarnations.

Mamiya covers the TLR and Rangefinder 6 x 6 formats with the C330 and the Mamiya 6, respectively. Both offer interchangeable lenses, and both can cut the mustard in the wedding world. On the SLR side of the aisle are Bronica, Hasselblad, and Rollei.

Bronica's SQ series features an electronically controlled leaf shutter with the timing mechanism and sync contact in the body. This is an important feature because once you attach your sync cord to the body, you don't have to change it every time you change lenses. On the downside, the Bronica SQ has a double exposure lever on the body that does not cancel after one exposure. If you flip the lever to shoot a double and don't un-flip it after you're done, the camera will keep right on placing exposures on that one frame of film. Although this will really reduce your film costs, I don't recommend it! If I were to commit my resources to Bronica, I would put a piece of gaffer tape on that #%$^@& double exposure lever. Overall, the Bronicas are workhorse cameras that are the least expensive of the current crop of 6 x 6 SLRs.

Hasselblad is currently the oldest manufacturer of 6 x 6 SLR cameras, but more important is the fact that while updating their design over the years, they have remained true to their lens, magazine, and viewfinder mounts. This means that, in general, older equipment works with the current product line. The amount of equipment available for the Hasselblad system is staggering. Magazines (film backs) are available for 6 x 6, 6 x 4.5 horizontal, and 6 x 4.5 vertical formats. There are viewfinders for 90°, 45°, and straight down viewing, as well as the traditional folding hood. There are cameras in the system that have built-in motorized film advance. The newest manual advance models can accept an accessory winder. There are focal plane shutter models and leaf-shutter-only models with full lens lineups for each. There is even a wide-angle

camera designed around the very special 38mm Zeiss Biogon lens, which is known for its rectilinear performance and sharpness. It is a large integrated system. Every wedding shooter that I know who shoots with Hasselblads uses the leaf-shutter versions and the basic design has been around since the 1957 introduction of the 500C.

In Hasselblad's old style naming code, the camera number indicates the top shutter speed, and the letter denotes the shutter type. Therefore, a Hasselblad 500C has a shortest shutter speed of 1/500 second and uses a Compur (or now, Prontor in the newer lenses) leaf shutter. A Hasselblad 2000FC has a shortest shutter speed of 1/2000 second and has a focal plane shutter but can also be fitted with a leaf (Compur or Prontor) shutter-equipped lens.

All Hasselblad magazines and bodies have a two- or three-letter code before the serial number, and through this code you can tell when the magazine or body was produced. The code looks like this:

V H P I C T U R E S
1 2 3 4 5 6 7 8 9 0

Here's how it works. Each letter represents a number, 1 through 0. Just substitute the number for the letter to get the year of production. If you have magazine TE 1234567, the magazine was made in 1969...the "T" represents the number 6 and the "E" represents number 9. I don't know how Hasselblad will handle the upcoming millennium, but for now they use this code. By the way, if there are three letters on the camera body or back, only the first two reflect the year of production (according to a source at Hasselblad).

All of this Hasselblad lore, its system size and continuity, and its fame has added two other characteristics to the brand—one real, one perceived. The first is value. For the past 30 years, only two cameras (other than weird collectibles) have appreciated in value. One is the Leica M series, and the other is Hasselblad's 500 series. Both cameras are produced in limited numbers and must

stand up to very rigid quality control. Second, both cameras have mechanical mechanisms and operate with a precision that feels good. Limited production keeps the value high. European craftsmanship (if you can accept that cliché) also adds to their panache.

An example of this can be seen in every Hasselblad magazine. The insert and the outer shell both bear the same serial number—the pieces are hand-fitted together so that a perfect joint is made with the insert. This kind of attention to detail is what reputations are made of. In 1969 I bought my first new Hasselblad 500C/M body, back, and 80mm lens for $600. Today, after putting umpteen thousand rolls of film through it, the camera is worth about $1,300 on the used market. As with automobiles, the value of almost every other new camera drops by up to 40% the moment you pass over the threshold when leaving the store.

Perceptions are funny. People's perceptions are colored by the news media and advertising. Hasselblads may or may not be better than any other 6 x 6cm roll-film SLR, but the general public's (your customer's) perception isn't based on the realities of wedding trench warfare. Hasselblads are known as the camera chosen to go to the moon or the camera that Ansel Adams used. In short, Hasselblads enjoy a sterling reputation. When you shoot with a Hasselblad, no one ever comes up to you and says your camera isn't as good as a Whizflex 500.

Hasselblad 503CXi with dedicated flash unit

To those people the Hasselblad *is* a Whizflex 500! In this case it is a matter of using the public's perceptions of a piece of equipment to your advantage.

Every camera, whether roll-film SLR, TLR, rangefinder, or 35mm SLR, has peculiarities. Keep in mind that nothing is perfect, so if you find a camera system that suits your needs, don't discount it because of a minor idiosyncrasy. My camera's advantages far outweigh any minor quirks in its design. As with anything, if a camera's advantages outweigh its disadvantages, it could be the right one for you.

Rollei is another company with a great reputation. The current Rollei 6 x 6 SLR is a technological *tour de force*. It is on the cutting edge of technology in many ways including automatic dark slides, autoexposure, motorized shutters, and motorized film advance. Rollei, as I mentioned earlier, is using new space-age materials for the leaf shutter blades in its lenses. Even so, Rollei's SLR is not as popular among hard-core wedding shooters. There are a few reasons for this. Cutting-edge technology costs a lot to design and implement, and that is reflected in the Rollei's price. Cutting-edge technology breeds complexity, and serious wedding shooters are often more interested in simplification both in operation and design. Rollei can be compared to a fine watch, but very often a $29 special is as accurate, simpler to understand, and easier to use. While this all may sound anti-Rollei, please understand that in many non-wedding situations, the Rollei SLRs offer advantages that other cameras cannot compete with. But the wedding photography world can be likened to trench warfare, and simplicity has great value in the trenches.

There are a few advantages specific to square negatives that bear examination. With a square format the camera doesn't have to be flipped on its side for a vertical or horizontal composition. Cropping to a rectangle is accomplished after the fact in the proofing or printing stage. While this may seem to waste a lot of negative area from each frame of film, it does speed things up considerably. For either a

vertical or horizontal composition, the camera is always positioned on a tripod the same way, and the same holds true for flash bracket mounting. When working with a square-format camera on a flash bracket, the photographer never has to reposition the flash unit so that the flash is over the lens for a vertical or horizontal composition. In candid situations where the photographer and camera's reaction times are very important, not having to make a decision between vertical and horizontal (or flipping a flash over the lens) can save seconds. In fact, I feel that a square-format camera is quicker than a 35mm SLR in a single shot flash scenario. With the square, you can shoot now and decide whether it's a vertical or horizontal later.

The square format also allows easy repositioning of the subject without losing much to a crop if the main subject is off-center. Here's how this works. If a candidman misframes slightly with a 6 x 4.5cm camera, the only way to recenter the image on the final print is to crop two (or three) sides of the negative. Once this is done, the final negative isn't much bigger than a 35mm frame. With a square format, if the subject is off-center (either to the right, left, top, or bottom of the negative), the photographer can crop off just one side of the negative and still end up with a full 6 x 4.5cm section of the negative.

Place strips of removable, thin, plastic tape on your viewing screen to remind you of the actual frame of the proof.

It's important that you mask your screen to the finished proportions of your proofs so you don't accidentally cut Aunt Charlotte from the family photograph. You can explain until you are blue in the face that even though someone or something doesn't appear on the proof it actually is on the negative. It won't matter. If customers can't see it on the proof, they won't buy it. Even worse, when the customers review the proofs with their families, you are not there to explain that although Aunt Charlotte isn't on the proof, sure as shootin' she's on the negative. If they don't see Aunt Charlotte on the proof, you probably bumped her off...on purpose!

Therefore, to eliminate customer wrath, and sell more pictures, mask your screen so you can frame and shoot for your proof size. The masking should be subtle so that you can ignore it when you want to use the full frame. Taping a viewing screen is easy. Your local art supply store can come to the rescue. Most of them carry a graphic arts product called Zip-A-Line, which is thin colored tape that's used to create graphs and borders. Zip-A-Line comes in a variety of widths and colors. The thinner versions are perfect for masking a viewing screen, and the color doesn't matter at all. I use 1/32-inch width, but you can use any size that works for you. But just remember, thinner is better.

Here's what I do: I carefully remove the viewing screen from my camera and cut pieces of Zip-A-Line tape to fit the screen. Once they are positioned correctly on my screen, I reinstall the screen, put my prism back on (that's the way my camera works) and start to take pictures. On the 2-1/4 square viewing screen I use the four pieces of tape (two vertical and two horizontal) to define vertical and horizontal compositions. When I shoot a vertical, I ignore the horizontal tape and vice versa. By the way, if you're using Zip-A-Line on a 35mm camera, take about 1/8 inch off the right and left of the screen's long dimension to define an 8 x 10 crop.

Pentax 645

6 x 4.5cm

The 6 x 4.5cm format is a relatively new design innovation. It was developed to maximize the number of frames a photographer could squeeze onto a roll of 120 or 220 film. The first 645 SLR that was built from the ground up as a 6 x 4.5cm camera was the Mamiya 645, introduced in 1975. It caused quite a stir. Even though it had a focal plane shutter, it was embraced by wedding shooters throughout the U.S. and introduced the idea of a roll-film "ideal" format smaller than 6 x 7cm. Like many great ideas it was simple, and the more economical use of the film was welcomed by candidmen exposing thousands of rolls per year. The latest Mamiya 645 (the 645 PRO TL) features interchangeable magazines and through-the-lens flash metering with the European SCA flash standard. Over the years Mamiya has made major improvements in the 645's design. The first 645 had only interchangeable film inserts (not fully interchangeable magazines), and as of this date, although the camera still has a focal plane shutter, there are three leaf shutter lenses within the system. The three leaf shutter lenses are 55mm, 80mm, and 150mm. With these three lenses the Mamiya 645 is a powerful wedding tool.

In this candid, the bride was caught right before a joyous "You did it!" The photographer used double light, dragging the shutter just enough to catch the last rays of light in the sky. By exposing for the assistant's stronger light, which was used as the main flash, he avoided turning the back of a guest's head into a bright spot in the foreground.

Following closely behind the Mamiya was the Bronica ETR (which became, in later incarnations, the ETRS, and the ETRSi). Unlike the Mamiya, the Bronica had a leaf shutter from day one, and it was an innovative leaf shutter design to boot. Instead of placing the shutter timing mechanism within the lens, Bronica designers put the timing mechanism within the body and left the actual shutter mechanism within the lens. This created numerous advantages. With a universal timing mechanism Bronica insured consistency from lens to lens, and the shutter design also allowed the PC flash connection to be on the body as opposed to having the connection on each lens.

PC cords are a notoriously weak connector and each removal or attachment of a PC tip weakens the joint. It is standard candidman practice to carry a few spare PC cords, because without one a candidman is up the creek, and they break constantly. Much has been written about the poor design of the industry standard PC connector, and Bronica's solution took some of the stress off the weak PC socket.

Two semi-automatic 645 camera lines also exist. The Pentax 645N is an SLR model with autofocus, interchangeable film inserts, and interchangeable lenses. The Fuji GA645, GA645W, and GA645Zi, which can best be described as autofocus, point-and-shoot, roll-film cameras are

also available. The GA645 has a non-interchangeable 60mm lens, and the wide version (GA645W) features a 45mm optic. The GA645Zi has a 55-90mm zoom. All three have hot shoes and the GA645Zi has a PC socket, which the other two lack. The Fujis fall somewhere between pro and amateur equipment. On one hand you have the quality of medium format, and on the other you have autofocus. These are weird little beasties, but they can get the job done.

35mm Cameras

But how about those who choose to go the 35mm route? Most young photographers start out with a 35mm camera, and therefore most young photographers who start shooting weddings use the 35mm SLR (single-lens-reflex) they already own. Today, there are two 35mm systems that compete for most of the professional photographic market. They are Canon

and Nikon. In capable hands, either can become the cornerstone of a perfect 35mm wedding system.

Since both camera systems offer parallel lens lines, there are other criteria worth considering. The first is how well designed the dedicated flash system is. Another question worth investigating is, are there other manufacturers' flash units that will work seamlessly with the 35mm camera you choose? While this may seem simplistic, it isn't. If you shoot 100 weddings per year, and expose ten 35mm 36-exposure rolls per job, and if about one-half of those rolls are shot with flash, you'll be popping your flash about 18,000 times per year. If you use batteries in the flash unit itself you're going to need a lot of AA cells. So the most logical (economical) question is, can you get a rechargeable battery for the dedicated flash? Does the camera you're interested in have a fast flash sync speed...at least a 1/250 second? Does the camera offer rear-curtain sync?

(You may want to have the flexibility to experiment.) Going back to the camera itself, you must be able to afford a second body, so is there a lower-priced model in the line that has the features you'll need? Can the automatic techno-marvel you've got your eye on work easily in manual mode? Finally, is there a large selection of used equipment available that will fit into your system? As I said, both the Canon and Nikon systems can easily do the job, but you have to investigate whether or not the features you need are available. The other players in the 35mm game (e.g., Contax, Minolta, Pentax) are all capable performers, and they too can be viable wedding tools, but the Canon and Nikon systems are the most extensive and enjoy the highest recognition as professional-grade tools.

35mm Camera Focal Plane Shutters

Focal plane shutter designers jump through hoops trying to increase the speed of the traveling curtains (or lower their mass) because that means shorter flash sync speeds, which offers the photographer more options. One neat trick 35mm designers have used is to have the shutter curtains travel over the shorter dimension of the rectangular film gate. The original Nikon F had a horizontally traveling, rubberized cloth focal plane shutter and could achieve flash sync at 1/60 second. In 1965 Nikon introduced the Nikkormat, which had a vertically running, metal focal plane shutter and...bam...the shortest sync speed jumped to 1/125 second. By reducing the weight of the shutter curtains of the Nikon FM2 and combining those lightweight curtains with a vertically traveling shutter, Nikon reduced the sync speed of the FM2 down to 1/200 second.

The Nikon FM2 breakthrough is noteworthy. To reduce the mass of the shutter curtains, Nikon designers tried to make them from very thin titanium metal foil. The thin curtains didn't have the strength required, but this didn't foil the Nikon designers! One designer looked at the wing of a butterfly and noticed that,

although it was very thin, it had tiny structural ribs running through it, which made it quite strong. The Nikon designer emulated these ribs, embossing a honeycomb-shaped pattern onto the thin metal foil, which made the curtain strong enough to hold up under heavy use. Obviously, butterflies figured all this out long before mankind. Advances in technology (Nikon has since moved to carbon fiber and polycarbonate shutter curtains) have eliminated the need for the honeycomb-pattern embossing, but it was a great solution at the time.

Enough of this abridged, simplistic history lesson. Today's focal plane shutters, which are often electronically controlled, offer accuracy at all shutter speeds, which was unheard of a short while ago. The focal plane shutter makes it easier to design fast lenses, and shutter speeds are consistent with all the lenses that fit on the camera. As a student of camera design and from my seat in the bleachers, I find that focal plane shutters are better than leaf shutters for everything...except flash photography.

A few focal plane shutter breakthroughs in the 35mm world are worth mentioning. Today, there are no 35mm cameras for the pro that have a leaf shutter. But because of advances in technology, today's 35s can offer sync speeds up to 1/250 second, and even faster on the latest techno-marvels. This puts them into the leaf shutter ballpark in terms of having a wide range of sync speeds. Electronic control has added other features to the 35mm focal plane shutter's feature list: rear-curtain sync and FP high-speed sync.

An important feature to the flash photographer is rear-curtain sync. This technique can be easily created only with 35mm cameras that have rear-curtain sync capability. Here's how it works. In most situations (when using a flash with a focal plane shutter) the first curtain opens, the flash fires, the exposure time is measured out, and the second curtain closes. If the photographer chooses a slow shutter speed to accentuate the

ambient light in the room and the subject is moving, sometimes there is a blurring at the edge of the main, flash-lit subject. With normal front-curtain sync, the flash fires first, and then the subject's motion is recorded by ambient light. The blurred subject is recorded in front of the flash-lit, clearly exposed subject. Not pretty.

With rear-curtain sync the first curtain opens, exposing the subject's movement with ambient light over the duration of the exposure, and then...just before the second curtain closes...the flash fires, freezing the subject's image in front of the already recorded blur. In this scenario, any blurring is recorded trailing behind the sharp image of the subject. With practice, you can create some interesting effects with this technique, and the images may sell, just because they are dynamic and different.

Manufacturers have realized the secret desire of many flash-toting shooters: flash sync with a focal plane shutter at 1/4000 second. Although not directly associated with the focal plane shutter, the latest flash units can produce many short pops of light that continue for the entire length of time it takes for the curtains to move across the film gate. This all happens so quickly that the human eye views it as one pop. The flash must be set to a low power output so that any one mini flash pop doesn't drain the flash unit of too much power for it to sustain the other pops. Therefore, the technique is great for flash fill but limited in situations where the flash is the main source of light.

LENSES

Whether you choose roll film or 35mm, your next decision is what focal length lenses to choose. For most wedding work, if you're using a roll-film camera, you'll need three different focal lengths: a wide, a normal, and a short tele. With a fixed lens camera (such as a TLR, except Mamiya) the choice is easy. You use the lens that comes with your camera. With a roll-film SLR (or the Mamiya TLR, or the Mamiya 6 or 7) you've got some decisions to make.

Some photographers believe in stuffing their camera bags with every lens available for their camera. They end up toting so much weight that after a hot weekend in June shooting four weddings they look like little old men walking stooped over. For me it is more important to be light and mobile than it is to have every lens available. When I work alone I use a small shoulder bag that has a 50mm wide-angle lens in it; a 100mm lens rides on my camera. Using these two lenses I can cover a wedding. If I had to choose only one lens for the assignment I would pick a 60mm (equivalent to a 35mm lens on the 35mm format) or 80mm (equivalent to a 50mm on the 35mm format). Either of these could be used for full-length, group, and with careful framing, bust-length portraits. If I had only that one lens to work with, I would forget about taking the close-up head shots of the bride and groom.

When I work with an assistant we can carry and have available more lens choices. My full wedding case includes a 50mm wide, a 60mm slight wide, an 80mm normal, a 100mm long normal, and a 150mm telephoto. In a case of spare equipment (often left in the trunk of my car) I carry a second 50mm wide, a second 80mm normal, and a 2x teleconverter. Although my 60mm lens can pinch hit for the 50mm wide, I feel the 50mm focal length is so important that I want two of them available. The same holds true for the second 80mm lens in the spare equipment case. Lastly, the 2x teleconverter, when used with an 80mm normal, can replace the 150mm tele in an emergency. By combining my 150mm prime tele lens with the 2x converter I have a 300mm lens available for those long shots.

Lens choice is a funny thing. Young photographers always want the widest or longest lens available. The trouble with that is that most photographs are shot with lenses that bracket a normal lens. In my 35mm system, I have lenses from 15mm to 400mm, but if I had to choose only three it would be a 28mm, a 50mm, and a 105mm (these convert approximately to 50mm, 80mm, and 150mm respectively in the 6 x 6 or 6 x 4.5cm formats). Over the years I've realized that while I can take a "show-stopper" with an ultra-wide or an ultra-long lens, 99% of my photographs are taken with the three "money lenses" I mentioned earlier. I call them "money lenses" because when the money is on the line I want these three in my camera bag.

In olden times, the three lenses that 35mm photojournalists all carried were a 35mm wide, a 50mm normal, and a 90mm telephoto. These focal lengths didn't impress their optical signature on the picture, and the viewer understood the photo because the picture angle appeared normal. In that era the 35mm rangefinder was king of the hill. With the advent of the 35mm SLR and as picture

These images illustrate two different techniques for taking candid photographs. The first was taken at eye level with a wide-angle lens from a distance of approximately 5 feet. The second was captured from a stepladder with a short telephoto lens at a distance of approximately 12 feet. By incorporating both types of candid techniques in your wedding coverage, you can often increase sales.

viewers (your customers, the public) became more sophisticated, the wide and telephoto parts of the troika were pushed outward. The three standards became a 28mm wide, a 50mm normal, and a 105mm tele. Standards have a way of changing, and today (at last count) many 35mm pros consider money lenses to range from 20mm to 200mm. A good part of this stretch are the 20-35mm and 80-200mm fast zooms available today that have great optical qualities.

The real lesson here is that you get much greater use from the lenses that closely surround your choice of a normal lens. In 35mm format photography, a 28mm or 105mm lens will see more action than a 15mm or 300mm. In medium format, a 50mm wide and a 150mm telephoto will give you more picture opportunities than a fisheye or 250mm lens. This doesn't mean that a 250mm lens on a roll-film SLR (or a 300 on a 35mm) should be overlooked entirely. Realize what your priorities are for the job you're going to shoot, in this case a wedding.

One of the biggest advantages to using a 35mm system is the zoom lens. While there are zoom lenses available for roll-film cameras, there is no leaf shutter zoom that can cover the medium wide-angle to medium telephoto focal lengths. Mamiya does make a 55-110mm f/4.5 zoom for the 645 that might be considered an "everything" lens, but it doesn't have a leaf shutter. Although a newcomer might be interested in a tele zoom for wedding work, the assignment calls for a type of picture, specifically groups and tight candids on a dance floor, that is the territory wide-angle lenses are made for. Although both Nikon and Canon make wide-angle zooms that both start and end in wide-angle focal lengths, the truth is that a medium tele and a normal lens are also required on the job. Therefore, some of the best lenses available for wedding work have a range from 28mm to about 80mm. An important factor to note is, the longer the zoom range of the lens, the bigger and heavier it becomes. Also worth noting is, the bigger the zoom's range (i.e., a 50-100mm zoom has a 2 to 1

range, while a 30-90mm zoom has a 3 to 1 range), the harder it is for the lens designer to conjure up. While we've all read about 28-200mm zoom lenses, the simple fact is that they aren't stellar performers compared to shorter-range zooms. As a hobbyist you might be willing to trade quality for convenience, but that decision is harder to accept as a pro who has to satisfy a customer.

Lens weight, speed, and sharpness are of vital importance to a wedding photographer. Although zoom lenses are very convenient, they require that you make certain sacrifices. Zoom lenses are usually heavier, slower (having a smaller maximum aperture), and less sharp than their fixed focal length cousins. Compare the 55-110mm f/4.5 zoom (left) with the 55mm f/2.8 prime lens (right). In addition, a zoom with a variable aperture (which changes as you zoom in and out) can create nightmares for photographers working with manual flash.

There are two different types of zooms available that you must consider. One has a variable aperture—the maximum lens aperture changes as you change the focal length. You might have a 28 to 70mm f/3.5-4.5 that starts at 28mm as f/3.5 and becomes an f/4.5 lens when zoomed to 70mm. It is very difficult to use manual flash with this type of lens. Both Nikon and Canon offer fixed-aperture zooms at the top of their lines. These lenses are designed for professionals, and as a wedding photographer, that's what you are. The Nikon system actually includes three zooms with fixed apertures in the

"money" range but their middle one includes focal lengths from 35mm to 70mm and is an excellent performer. Canon's equivalent entry runs from 28mm to 70mm, and that extra 7mm on the wide end can be a lifesaver. If you're willing to commit to auto flash, Nikon has recently introduced a 24-120mm variable-aperture (f/3.5-5.6) zoom lens that offers excellent optical performance and a zoom range that smart candidmen would be willing to die for. Within two months of Nikon making the 24-120mm available, pro photographers snapped up the entire supply, a supply that Nikon thought would last for a year. This lens, even if not used for wedding work, is a perfect choice for a one-lens system.

Lens Accessories

Number one on the important lens accessory list has got to be a lens hood. Lens hoods offer protection from stray light rays that can cause flare, and they can protect the front element of the lens from oily fingertips. They can also absorb some of the impact when you drop a lens...yes, *when*...accept it...eventually you will! Whenever possible, I prefer to use bayonet-mounted, ridged lens hoods instead of bellows-style compendium hoods. Some shooters I know use collapsible rubber hoods with success. Although compendium lens hoods have their place (such as when shooting portraits using a hair light) the ridged ones are smaller and, if they bayonet into place, they can be removed quickly so you can easily add a filter.

For shooting weddings, there are some filters I cannot live without. Whether you shoot roll film or 35mm, today's lenses are very sharp...sometimes too sharp! The lenses available today can record with great clarity every pore and blemish that is part of the complexion of all normal people. Sometimes this level of detail is not what I have in mind! For this reason my camera case has three different types of diffusion filters in it, and each has a specific purpose. While a touch of diffusion can cover the ravages of time on a grandma's face, a great big spot of

diffusion can take a mundane picture and elevate it to a romantic, pictorial event that can become the centerpiece of the newlyweds' living room.

For just a touch of diffusion there are a few ways to go. Of the methods I use, one just cuts sharpness while the other cuts sharpness and also makes the highlights in the scene glow (they have a halo). To just cut sharpness, as I might want to do in a portrait of an older woman, I use a piece of very fine black veiling stretched over my lens. I hold the square of veil in place in front the lens by attaching my lens hood over the material. This eventually tears and shreds the fine veil, but the material costs $1.69 for a 45 x 36-inch piece. Since I cut 5 x 5-inch squares of the stuff from the big piece, my cost per filter is only about 3 cents, so if it shreds, it shreds. I just throw it away and cut another piece! If this seems like too much trouble, you could use a Tiffen Softnet Black filter. Because black veil doesn't make the highlights glow, it doesn't impress its signature on the picture. The only trick

Soft-focus filters often help express the romance of the wedding day, and they are available in many variations. In this example the photographer used a "center sharp" soft-focus filter, which works best for a scenic image in which the primary subject is centrally located. Photo © Franklin Square Photographers, Ltd.

This available-light photograph was taken at the very end of a session in the park as the sun was setting. By stopping the lens down to the taking aperture, the photographer could see the effect the filter would have on the sunlight. Four-point star filters, such as the one used in this photo, are frequently found in a wedding photographer's arsenal. For more versatile effects, try one of Tiffen's Hollywood/FX Star filters, which have multiple points of varying intensity, adding the perfect dramatic touch.

A piece of very fine black tulle or veiling makes a perfect substitute for a soft-focus filter. While white also works, it can create a halo around the subject and increases the chance of flare when backlit.

to using this filter is remembering to open the lens when it is in place. Depending on how coarse it is, black veil prevents about 1/3 to 2/3 stop of light from reaching the film.

The second type of diffusion filter I use has small lens-like elements within the glass. They scatter light and selectively defocus details while maintaining the overall appearance of sharpness. These filters are available in varying degrees of diffusion. Tiffen's Soft/FX and Warm Soft/FX filters are both available in five densities. Zeiss makes its version, the Softar, in three levels of intensity. Of the three, the Softar I is my first choice (although I also carry the more diffuse Softar II), and when used in sunlight it makes highlights take on an angelic glow. Unlike the black veil, filters of this type do impress their signature on the picture. In other words, once you've seen the effect these filters produce, you'll recognize it when you see it again. Diffusion filters of this type are expensive, but their sophisticated design maintains image clarity while creating soft, luminous high-lights—perfect for wedding photographs.

The last type of soft-focus filter I use is a homemade variety. Photographers often use Vaseline streaked, smeared, and/or dabbed on a UV filter to make a soft-focus filter that is soft only where they want soft focus and sharp in other areas of the composition. Although the idea is a great one, while shooting a wedding there is no time to clean the glass and reapply the Vaseline for each shot. I buy old scratched, ratty skylight filters from the junk boxes at photo shops and swirl on clear nail polish in various patterns. My favorites have a dime-sized clear area slightly off-center, and when I put it on my lens I orient the clear spot so

There is a whole world of special effects filters for you to experiment with. Graduated glass filters from manufacturers such as Tiffen are available in a wide variety of colors. The orange-to-clear gradation of the Tobacco filter used in this photo added warmth to the drab, gray sky, allowing the photographer to make the best of less than perfect weather. Photo © Franklin Square Photographers, Ltd.

YOUR TRIPOD AND YOUR METER

If some wicked witch were to cast a spell over me that would allow me to carry only one accessory other than my camera and flash (she's not totally wicked...she let me start with my camera and flash!), I would be hard-pressed to choose between my tripod and my light meter. If I was using a 35 with a built-in meter, my choice would be easy. In fact, my camera doesn't have a built-in meter, and my choice is still easy: Give me my tripod! Sure, tripods create a presence for the camera, but what's more important, they make a new range of shutter speeds available, which in turn makes more apertures available, which gives the candidman more tools to work with. Picking the right tripod isn't easy, but before I get specific there are some generalities to consider.

Taking pictures of people quickly with a tripod-mounted camera requires a specific set of criteria. The choice of features one needs in a tripod should be made with speed foremost in mind. Consider the following:

1. Although leg bracing (i.e., rods, either adjustable or fixed, that attach between the tripod's center column and its legs) makes for a sturdy tripod, it is not conducive to fast tripod-shooting technique. Tripods with quick-release leg locks operate much faster.

2. The tripod's ability to be extended or collapsed quickly is important.

3. Ballheads or speed-grip tripod heads are much faster than pan/tilt heads for taking people pictures (which is what wedding photography is all about).

4. A geared center column not only slows you down, but also makes you carry unnecessary weight. The kind with a sliding, friction-locking center column is lighter and faster.

that the part of my composition I want to be sharp is aligned with the clear area of the filter. I might put the clear spot straight up for a portrait and straight down for an alter picture. Although my diffusion filters work for me, there are dozens of other soft-focus devices that I have seen photographers use over the years. From translucent plastic cups riddled with holes to very expensive Imagon soft-focus lenses, each candidman has

favorites. Over the years I've tried many softening devices, from crumpled cellophane with holes burned in it to breathing on my lens in cool weather. Although I have listed the four I'm currently using, if you asked me to list my favorites next year they would probably be different. Whether you try my ideas or are creative and think up some of your own, diffusion is a useful tool in the wedding equipment arsenal.

5. Weight and sturdiness also must be factored into your choice. It used to be that strong meant heavy, but not any longer.

6. Spike-tipped tripod feet might be great for shooting in the muck and mire, but you'll regret it if your tripod scratches up a caterer's parquet flooring. Avoid spiked feet.

7. Your height plays a role. Many of your shots will top out at eye level. For this kind of shooting, it doesn't make sense to carry a 10-foot-tall tripod if the highest camera position you'll be shooting at is eye level.

From looking around at the 30 or so candidman I associate with regularly, I can say that the favorite 'pod among my peers is the Cullmann Titan. This tripod's claim to fame is a two-section leg that is both released and locked in position by a lever at the top of the leg near the tripod leg yoke. This makes for lightning fast leg operation. On the negative side, the two-section leg means the Cullmann doesn't collapse compactly, which is not a big concern in wedding work. The tripod is also heavy and requires a special Allen wrench to keep the tripod screw tight. On the other hand, a few of us swear by our Gitzo tripods (imported by Bogen), and the first one I bought over 30 years ago still works well. Gitzo's latest tripods are made from carbon fiber (although they still make metal ones), which is lighter and stronger than the aluminum it replaces. However, the 40% reduction in weight and the increase in strength is very expensive. Other contenders to the tripod throne include models manufactured by Manfrotto (also known as and distributed by Bogen in the U.S.).

No matter which tripod you decide upon, the tripod head is another choice you've got to make, and serious shooters mix and match different brands to suit their needs. Pan/Tilt heads are slow compared to ballheads when used for people pictures. The Bogen 3265 Grip Action Ballhead has a spring-loaded release

lever. By squeezing the head and the release lever together, the camera can be positioned as you like; by releasing your hand pressure, the head is locked. Very nifty. My choice is an older model Linhof ballhead that is almost as quick and indestructible. Whatever head you decide upon, look into a quick-release camera coupling between the tripod head and your camera. The same type of coupling should be on your flash bracket so you can switch the camera back and forth quickly between bracket and tripod. Some candidmen add another quick-release coupling beneath their flash bracket so they can quickly mount it onto the tripod. Once again, speed is of the essence, and anything you can do to make the flash bracket-to-tripod switch happen quickly is advantageous.

Even if you use an automatic flash and a BTL (behind-the-lens) metered 35mm camera, a light meter is a worthwhile accessory. And if you decide to shoot with manual roll-film cameras and manual flash units, a light meter is a necessity! With brides dressed in masses of white and grooms and ushers dressed in masses of black, the light meter you choose should be able to measure incident light. Reflected light meters are calibrated to read anything they are pointed at as a middle gray. Therefore, brides (masses of white) are underexposed to be recorded as middle gray, and ushers (masses of black) are overexposed to be recorded as middle gray. Although you will be able to record detail in the bridal gown and tuxedos this way, it will play havoc with the rendition of skin tones. When shot using a reflected light meter's exposure suggestion, brides look perpetually sunburned and grooms always look pasty.

In addition to making sure it can read incident light, make sure it can also handle flash readings. Currently, again using my circle of candidmen colleagues as a sample, the Minolta Flashmeters are the favorite choice. Specifically, the Minolta Autometer IVF, which is simpler and less expensive than other Minolta models, has all the features a candidman needs. Some candidmen choose from the Sekonic line (imported by Mamiya

America), which has smaller, more compact models available, and if your eyesight is better-suited to reading headlines (as opposed to the body copy) on newspapers, the Polaris (imported by The Saunders Group) has much to offer for the price and features very large readout numerals.

Even if you know your guide numbers like the back of your hand and can read available light very accurately by eye, a flash/ambient incident light meter can be used to check out a manual flash unit's output or your exposure guesstimate of a sunlit scene. I carry two nearly identical meters on every assignment and check one against the other (and both against a known, manual flash) at the beginning of each assignment. For me, the peace of mind is worth carrying two flash meters! As an aside, in my equipment cabinet at the studio I have a third flash meter that never goes out on the road. This meter, which lives a life of ease in its foam-lined box, is used as the standard against which I test all my other meters.

FLASH

Battery-Powered Flash

Although young photographers think of their flash unit as an afterthought, seasoned candidmen consider it to be one of their most important tools. That's the reason why I've devoted a whole chapter to shooting with flash. Before I give specific recommendations about the brands that have withstood the test of time, there are some general features that you should look for. Let's take a look at portable, battery-powered flash units first because they are the cornerstone of your flash equipment.

How much flash power you need is the first question that must be answered, and that depends on other factors. Format, film speed, lens, and hall size are all contributing factors in your choice of flash. So let's generalize for a minute, and then you can tailor these generalities to your requirements. Consider the following criteria:

1. You need at least three different levels of flash output from your flash unit. Ideally, each power setting should be 1 stop more or less powerful than the adjacent setting.

2. For best lens performance, you should be able to work at an aperture at least 3 stops down from wide open, and you probably want to shoot group pictures at 15 feet at about f/8 to gain enough depth of field to cover focusing errors. Thus, you should check the guide number of the flash to make sure it will deliver this combination at the ISO of the film you shoot.

3. Use rechargeable batteries. You don't want to empty your wallet each weekend on fresh, disposable batteries. It's expensive, and it's bad for the environment.

4. You need to be able to get 200 to 300 flashes (at mixed power settings) from a battery before you need to recharge it. While you may make it through a June lawn wedding with only 50 to 100 flash pictures, there

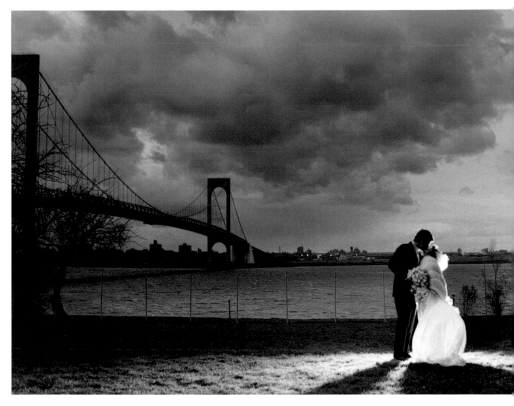

With the help of radio remote triggers you can use a flash unit to help spotlight a couple surrounded by a big scene. In this example the photographer placed a light behind the subjects and used a second light to add a touch of frontal fill. This turned the kissing couple into the center of attention and at the same time reduced the bridge and sky to supporting instead of starring roles. Photo © Franklin Square Photographers, Ltd.

Metz 50 MZ-5

will be a January evening wedding that starts and ends with flash photos, so be prepared. However, you might look into smaller batteries with smaller capacity (the advantage being their reduced size and weight), but expect to change batteries during a break in the wedding action, which leads us to number 5....

5. You need to be able to change to a freshly charged battery quickly and easily.

6. Balance your lust for power (both from the flash and the size of the batteries) with the consequences of size and weight.

7. The reflector on your flash unit should more than cover the widest lens you'll be using and provide even illumination. That way, if your flash

unit becomes misaligned on your bracket, its coverage will still be adequate for what the lens sees.

8. You might be interested in having bare bulb capability for working in small white rooms (such as the bride's house) or for putting out just a small puff of fill light.

9. Although it can be handled by your flash bracket, your flash unit's ability to bounce can also be helpful.

10. A fast recycle time is very important in the wedding business. You can't tell the bride and groom to stop on the aisle for 10 seconds while your flash unit cranks up to power. In that instance, 10 seconds might as well be a year! Think in terms of a 1 to 2 second recycle time and you'll be on the right track.

11. Some manual flash units that satisfy criteria 1 through 10 also have auto flash capability. Therefore, if you think you might ever use auto flash, this could be important to making your decision.

Some photographers like self-contained units (with batteries in the flash head itself), and others prefer a separate battery pack that's worn on the belt or shoulder. Personally I prefer a shoulder pack because I like my camera-flash head combination to be light and whippy. Because my flash head is 6 to 8 inches over the lens, any extra ounce puts extra stress on my wrists. Eight extra ounces in the flash head might not seem like much, but it can really add up after a three-wedding weekend.

Once again, using my candidmen associates as a sample, the most popular flash unit by far is the Lumedyne, which satisfies all eleven criteria I listed above. In fact, from my entire circle of candidmen coworkers, all except two use Lumedynes! Of those that do, almost all use the 200-watt-second 065X packs, which have a faster recycle time than Lumedyne regular (non-"X") packs. The two candidmen who walk to the beat of a different drummer use Metz 60 CT-4 flash units (distributed by Bogen). Both of these shooters work in the automatic mode but do not use the Metz's BTL (behind-the-lens) capability. Another excellent auto flash is the Qflash made by Quantum. This particular unit is so popular that Lumedyne makes an adapter to attach a "Q" head to a Lumedyne pack. For smaller shoe-mount flash units, Quantum also produces the Turbo Battery, which increases the number of flashes available because it has greater capacity than the flash unit itself.

My associates and I choose Lumedyne for reasons that may not be important to you, although this brand's power, reliability, and features are compatible with our style of shooting. If you are shooting with 35mm or using ISO 400 film, you might get by with a less-powerful flash. In addition, some 35mm brands have accessory flash units with features that might be very important to you. If you do go this route, realize that, 1) You'll still need an accessory battery pack with its larger capacity, and 2) Many popular 35mm accessory flash units aren't designed to take the strain placed on the unit by 200 to 300 manual flashes in 5 to 6 hours.

Some of these shoe-mount flash units are designed to be used as fill flash in the automatic mode, which creates less heat in the flash head and uses less battery power. Of the aftermarket shoe mount flash units available, the Vivitar 283/285 series has proven to be particularly reliable and adaptable. Top-of-the-line Sunpaks are also in the hunt, but to a much

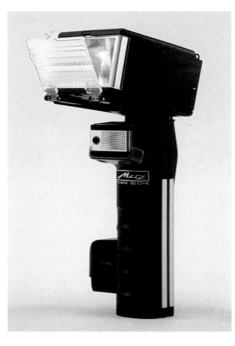

Metz 60 CT-4

lesser extent. In the New York area, various strobe shops that cater to candidmen modify these units by replacing the fragile hot shoe with an aluminum plate that's been drilled and tapped for a 1/4"-20 screw or by adding small, external gel cell battery packs to increase their capacity. If you can find a local strobe shop (or an adventurous camera repair person) in your area, it pays to establish a good rapport with them and find out what they can do to satisfy your special needs.

Sadly, just like cameras, all flash units break, and a candidman without a flash is hopeless! With that thought in mind you should plan for this calamity beforehand. If you're shooting double light (with an assistant holding a second strobe on a pole) you have to be ready in the event that the second flash unit breaks as well. Batteries die or refuse to hold a charge, flash tubes blow, pack switches burn out, cables fray, and so on. My system includes four Lumedynes, although I bring only three packs and three heads to every assignment. The fourth one (which is a spare and stays back at the studio) is rotated into my traveling equipment regularly.

Flash Brackets

The union between your flash and your camera is the flash bracket, and for many candidmen it is an expression of individuality. While there are some excellent ready-made brackets on the market, many serious players customize a store-bought item to better suit their needs. Since each candidman's bracket is different, it pays to look at some of these weird beasts to get a better idea of what each shooter considers important.

For my 6 x 6cm camera, I use a modified 35mm bracket with a few interesting wrinkles. The ability to hold my camera securely with either hand is important to me. So, the bracket's long base, designed to hold a 35mm camera, was cut down considerably, but I left a stub of it sticking out on the right side (opposite the hand grip) to help stabilize my grip on the camera with my right hand. The stub is short enough that it doesn't interfere with my hand when I advance the film but long enough that I can hook my right thumb over it and still have my index finger reach the shutter release button. This stub allows me to hold the camera and release the shutter with one hand. The stub's proper length (for me) was found by trial and error (and a lot of skinned knuckles along the way!).

My next modification involved removing the large, knurled camera-mounting screw on the bottom of the bracket and countersinking the hole so a flathead 1/4"-20 screw could be used to mount a

quick-release camera coupling. That way, the bottom of my bracket is flat, so I can rest the camera on any flat surface.

Next, butted right up against the quick-release coupling is a short brass bar that has been drilled, tapped, and screwed to my bracket. This bar stops the quick-release coupling from rotating on the bracket. A groove is cut into the wooden handle on the left side, which acts as a thumb rest when I hold the camera-bracket combo in my left hand.

Last, there is a notch filed into the bar that holds the flash head. There is a small nut on the bottom of my Lumedyne flash head that fouled the bar when I tried to rotate the flash head into a bounce light position. The notch lets the nut and the flash head bar peacefully coexist when I want to use ceiling bounce. Study the pictures of the different brackets I've shown and look at the brackets of other candidmen in your area; incorporate those ideas you find helpful. Remember that your bracket is a personal thing, and if it's comfortable for you (you'll be holding it a lot) and does what you want it to, then it's right.

AC-Powered Flash

While many candidmen don't use AC- (wall outlet) powered strobe units, I find that they can add a new dimension to wedding work. I use them as room lights to open up backgrounds during the reception. With them I can avoid the "coal miner's helmet light" look so common in wedding photography. When I'm part of a team photographing a wedding in a New York hotel ballroom, it isn't uncommon to see three or four 1,000-watt-second strobes positioned in the balconies. If there is time, and an available wall outlet, they can change a large church from a dark cavern into an ornate castle. To pull this kind of lighting magic off requires a team approach, and with the help of a good assistant (not to mention the 1,000-watt strobe) I can be shooting single-light pictures of the bride getting out of the limo while my assistant is setting up room lights. But these bruisers shouldn't be limited to just illuminating backgrounds.

Using two portable flash units for taking candids is the obvious way to go for wedding photography, but once you settle into a location where you intend to shoot many photographs, you might explore the advantages offered by AC-powered flash units. While there are disadvantages to carrying extra equipment, lugging the extra weight, and being tethered to a wall outlet, AC units offer more power, modeling lamps (to preview the strobe's effect), and the luxury of never having to worry that the battery will be too spent

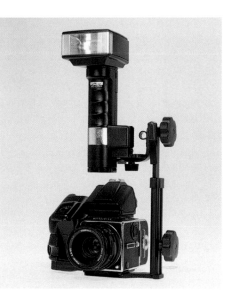

Stroboframe carries a wide variety of flash brackets, able to accommodate almost any camera and flash combination. The Pro-66 bracket, shown here, is designed specifically for square Bronica and Hasselblad cameras with grips. It includes a flash tilting feature for ceiling bounce and a flash-height adjustment … just the thing for eliminating red-eye!

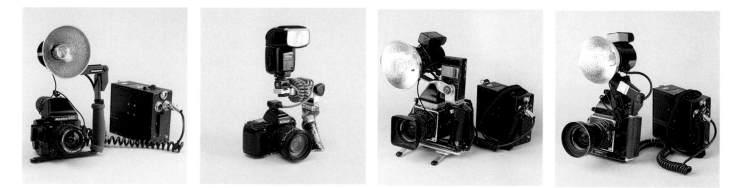

Every photographer has different requirements in a flash bracket. Look for a bracket that suits your shooting style and is compatible with your equipment. If certain features don't come standard, brackets can be modified to suit your needs. The first photo shows an off-the-shelf, unmodified bracket—a basic wedding rig. The second photo shows a 35mm setup. The third photo illustrates a bracket with four metal feet, which make the rig more stable when rested on a table. In the fourth photo the bracket has been fitted with a quick-release coupling, which speeds up the "on the bracket"- "off the bracket" changeover. This bracket accommodates the rectangular format by allowing you to swing the strobe head over the lens when making vertical compositions. Notice also that 35mm auto flash requires a cable to allow communication between the hot shoe and the flash unit.

to recycle the unit. No matter how much pack weight you're willing to lug about, a battery-powered strobe is outpowered easily by an AC unit. AC strobes offer faster recycle times, also. This power, along with the modeling lamps, allows the candidman the luxury of working with umbrellas or softboxes that offer superior light quality when compared with direct flash. While Lumedyne offers a special head with a modeling light, I have found that the modeling lamp draws so much of your battery power that the tradeoff in lost flashes isn't worth the luxury of the modeling lamp. Because AC units use wall current, the modeling lamps are not a liability.

Without being brand-specific, I'll offer you a few criteria to consider. First on your list should be small size and light weight. While to some this might mean a 500-watt-second output, I have found that a photographer who wishes to use AC units for portraiture or as room lights needs at least 1,000-watt-second output. Today's 1,000-watt-second strobes are small compared to the units of a few years ago, and while it's easy to throttle down a big pack, you can't increase the power of a small pack. These AC units are a good compromise between portability and output.

The best thing you can add to candid reception coverage are room lights. Notice how all the guests are illuminated in the background of this photo. Very often people buy pictures like this one not because of the bridal couple's image but because Uncle Harry and Aunt Sylvia are well lit and smiling in the background! Photo © Vincent Segalla Studios

Form Your Capacitors

Inside every flash unit there are capacitors, which store up the energy from the battery until there is enough power to excite the gas in the flashtube when the flash is fired. For flash units to work reliably the capacitors have to be able to store and hold a charge. Through use, capacitors are "formed," which means they don't let the charge they're holding dribble away. The flash doesn't have to be fired, but energy from the battery (or the wall outlet with AC units) must be poured into them from time to time to keep them formed...even if they aren't being used. So, to keep your flash units healthy, it pays to use them regularly. Even if it is mid-February, and you don't have a wedding until April, you can do this by occasionally turning on all your flash units. Just let them "cook" for a while (anywhere from 15 minutes to a few hours), and then turn them off again. Over the years I've gotten into the habit of turning on all my battery-powered flash units at the end of each day's shooting. As I drive home, my battery-powered flashes are happily chirping away in their case, getting ready for tomorrow's shoot. Obviously, the drill also includes charging the batteries as soon as I get home. My repairman once told me that this advice was just a word to the wise, but that it would keep my flash units up and working. Wise words indeed. It works!

Where you live and work might make a large difference in which brand of flash unit you buy. Let me clarify why. The brand of strobe your local supplier sells and repairs makes that brand one of your best choices. There once was a truism that shooters on the West Coast of the U.S. used Normans (made on the West Coast), Midwest shooters used Speedotrons (made in the middle of the U.S.), and East Coast photographers used Dyna-Lites (made on the East Coast). This was not because any of these flash units were necessarily superior, but because the photographers were closer to sales and service facilities, a very important factor. Today, with flash units being manufactured internationally (Comet, Broncolor, Elinchrom, etc.), and the existence of national distributors who ship equipment everywhere, this old truism isn't as absolute as it once was, but my choice of flash system is strongly influenced by what I can buy and have repaired locally. Today, with Express Mail, FedEx, and UPS Overnight, the world has shrunk considerably, but there is something to be said for whatever brand a local, reliable dealer displays, stocks, and repairs. This "local dealer" thought must be tempered by what you actually require, but many brands of strobe units can satisfy your needs.

The next thing on your want list is low power consumption, and with this there are a lot of considerations. Power consumption, as I use it here, is how many amps the flash draws from the power supply when it recycles (with AC units, it's the wall outlet). Today's AC strobes designed for location work draw about 7 amps of power, and since most outlets have 20-amp circuit breakers, you might think all is well. In fact, it is and it isn't. If there is a video crew at the wedding you're photographing, they also might place a load on the circuit you are plugged into. A 1,000-watt quartz video light uses 7.5 amps of power. If the video crew is using three lights (as many do), they require two 20-amp circuits to themselves. The band or orchestra is another

amp-hungry beastie. Without going into their requirements (which vary wildly), let me point out that while many ballrooms have an entire 100-foot wall festooned with outlets, frequently all of them are on the same 20-amp circuit breaker! Between you, the videographer, and the musicians, 20 amps doesn't go very far! In a perfect still-photographer's world, you would always find the power you need. Too bad the world isn't perfect! Finally, consider that while an AC flash might only draw 7 amps, each 250-watt modeling lamp is going to add another 1.5 to 2 amps of draw to your requirements. Therefore, sometimes, by turning off the modeling lamps on room lights you can get your amp draw down to an acceptable level.

In the world of AC strobe systems there is a battle raging between two camps: self-contained flash units, and separate flash head and power pack designs. Both designs are worth considering. Self-contained strobes are smaller, and if you are using multiple units and one breaks, the rest of the system is still up and working. On the other hand, self-contained strobes are usually less powerful than their separate head and pack cousins.

The separate head and pack units have features all their own. In the first place, you can very often substitute a more powerful pack from the same system and use it with a head you already have. For example, some Dyna-Lite flash heads can work with 500, 1,000, or 2,000-watt-second packs. If you are using more than one AC strobe unit in your system, and you blow a head or a pack (and you will eventually), the remaining pieces are still useful while the blown piece is being repaired.

One reason that I use separate head and pack designs has to do with liability. Liability? Let me explain. When I use an AC flash unit as a room light, I put the flash head on a 10-foot stand, making it an easy target for someone to knock over. Self-contained units are usually heavier than equivalent separate-pack flash

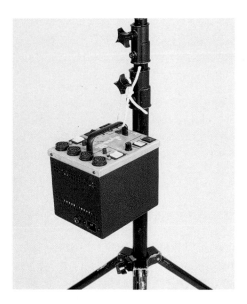

One easy way to stabilize a top-heavy light stand is to hang the light's power pack from a lower knob on the stand. I use loops made of tough, 1/4-inch nylon rope. If you decide to go this route, here are a few tips: 1) Keep the nylon rope ends from fraying by melting them with a flame; 2) Use a knot that doesn't slip— I use a square knot, but there are other suitable knots; 3) Douse the knot with instant adhesive or epoxy (and let it dry) as a further precaution against it coming undone.

heads, making the light stand even more top-heavy and easier to topple. For added stability, I have tied a short rope loop on the handle of each of my 7-pound AC packs and use it to hang the pack from the base of the stand. While I carry a substantial liability insurance policy as a safeguard, I prefer never to have to use it!

Packing Tips for AC Strobes

My normal complement of AC strobes includes three 1,000-watt-second packs and four flash heads. The whole system packs into different-sized hard cases, which double as posing aids once I have the lights set up. I've designed a three-case system for my AC strobes that nestles into the trunk of my car. The first case, which is medium sized, carries one pack and two heads. My second case, the largest, carries two packs and two heads. My third case, the smallest, is used for spare equipment. Each case has all the cables and connectors necessary to make the equipment in that case usable. This is called "stand-alone packing," which means that each case has all the bits and pieces needed to make all the things in it work. It's worthless to drag in a case that's loaded with equipment but missing an integral part (such as a power cable) that is stored in another bag in the trunk of the car.

If you decide to travel the AC strobe route, include some grounded extension cords on your equipment list. You'll always find that the perfect position for your room light is two feet further from the wall outlet than the length of the power cable that comes with the strobe. I carry three 10-foot and three 25-foot extension cords in addition to the three 10-foot power cables that come with my three AC strobes because, hey...you never know.

In addition to the extension cords, my spare equipment case includes an extra modeling lamp or two, a set of grids (in case I want a spotlight effect or a hair light), some extra batteries for my light meters, a few extra soft-focus filters, a small roll of gaffer tape, and a larger roll of duct tape. (Duct tape is less expensive than gaffer tape but it's not as well-suited to every situation as gaffer tape because it melts under heat and its adhesive comes off on everything.) I use the duct tape to tape down any extension cords I'm using to lessen the chance of someone tripping on my cables. I have all this equipment available just in case it's needed. You might say it's the "just-in-case" case!

If you're going to have all this equipment available, you have to find a way to cart it all around easily. For me this means piling my cases on a very sturdy luggage cart and rolling it into the reception hall. I recommend carts with large wheels and a sturdy steel wire construction. While I don't always bring all three cases in to every assignment, I always wheel in at least one.

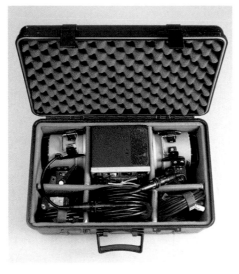

This room and portrait light case is a perfect example of stand-alone packing. Everything that's needed to make this flash work on the job is included in the case. The extension cord (the red one) and radio remote receiver are tucked into the front compartments. Notice that I put a piece of gaffer tape over the on/off switch on my radio slave so that it doesn't turn on accidentally and drain its battery.

ACCESSORIES

Sync Cords

Without a sync cord between your camera and flash, all your other preparations are worthless. Within every sync cord is a multi-stranded wire whose filaments are each almost as thin as a human hair. Consequently, sync cords are very fragile. These things break just as surely as night follows day. To add insult to injury, if the wire doesn't break, the PC tip becomes deformed and can't make good contact. Over the years, the flash industry has

been lambasted for settling on the PC tip as the standard. I personally consider this debate to be a waste of time. The fact is, the PC tip is the standard, whether it is a weak link or not. The real question pros must face is how to deal with the situation.

My solution is simply to carry a half-dozen spares on every assignment. Some may think that six extra cords is overkill, but frequently when a cord breaks, a photographer will replace it but never add a new spare to the case. Eventually, usually in the middle of a hot, June wedding, a cord breaks, and the photographer finds that the cupboard is bare...a very sad tale. I once got an emergency phone call from one of my associates asking me to please bring a sync cord to the church for him. Talk about not being prepared... Many photographers can't bring themselves to throw away bad cords, and instead they tie a knot in them (to signify it's no good) and put it back into their case. I think they secretly hope the knot-tying game will magically repair the bad cord. Eventually, the bottom of their case is filled with a rat's nest of knotted cords, and not a one is in working order. Forewarned is forearmed. So always carry spares, and throw out the bad ones!

Banks and Umbrellas

If you're set up to take portraits, one of the easiest things you can do to improve the look of a subject's skin tone is to increase the size of your light source by using a light modifier of some kind. This is most easily accomplished by using a bank light or umbrella accessory. Without such accessories, flash can produce large, hard-edged shadows on a subject's face, accentuating every imperfection. However with a light modifier, the size of the light source is increased, producing smaller, soft-edged shadows and minimizing skin imperfections.

Umbrellas come in a variety of colors, each of which affects the tone of the light reflected on the subject. I have found that the soft white variety (I use Photek) creates a more pleasant skin tone than those with silver or gold reflective segments.

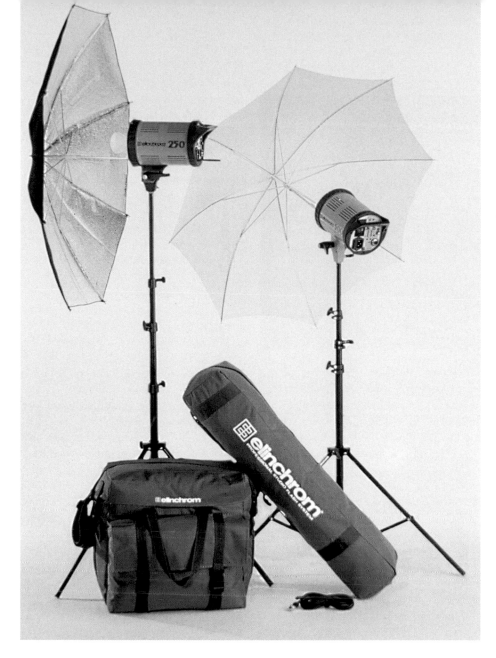

two-piece Photek telescoping background support pole, and a Lowel pole for my assistant's light. All of this fits into a soft Tenba light stand case that is slung over one of our shoulders when we walk into the catering hall. When I work "light" (with only two battery-powered lights), I pull the Lowel pole out of the case and leave the rest of the system in my trunk.

Backgrounds

By carrying a background along I can shoot formal portraits on location by setting up a small studio wherever I am. It's great not to have to worry about ratty wood paneling in a VFW hall and not have to shudder when you see the painted cinder block walls of a basement meeting room! So into the trunk of my car I tuck a 10 by 20-foot muslin background. It is stuffed into a bag, which contains another, smaller bag that has all the clips needed to set it up. Remember: Stand-Alone Packing.

How the background is stuffed into the bag deserves a brief comment. Many novice photographers who buy a background notice that it always comes to them neatly folded. They dutifully

Although I have found that banks and umbrellas produce similar effects when used in large dark rooms, when used in smaller light-colored rooms, bank lights create a more directional, contrasty light quality than umbrellas. I have also found that umbrellas are quicker to set up and more compact to tote than banks.

Light Stands and Ways to Tote Them

Some might say that a stand is a stand is a stand, and to a certain extent they are right, but even when it comes to light stands, thinking of your equipment as a system has advantages. No matter what kind or how many light stands you carry

with you (it depends on your lighting choices), make sure that all of them have the same diameter mounting stud. It is too frustrating to try to remember that one light stand requires a bushing to mount a specific light and another doesn't. You'll probably misplace the darn bushing anyway, and then you'll be sticking stuff together with gaffer tape, which only works in a pinch. The mounting studs on all my light stands are 5/8-inch diameter, and all my flash equipment fits this size mount. Just make sure all your lighting equipment works with all your stands and you'll be okay.

I carry four 10-foot Bogen stands, one 7-foot Lowel, a tiny PIC stand (for a back light), four soft white Photek umbrellas, a

Never fold your muslin background. It should be stuffed into its carrying bag to give it a soft random pattern.

continue to fold it up every time they pack it away. After a while the creases in the background show up as a checkerboard pattern in their pictures. A better alternative is to stuff the muslin into its case willy-nilly. This way, you end up with a random pattern that, when thrown out of focus, doesn't distract from the subject.

Posing Drapes

One accessory that rides in every equipment case of mine is a posing drape—a piece of nice material that can be used for a variety of things. I carry black ones that are about 45 inches square, but gray, white, and other colors can also be used (I carry a white one in my just-in-case case). The cut ends are folded under and sewn with a simple line of stitching. The stitching keeps the material from fraying and makes the drape look neater and more professional.

What do I use a posing drape for? Here are just a few suggestions: My black drape can be used as a quickie background for a head shot. I either tape it or safety-pin it to a wall or curtain but, in a pinch, I've even had an assistant or casual bystander hold it behind the subject. Often I use a hard camera case as a posing prop, and I can hide it by throwing a drape over it. My black drapes can also do double duty as a scrim (or flag) to block light from hitting some part of the subject or background that I want to stay in shadow. Finally, I've even rolled one up and used it for a pillow when I needed a nap!

Tool Kit and Emergency Kit

Two things that might save your day are tool and emergency kits. What you include in yours is very personal and should be tailored to meet your needs and equipment system. My tool kit includes the normal complement of needle nose pliers, jeweler's screwdrivers, and a Swiss Army knife, but along with those three staples I've added three Allen wrenches that fit my light stand locking screws, the hinge screws on my stepladder, and the Allen-type locking screw on my Dyna-Lite variator knobs. My kit also includes an open-ended metric wrench that fits the leg bolts on my Gitzo tripod yoke....but these tools fit my system and your tools should fit yours.

My emergency kit includes adhesive bandages (the flexible fabric kind the doctor gives you), acetaminophen, antihistamine (sometimes pollinating roses give me sneezing fits!), safety pins, bobby pins, pearl-topped hat pins (for CAREFULLY pinning down a train on a windy day), and rubber bands all stored in a plastic 35mm slide box that I've covered with gaffer tape. While these small things seem insignificant, if the groom pops a suspender button and his pants keep falling down and looking schlumpy, my safety pins can save the day! Once again, the stuff I include (although it is chosen with the eyes of experience) should only be a jumping-off point for your kit. You might not need the antihistamine, and you may want to double up on the headache medicine...which is fine!

Ladder

I've saved this for last because it is one of my most important accessories. In the trunk of my car, beneath all my cases, is a 30-inch stepladder. The more photographs I take, the more I use my stepladder. If I want a high view to shoot over the crowd, my stepladder is ready to lend a boost. If I need a place to seat a subject to make a more interesting pose, I use my ladder. If I need to get an equipment case off the ground for easy access, my stepladder is with me. In fact, once all my equipment is tucked away in the catering hall or church, the equipment that stays with my assistant and me includes the camera, our two lights, my camera case, and the ladder. My ladder is one of my best friends on a job.

I use the three-step Little Jumbo ladder made by Wing Enterprises. They can be ordered from York Ladder, but you might try looking for a local supplier. More like a portable staircase than a ladder, the Little Jumbo is very sturdy and heavy, but for me it is the way to go. I use all three of its steps for posing people, and it can change a lineup into a grouping in the blink of an eye. One modification I've made to my Little Jumbo has to do with the spacer plate that is riveted between the legs on the non-step side. I've found the rivets loosen over time, and the thing becomes rickety. To combat this my spacer plate was welded in place by a local welding shop for $20, which was worth the expense.

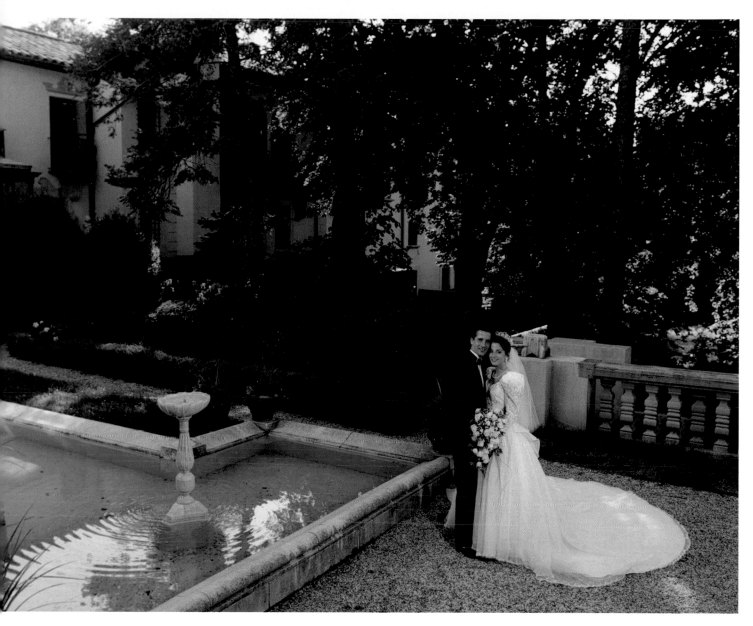

CONCLUSION: DO IT YOUR WAY

At the start of this section I told you that whatever equipment I would suggest some other photographer would disagree with and, in reality, they are right...in fact...we're both right. In the final analysis, no one (except maybe another photographer) is interested in how you got a particular picture, just how the picture looks. My suggestions are based on my experience both from an ease of use and reliability standpoint, but your requirements and preferences may be different. If you decide to shoot a wedding with one flash and a low-end 35mm camera, that's fine (even though I still think you should have at least a back-up camera and flash). The goal of any equipment choice is to create beautiful, salable, profitable pictures consistently. How you do that is up to you. And, if, after one hundred weddings you decide that you must have a stepladder or tripod with you, I'll never say, "Told ya so!" (OK, OK, maybe I'll say it once.)

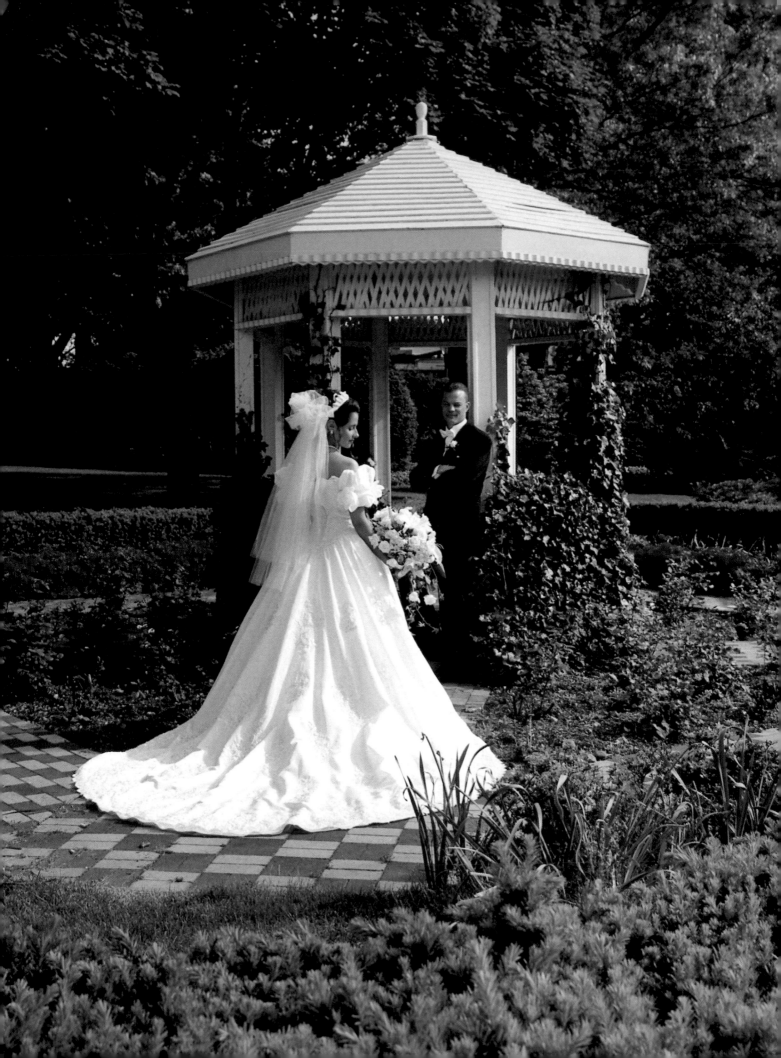

RELATING AND SELLING

She's the perfect bride, on the perfect day, after the perfect church wedding. She is beautiful, chaste, angelic,...glowing in white, with flowing blond hair. She speaks in a quiet, refined voice. At the park, during formals, a large, yellow-and-black butterfly floats by and lands on the bride's bouquet. I, very quietly, tell the glowing white vision not to move and prepare for the picture that dreams are made of. The maid of honor comes running up to the bride, waving her arms and yelling, "A butterfly...A BUTTERFLY!" Said butterfly decides to leave. The chaste, white, angelic visage turns to the maid of honor and says, "YOU are a f——g a——e!!!" My image of this chaste angel is gone forever....I keep right on shooting."

I consider this to be the most important chapter! When I first started to outline this book, I discussed a few of my ideas with one of my mentors. When I got to the chapter about relating, he listened and told me that if I could teach the reader this skill, I would be doing a great service—both to bridal couples and to the photographers themselves. While many will argue that it is the final picture or album that really counts, I have found that, in the wedding photography realm, making your subject feel comfortable is just as important as the quality of the final photos. We candidmen are working with stressed-out subjects who may have unrealistic expectations of perfection, which only adds to their stress. In this situation, *it is as important to be nice as it is to be creative*. I believe that as many recommendations (if not more) are generated by a photographer's pleasant personality as are generated by good wedding pictures.

RELATING

If you think for a moment about the complexities involved in taking wedding photos, there are some simple truths worth noting. On their wedding day brides and grooms look their best. Brides (and to a lesser extent grooms) invest tremendous effort into how they look. Professional hair arrangements and makeup applications are usually the rule rather than the exception. Much thought is put into the choice of wedding dress as well as the formal attire for the groom, and an almost equal amount of effort is put into the attire of the bridal party and members of the immediate family. Every aspect of the day is planned and replanned with an eye toward perfection. If you accept this premise, then it is easy to make the leap to believing that the wedding day (from the invitations to the dessert table) is as close to perfection as your client can make it. Because you are photographing your customer's perception of perfection, delivering good photos becomes an easier proposition.

If perfect subjects make it easy to create beautiful pictures, what about the interpersonal, relating side of the equation? Without rewriting the Dale Carnegie book, *How to Win Friends and Influence People* (although it is worthwhile reading for anyone who wants to shoot any kind of people pictures), there are some things I've noticed that can make or break your interpersonal skills. Knowing which of your actions to cultivate and which to avoid can lead to success as a candidman or studio owner.

Six Secrets of Relating Well to Your Customers

Pleasures are treasured...and remembered. Here are some concrete things you can do that will make you a pleasure to work with. If every wedding you shoot generates three recommendations, you will soon be a very busy photographer!

1. Have Compassion and Develop a Positive Attitude

Practicing the Golden Rule is one thing that can make you a great people person. There is a reason that "Do onto others as you would have them do unto you" is a cornerstone of the Judeo-Christian philosophy! If you can apply it to your business, you'll be on the right track. It helps to put yourself in your subject's shoes.

I can't understand why some photographers feel it is necessary to point out physical "flaws" in their subjects (after

Faced with inclement weather, most couples rise to the occasion if given a chance. Here the combination of a petite bride, strong groom, and helpful best man made the best of a rainy day, and the resulting picture captured a light-hearted, fun-filled moment. A photographer's reaction to any situation is contagious, and if you keep your spirits high, the bridal couple and the rest of the bridal party will generally follow along. Photo © In-Sync Ltd.

all, they are the customers!). How a photographer can look a fragile bride in the eye and say, "What are we going to do with that pimple on your nose?" is totally beyond me. Likewise, I don't see any point in telling a bride how tired I am, that I have a headache, that she's late, or that her dress is soiled. I think that those photographers who get some perverse pleasure in saying these types of things are really just overly concerned about their own insecurities and want to drag

other people into their pit of misery. It would be better for those photographers (and their businesses) if they could climb out of their pit and join the others on the hilltop. In this business, a negative attitude is totally counterproductive. Without being saccharine sweet, you can make it part of your style to always see the bright side and be positive. Of course, underlying this is the assumption that you like people. And if you don't like people, you should question your career choice!

Positive energy is contagious. For example, I once shot a wedding the day of a huge snowstorm. One hundred-fifty (of the 200) guests, along with the band and photographer (me), marched through hell to get there. I made sure to get a few pictures of the couple in the snow, pointing out that the snow made their wedding unique and, in twenty years it would be a great memory. I also pointed out that the 150 guests who made it had to love them dearly to come, and that they were lucky to be surrounded by such supportive friends and family. It was a great party and the band played "Let It Snow! Let It Snow! Let It Snow!" more than once that afternoon.

Every situation has both negative and positive components. At almost every wedding something will happen that can be looked at in two ways...be it a summer squall or an inebriated guest! Don't ever let a minor quirk of nature or human behavior get you or your subject down. Instead of saying, "Oh *#@%*!, this ruins everything," instead say, "Boy, this will be very funny....next week. But right now let's make beautiful pictures!" You are acknowledging that whatever happened is a drag, but you are also pointing out that the joy of the day overshadows the snafu.

You can even generate enough positive energy to navigate around a tragedy and finish the job. At one wedding I was shooting, the bride's grandfather dropped dead...face down...right into his soup! I know many photographers who would have stopped shooting, and that would have been the end of the wedding. Instead, soon after the paramedics left with the gurney I walked right up to the bride, looked her in the eye and said, "Your grandfather wouldn't want to ruin your wedding day. Go into the bridal room, fix your makeup, and let's keep going." Mind you, I didn't say, "Let's Parteee," but rather my comment pointed out that, 1) Life goes on; and 2) Her grandfather loved her. The bride stared at me for a second and then got up to go fix her makeup! Believe me, I felt like I was walking on thin ice, but I had good rapport with the bride, and I didn't want to

let anything totally ruin the day. Sometimes we have to walk a fine line, but if you have sincere compassion for your subjects (I mean, you really care about them), you can get over almost any bump in the road.

Make it your goal to accentuate the positive and eliminate the negative for success, not only in wedding photography, but in everything you do! While this might sound inane, it does work, and you can apply it to almost all aspects of life. Winners (in both life and wedding photography) see the roses, not the thorns. This doesn't mean you are oblivious to the thorns, but you are more interested in the roses.

2. Gain Control

During my early days as a wedding shooter, the first wedding photographer I assisted told me repeatedly that great wedding photography was a matter of control. I would say, "Yeah, yeah. I understand..." but I really didn't. Later, when I moved into commercial photography (though I continued to shoot weddings), I learned that most advertising pictures were rigidly controlled. A photographer in the studio, sweating over a still life, must examine everything in the frame. Even if something in the frame is not central to the composition, the photographer must examine it and make a conscious decision as to whether it does or doesn't matter.

This extreme type of control is not always possible at a wedding. Most novices, when first trying to exercise subject control, are very heavy-handed. They raise their hand and demand that the world stops for them. If you can get past that rigidity, you realize that while you might think you want total control, what you're really after is a controlled situation in which the subjects are free to express themselves.

Let me draw an analogy. Imagine a bird, softly enclosed in a hand. At the right moment, the hand relaxes its grip, and the bird is free to fly. But the softly enclosed hand was comfortable enough that, after the bird does its soaring, it returns to the hand once again...by

choice. In the same way, you want to gain control of your subjects in a way that is comfortable to them. You want to release your control, allowing their natural expressions to be recorded on film, and then regain control of the situation once again. While all this sounds very Zen-like (and it is), it does make for successful pictures and happy subjects.

3. Find Out Who the Important Players Are

Before every wedding I make it a point to find out from the bride and groom or their parents who the important players are. I like to know how many siblings the bride and groom have. I also ask about grandparents, godparents, and important aunts, uncles, and cousins. In fact, I want to know about anyone who is important to the couple or their parents—a best friend, a boss, or even people from the office.

Once I have the information, I make it a point to act upon it. If "mom" mentions that she has a favorite brother, I'll go up to her sometime during the party and say, "Is now a good time to get a picture of you with your brother?" Mom beams; after all, I listened *and* remembered(!), and chances are good that when her next child gets married she'll remember me!

4. Remember Names

One thing you can do to make your customers feel at ease is to remember their names! If you say to the bride, "Bride, take a step to your left," she is not going to feel special! I make it a point of remembering peoples names...in my eyes it is a sign of respect. If the parents (whom I always initially call mom or dad or Mrs. Smith or Mr. Smith) tells me to call them by their first names, I always say thank you because they have let me move "inside" to a more intimate relationship. In fact, whenever I do a portrait of someone (or a couple) the first thing I say is, "What is your name?" From that moment on any direction I give is always personalized: "Mary, snuggle into John." I even try to remember names of siblings and the bridal party members.

Almost anything a little kid does is cute, but sometimes getting them to smile on command can be difficult. Many times when kids are making faces, I offer to trade them one funny face for one smile, and sometimes the funny face is the better picture!
Photo © Jerry Meyer Studio

5. Isolate and Attend to the Trouble Spots

Sometimes there is one member of the bridal party who is a troublemaker (and it is almost always a guy). This person is never interested in being photographed or doing what the bride and groom wants. Usually his goal is to get to the reception as quickly as possible. If left unchallenged, he tries to become a ring-leader intent on reducing the day to a drunken, bleary-eyed non-memory. Controlling him (or her) is difficult, but it is easier if you know his name. I make it a point to direct some of my comments to him while I'm shooting pictures that he's in. Very often I'll say, "Let's do a picture of all the ushers. I promise to make it quick, John!" Although I want to isolate him from the crowd, I don't want to antagonize him, so everything I say is done with a smile, and I never attack him personally. As a last resort, if Louie is a problem child whom I just can't control, no matter how hard I try, I do the pictures that include him first and then let him go drink his beer in the limo while I finish the portraits.

Often before starting the formal pictures I'll call a bridal party huddle so that everyone knows my plan. I actually say, "Let's have a quick meeting." Once I have everyone's attention, I lay out a game plan. I say things like, "The sun is going down so we have to work quickly," or "I want to get these pictures done quickly

so we can get to the reception," or "I want to do these pictures now so that when we get to the reception I won't have to bother you." Notice that I mention that I will work quickly, we will all get to the reception soon, and I won't bother them after this. My game plan always includes the reason why I'm subjecting them to this and the resultant reward (in this case, a no-hassles reception). Usually most bridal parties understand that by helping to meet my goal they will meet theirs, and they get their acts together pretty quickly.

6. Avoid Saying "No"

It would be ideal if the word "no" was eliminated from wedding photographers' vocabularies on the day of the wedding. On that day, "no" is the last word any bride wants to hear. Given budgetary constraints and supplier limitations, she's probably heard "no" enough during the planning stages: "No, we can't make a German nut cake for your wedding cake," or "No, we can't serve the lobster tail entree and stay within your budget," or "No, we can't get yellow roses in February." No is a powerful word, and it

puts an end to almost any further communication from the moment it is uttered.

Even if the couple (or a parent) asks you to do something impossible at an inopportune moment, you still shouldn't use that word! You might say, "That's a great idea, I'll fit it in later," or "Absolutely, I'll remember to get that," or just say anything else that will keep the lines of communication open. Even though your clients have hired you for your expertise, they are still the ones paying the bill, and almost any request of theirs deserves to be honored. Besides, if a bridal couple makes a specific request, it is almost always destined to become a sale (they *want* it!), and selling is the real bottom line in the wedding photography biz. Even if you think an idea is ridiculous, the cost of time and film to try it once is well worth the goodwill it creates.

SELLING

Selling is another place where your interpersonal skills are put to the test. Selling the job is really a two-pronged effort. First you have to sell your potential customer on your work and making an initial order, and then when the proofs are returned you have to sell your customer on purchasing extra pictures. Since the second sale will never happen if you're not successful at the first, let's start with getting the job. (This doesn't mean that the second sell is unimportant, because without it the wedding business, seasonal as it is, is not very profitable.)

Selling the Job

Success at the selling game is not easy, but there are some rules that can help you. If you have a natural "gift for gab" (which is almost a requirement for being a success-

ful wedding photographer) the battle is almost won, but here are some other ideas to improve your percentages. Obviously, you should be dressed neatly and have clean, well-organized samples to show, but also consider the following.

1. Sit at the Kitchen Table

When you visit a prospective customer, try to describe your services and display your work at the kitchen table. Although this may seem like an odd suggestion, I have found that most important family decisions are made at the kitchen table. While the living room is reserved for more formal meetings, people let their hair down in the kitchen, and it is easier for the customer to treat you as a friend (instead of an adversary) there. The table allows you to sit opposite the customer and look them straight in the eye as you make your pitch. However, you must be careful, because with you sitting on one side of the table and the customer's family on the opposite side, the table becomes a barrier between you. I circumvent this by always bringing two sample books with me, and while one side of the table looks at one book, I invite a family member to my side so we can view the second book together. My invitation is usually made to the mother because I try not to break up the bride and groom and, quite frankly, I've found that most fathers are more interested in the bottom line (how much?) than the quality of my work. Besides, if mom likes your work (and you), she can often cajole dad into springing for the bucks.

2. Listen Carefully

Many times, in the course of a sales meeting, the customer will tell you what they are looking for. They say things like, "I don't want a pushy photographer," or "Family pictures mean everything to me," or "I don't want to miss the cocktail hour." Remember those words, and sometime later in your pitch throw them back at the customer. As you describe what will happen at what time on the wedding day, you might say, "I would like the immediate family to come to the park with us for the family pictures so I don't have to act like a pushy photographer at the reception," or "Tell me who is in the immediate family so I'm sure not to miss anyone," or "Let's plan on doing the family pictures after the main course so we won't have to spend valuable time doing them during the cocktail hour." Although this might seem insincere, in reality it is not. It simply acknowledges that you were listening to them and are willing to meet their needs. All wedding coverage should be tailored to the customer, and you're just saying, "If you want it, it's yours!"

3. Take Notes

When my potential customers outline what they want I make a mini-big deal about writing it down. I want them to see me doing it, and I question them about what I've written down so they can make sure I've got it right. I tell them that I'm going to attach the information sheet to their contract so I'll be sure I won't forget. This has a few added benefits. My information sheet assures the customers that I'm catering to their individuality and that I care about their desires. A second benefit is that by saying I'll keep it with their contract (notice it's their, not my contract), I've broached the subject that there will be a contract. Once they start giving me specific information, we are both beginning to work on the assumption that I am their photographer, and this assumption will make closing the deal easier.

4. Don't Belabor the Technical Side of Your Photography

When showing your samples, don't dwell on how you got the shots. Other than another photographer (or an avid amateur), no one is really interested in what f/stop you took a picture at. Forget about most of the techno jargon that you could throw at your customer because most of it goes over their heads and, besides, it gets very boring very quickly! Instead, ask about the day, the gown, the flowers, the church, the park, the reception (anything they can relate to) and only mention technical considerations in passing.

If you've done one of their friend's wedding (and that's how you might have gotten the lead anyway), talk about that instead. Find out what they liked and didn't like about it, and be sure to write it down (in front of your prospective customer) on the information sheet you've been working up. Let your pictures, not your mouth, prove your professionalism.

5. Ask for the Order

It is amazing to me how many photographers never tell their prospective customer that they want the job! You have to ask them to give you the assignment. People hardly ever say, "I'm sold!" So, at some time near the end of your pitch you have to say, "Look, you seem happy with me and my work. I did Sally's wedding. Can we wrap this up now? I would *love* to be your photographer!" Now comes the tricky part. They'll probably say that they have to check with other photographers, or maybe even say "no." Do not get discouraged. Many great salespeople will tell you that the real sell doesn't start until your prospective customer says "no."

6. Offer Incentives

Sometimes after the customer says "no" you can snatch victory from the jaws of defeat by offering an incentive. Look your customer right in the eye and say, "I really want to shoot your wedding. If you're happy with my work, what would it take to close the deal right now?" Sometimes, lo and behold, the customer will say, "Well, XYZ Studios offered us two extra

8 x 10 portraits and 100 photo thank-you cards in their package, and because we're on a tight budget, that may become important to our decision." If you know what it takes to get the job then you can decide if the incentive is worth offering. If this prospective customer is talking about three albums and a video (which have a high profit margin), two 8 x 10s and 100 thank-yous are a cheap price to pay for their signed contract. If they're considering a minimal package (without much profit), you might say you're willing to split the difference and offer the 8 x 10s but not the thank-yous. That might work anyway because some customers aren't always truthful about just how much they are offered by your competition.

Whatever happens, be aware that the last photographer a prospective customer sees is usually the one he or she signs up with so you want to do everything in your power to close the deal when you are there. There are other incentives worth offering, such as giving them all the proofs in a slip album or the first hour of overtime at no charge. Just be aware that if you give away too much, your generosity may come back to haunt you. Other recommendations that come from this job might ask for the same deal that you gave them, and you must remember that doing wedding photography is a business not a charity.

7. Get a Deposit

No matter what you think, until you have a deposit in hand to reserve the date you haven't completed the sale. You can be absolutely sure the customer is yours, but without a deposit, it just ain't so. Some customers will tell you that their word is their bond, and no deposit is necessary once you have their handshake on the deal. Forget it!! Even a first-year law student will tell you that without an exchange of something of value, your contract, even though it is signed by the customer, is nothing but a piece of paper. If the customer decides to renege on their commitment to you (and hire another photographer—one who probably got a deposit!), it won't be worth the time, the energy, or the expense of taking them to

court to force them to pay for the job they agreed to. Besides, you'll lose anyway. The judge will look at you sympathetically (because he'll know you are a naive businessperson), point out that you never produced a single wedding picture for these people, and throw it out of court.

In accepting a job, you are giving the customer a guarantee that you won't accept another job on the day of their wedding. The customer is giving you a guarantee (in the form of the signed contract...AND A DEPOSIT) that they have chosen you to be their photographer. Many photographers just starting out are afraid to ask for money. They must get over it. Some think money is crass and evil, and they trust the word of their fellow man. I also trust the word of my fellow man, but business is business. Get a deposit! No exceptions! Well, maybe, if the client is your mom....but...come to think of it...even then...GET A DEPOSIT!

Who Is Buying the Pictures?

Generally, at any wedding there are two possibilities as to who will be paying your bill. Either one of the sets of parents could be laying out the money, or the newlywed couple might be buying their photographs. While it doesn't really matter who is paying the tab, there is a difference about how each of the prospective customers sees the result. Let's look at each one separately. Parents first.

For a moment let's look at the bride through her parents' eyes. Put yourself in the father or mother's place. Here is your child getting married. She is dressed and quaffed to the nines, *and* you love her. Parents don't really see the bride (or groom) in the harsh light of reality. Instead, hopefully they see first steps, school graduations, happy family dinners and holidays, sports team victories, and a raft of other fond memories. They also see the beginning of the end of responsibilities, a feeling of freedom on the horizon, and a continuation of their bloodline. These are easy people to please! In fact, other than your bill, you are giving these people nothing less than fond memories. Now, step back into your shoes as the photographer. If you present pictures

that are sharp and centered, chances are good that the parents are going to love them, after all they already love the subject. These people are an easy sell.

Now for the couple. Brides (because, for the most part, the groom just goes along for the ride) can be a much more difficult sell. Often it is the first chance for a bride to show that she is a smart shopper. This may cause her to go overboard in looking for the photographer who can give her the most value. Another point to consider is that her pockets may not be as deep as her parents', and any suggestions you can make to ease the financial burden will be appreciated. You might suggest that she ask her parents to pay for their own albums or offer to start her out with a minimum package so that she sees you're interested in saving her money.

If she is young and inexperienced and if you come across as someone she can trust, she may be willing to follow your lead. Mentioning that you are creating an heirloom that will have great value in future years sometimes helps, but often it isn't enough. What does work, in my experience, is the idea that you are producing a very personal thing for her and that you are working as a team. As I pointed out earlier, your information sheet can be the deal-maker. The bride has to feel that you are extremely interested in her unique needs and that you will work tirelessly towards that goal.

Finally, never overlook the fact that you've done weddings for her friends (if you have). Peer pressure can be used to your advantage. Overall, I feel that brides are more difficult to sell to than the parents, but it is still possible!

The Second Sell

Unlike the first sell, the proof return has a different set of sales goals. While at the first sell you might offer incentives to get the job, when the proofs are returned your object is to maximize your profit. An analogy might be a builder who throws in the kitchen sink to get a signed contract and then charges the customer for the faucet and hardware required for the sink to work.

Building up an order is as much an art as getting the assignment in the first place. Realize that your customers have already paid for the caterer, flowers, band, clothing, limousines, and invitations, so sometimes the cupboard might seem bare. On the other hand, you should have pictures of everything they spent their money on, and most people like to see where their dollars went.

The proof return is the time for you to enjoy the fruits of your labors. I usually let the customer show me their choices of what to include in the album before I make any suggestions. Once they've shown me their choices, I arrange them in a loose, chronological order and then I start to look for holes. It's amazing, but very often couples leave out entire sections of their wedding day. These are some of the easiest sales to make. For instance, the bride might select a picture of her dad walking her down the aisle and then her next choice is a picture of the newlyweds getting into the limousine. All we have to do is look at the two images and usually we both just laugh out loud. Sliding in a photo or two of the ceremony is an easy sell!

On my next go-through I pick out all the single images for which I shot a matching second image. Sometimes the bride forgets to include a picture of the groom's parents alongside the picture of her parents. "Ker-ching!"...the cash register rings! Look back through the repertoire for other similar sets, such as the bride dancing with her father mated with the groom dancing with his mom, or the selective focus shots of the bride and her parents mated with the same shot of the groom with his parents, and the order can be built up nicely. Finally, check to see if she has included a photo of one sibling and not another. It is an easy step to have most couples include photos of the other siblings once they've included one. Review my repertoire and note every place I claimed something was a sure-seller. If the bridal couple hasn't included most of them, they should be targeted by you as suggested inclusions in the album.

Local wedding suppliers can always use good photographs of their work. Every so often a florist gets an assignment where he or she can go all out. When you're presented with a stunning display such as this, remember to take a few images for both the bridal couple and the florist. The florist will appreciate your thoughtfulness and have a sample of your work, which could result in referrals later on. Photo © H & H Photographers

After you've done this, take a last spin through the unselected proofs and pull out any images that you feel look great and ask the couple if they might be interested in those. You might point out that while the food was eaten, the band went home, and the flowers wilted, your pictures are the only permanent memory of the great day, and your product is the only one they are purchasing that will become more valuable as the years pass.

While you are at it, remember to suggest a picture of the bridal party for each bridal party member. If the proof return happens at an opportune time of the year, the idea of pictures as Christmas gifts for family members is another idea worth mentioning. Some photographers also offer framing services for the gift prints, and that is another way to maximize profits.

As in the entire wedding game, presentation is important. Because big prints are very profitable, some studios work with an overhead projector and project huge images into blank frames so the customer can get an idea of how the photograph will look on the wall at home. Obviously, if you go this route, framing can be a very lucrative option to offer.

Secure a Deposit

The last part of the proof return requires you to total up the remaining bill and get at least half of it as a deposit. You should not start to produce the wedding albums without this final deposit. Some couples will rush to give you the print order and then disappear for a year as the finished albums languish on your shelf. The whole idea of getting deposits as the job progresses is this: All production costs should be paid for with the customer's money. You are their photographer, not their banker.

Find a Partner for Sales

Selling is so important that it can make or break a wedding studio's success, and oddly enough, many excellent photographers with loads of blue ribbons on their pictures are terrible salespeople! Whether it's because their egos are easily bruised when the customer doesn't fall in love with their work or they are just more comfortable with the technical side of things, the reason is really not important. What is important is that they realize that selling is not their (or perhaps your) strong point. Some of the most successful studios in my area are comprised of an excellent salesperson and a photographer.

If you find that selling is not your cup of tea, you can still be a studio owner. To pull it off requires that you find an excellent salesperson to work with you. Photographers who are excellent businesspeople but not great salespeople realize this and actively look for someone to handle the selling side of the business for them. If you meet someone with a golden tongue, consider forming a working relationship with him or her. Many novice photographers first build a wedding studio business to 100 weddings per year (about $200,000 to $300,000 gross) and find a salesperson at that point. That then allows the business to grow to more than 300 weddings a year (about $1,000,000). It is wise to remember how these photographers expanded their businesses, and you might be able to apply this to your situation.

Finding Work and Generating Leads

Without an ongoing source of new business, your budding wedding photography business will wither and die. On the flip side, a growing wedding photography business is usually operated by a photographer who is always on the lookout for new customers.

Build a Portfolio

Getting your very first assignment will be the most difficult because you have limited samples to show, and without samples it is hard to show a stranger the quality of your work. Therefore, for most young photographers, the first few assignments will probably come from family and friends. On these assignments it is imperative that you do your best because these photos will become the basis of the sample pictures that you need to establish and expand your business.

Remember also that every bridal party is brimming with potential customers. When I suggested in the repertoire that you include pictures of unmarried couples in the bridal party, I had an ulterior motive. These people can become future assignments. If you do a good, conscientious job, each wedding can produce more leads for future business. Growth by word of mouth is a very slow process. While these assignments and the leads they generate can slowly build your reputation and your client base, there are some other things you can do to help accelerate the growth of your business. Here are some other ideas for generating new work.

Become Active in the Community

In all likelihood your local clergy are the first people in the community to know about upcoming weddings. Although you can't turn them into your sales force (they already have a job, anyway!) you can meet with them and introduce yourself. You might be willing to offer your photographic services (gratis...of course) for a local church function. You might participate in community bazaars or even donate your services (providing a family portrait, for example) as a prize in a raffle.

Make Friends with Caterers

Caterers are the big fish in the wedding business pond. All the other suppliers, including photographers, are the pilot fish that swim around these behemoths. They are always in need of photographs that show off their talents. Not only do they need pictures of their food presentations, but they also need pictures of their facilities to show prospective clients. Although they can invite potential customers to view their facilities in person, showing them pictures of rooms set up for a party with smorgasbord and dessert tables creaking under the weight of gastronomic delights can be a more powerful sales tool. Some upscale caterers create such beautiful individual dishes (or ice and fruit carvings), that even these are worth a picture. So while at a reception, shoot some pictures; then make some prints, dress neatly, and pay them a visit. And remember to bring some business cards with you!

Although it is beyond the means of most beginners, a photography concession is offered by some caterers at their banquet facilities. Other times, a caterer is willing to accept a fee for recommending a particular photographer, florist, or limo service. However, this is a tricky negotiation and really not a place for a beginner to experiment. But it pays to remember that there are many ways to form symbiotic relationships within the industry that can help insure success for all concerned.

Make Friends with Other Wedding Suppliers

Florists, dressmakers, bands, makeup artists, hair stylists, and classic car limousine companies all need pictures to advertise and develop their own businesses. And, coincidentally, pictures are what you do! Therefore, providing these people with free samples of your work, which shows off their work, is always a good idea. I make it a point to burn a few extra frames of film on floral displays and custom-made gowns to give to these people. It is amazing to me, but very often these businesses don't have sample pictures of some of their best work. If you make a

I make a point of shooting a picture of makeup artists and hair stylists if they come onto the "set" for a quick touch-up. Make sure to give them a copy of the touch-up picture and an image that shows off their finished work. Make an effort to build good relationships with caterers, makeup artists, hair stylists, and florists. By helping them with your images, they'll be more likely to help you with referrals. It's a symbiotic relationship.

point of seeking them out and giving them an 8 x 10 that shows off their artistry, you've made a friend—a friend that can recommend other customers to you. Without being heavy-handed, explain that you are also looking for wedding customers and that you would be appreciative if they sent some leads your way. Offer to shoot pictures for them from time to time, and ask if they could pass around your business cards when appropriate. Realize that in most areas wedding suppliers work together and refer customers to one another regularly. Offer to set up reciprocal relationships with these people and understand that

you are both in the business for the long haul. Treat them like you would like to be treated.

As I said earlier, success in the wedding photography business requires relating and selling skills that are at least equal to your photographic skills. Some think (and I tend to agree) that relating and selling skills are more important than photographic technique. Most photographers like to take pictures and shy away from the relating and selling side of the business. This is too bad, because it's the relating and selling that can guarantee your success!

PRICING AND PACKAGES

As a salesman I was green. I promised my customers everything. The bride's father looked at my lacquer-sprayed prints in their leather binding and asked if the pictures were as well protected as his wedding pictures, which were in plastic-covered pages in a plastic binding. I said, "My photographs are absolutely waterproof!" The father looked at me, picked up my sample book, placed it in the sink, and turned on the faucet! Only in New York. From that day on I always told perspective customers that my pictures wouldn't be bothered by a few drops of water because of their lacquer spray...but they weren't meant for viewing underwater!

The goal of any business is to make a profit. I define profit as the difference between the price charged for a product and all the expenses involved in producing it. Wedding photography is not just an enjoyable pastime but a business endeavor that must generate a profit. With that profit you can eat, pay rent, buy a car (or a house), or pay for a child's college education. Some newbies at the game think their expenses are limited to the cost of film and processing, making prints, and having albums bound. These photographers are doomed to failure...or at least to a life of eating gruel. Since gruel is not too tasty, it pays to spend a lot of time defining what your expenses are to maximize your profit.

TIME IS MONEY

Before I get into the concrete costs of producing wedding photographs it is important to realize that one of the items you are selling is your time, and because time is finite, it is very expensive. How much should you charge for your time? How much do you want to make? Everyone always answers, "A LOT of money!" Obviously. But for a more concrete answer you first must figure out some other things. How many hours can you work at wedding photography in a week? How many in a year? Before you answer, consider these facts:

1. Booking, shooting, and producing a set of wedding photographs takes longer than the six hours you spend shooting on the wedding day.

2. About the same amount of "non-shooting" work time (selling and production) is required whether you spend two hours or six hours shooting an assignment.

3. You can't shoot wedding photographs 40 hours per week, 50 weeks a year.

Let's look at each statement individually.

1. How much time does it take to complete an average assignment?

Here are the tasks involved in delivering (i.e., selling, shooting, and producing) a set of wedding photographs to a customer and approximately how much time each task takes:

Book the job (selling)	3 hours
Preparation on the shoot day	1 hour
Travel to the shoot	1 hour
Set-up time	0.5 hour
Shooting time	6 hours
Breakdown time	0.5 hour
Travel from the shoot	1 hour
Deliver film to lab and pick up	1 hour
Sort proofs (cull rejects)	1 hour
Review proofs with customer (selling)	3 hours
Pull negatives	1 hour
Deliver negs to lab and pick up	1 hour
Check prints	1 hour
Deliver prints to bindery and pick up	1 hour
Deliver albums and prints to customer	2 hours
Estimated Total Time	**24 hours**

Bread and Butter

Many wedding photographs aren't necessarily creative, but do provide an accurate record of the event. In candidman parlance, these are often called "bread-and-butter" pictures, and without them, all the creative effort in the world won't fill out a fat (and profitable) wedding album. Whether you decide to shoot weddings for yourself or as a candidman, it pays to understand what the customers might buy. If you shoot 96 drop-dead gorgeous, bust-length portraits of the bride, the maximum number that you are going to sell is two! OK, OK, maybe four. If, on the other hand, you shoot 96 frames, but only 24 are drop-dead gorgeous, bust-length portraits of the bride and the other 72 are of the couple with friends and family, you could sell many more. You would still have shot 96 frames, but the second strategy can yield a whole lot more profit, both in primary (the bridal album) and secondary sales (other albums or extra prints). In either scenario, you'll still sell the two (or four) drop-dead gorgeous portraits of the bride, so you decide.

Wedding photography tends to be seasonal weekend work. Jobs may be scarce in January but plentiful in June. Photo © Franklin Square Photographers, Ltd.

As you can see from this estimate, the time needed to produce the entire assignment is quadruple the time it takes to shoot the pictures. I have heard some photographers claim that they can book an assignment in 15 minutes (sometimes that's true) or that they mail their film to their lab and that only takes 15 minutes (sometimes that's true also), but I have found the time numbers I cite here to be fairly accurate for most assignments. Every photographer has their own system and their own special set of circumstances, so make up your own time sheet and see what you come up with. You might also consider the time it takes to buy, test, repair, and organize equipment; clean tuxedos (not to mention buying tuxedos); test films; choose samples of your work; make those samples; and do your paperwork.

2. Some photographers offer minimal wedding coverage (at minimal prices) to try and break into the market in their area.

This creates two problems. No matter how short the actual shooting time, the selling and production work remains about the same. Because of this, and the fact that the short assignment is usually low priced, you end up using a disproportionate amount of time on short assignments, which lowers your profit. This type of assignment has other pitfalls as well. By offering the short, low-priced assignment to your customers,

you run the risk of committing to a small (low-profit) job on a day when you might get a big (lucrative) assignment. Furthermore, if you offer the low-priced option, you leave the bigger assignments for your competitors...and in wedding photography, bigger is better, or at least more profitable.

3. Wedding photography is seasonal— It's feast or famine.

Wedding photography assignments are numerous in the spring and early fall and sparse through the dead of winter and the dog days of July and August. It seems that nobody living in the snowbelt wants to risk having their wedding canceled on account of a blizzard. Others, living in warmer climates may choose not to wed during the steamy heat of summer. You will find that you need 48 hours in a day just to stay even during "the wedding season" and you are bored to tears in the dead of winter or the peak of summer.

A top candidman who shoots for a number of different studios in a large population center can find enough work to stay busy year round. But even candidmen in this enviable position are less busy in midwinter and midsummer than in the spring and early fall. For a studio owner with a big staff to support, keeping everyone working during the off-season is difficult. To make matters worse, you'll find that while you can get six jobs on Valentine's Day or a Saturday in June, you can shoot only one or maybe two of them (and even then, only if the timing is right).

Shooting weddings, for the most part, is weekend work, and even considering all the preparation and post-production work that's entailed, it is hard to milk a 40-hour week out of two days and one evening year round.

CONCRETE COSTS

Many who are just starting out think that their only expenses are the cost of film, processing, proofs, prints, folders, and albums. These people are taking a very simplistic view of the expenses involved. Without belaboring the point, here is a list of *only* some of the other expenses that comprise your costs:

1. The cost of camera and flash equipment (including spares); equipment also needs to be updated from time to time, so this is a never-ending expense.

2. The repair of that equipment when it breaks (and it will)

3. All-peril insurance in case your equipment is stolen or damaged

4. Liability insurance—*a must-have for both the studio and candidman*

5. A reliable car

6. Car repairs

7. Car insurance

8. A tuxedo (busy shooters need multiples)

9. Tuxedo cleaning

10. Phone service

11. Fax and answering machines

12. Studio rental

13. Stationery and office supplies

14. An accountant

15. Legal advice

16. Studio staff (even if it's only part-time help)

17. Medical insurance

18. A retirement plan

19. A SALARY FOR YOURSELF

If you decide that any of these (except maybe staffing, which might not apply now) are irrelevant, you are setting yourself up for failure. Furthermore, your specific needs may add other expenses to the list—some hard work with a pencil, paper, and calculator is required. If you think that you can't be bothered with all this accounting-type work, and you live in a major population center, investigate the idea of being a candidman as opposed to a studio owner. But even being a success as a candidman requires that you know the costs involved, and many of the costs listed apply to both studio owner and candidman.

"But How Much Should I Charge?"

Figuring out how much to charge and how to collect your money are the most difficult and most important parts of the wedding photography game. Putting aside the collection aspect for a moment, let's start by looking at the smallest unit of your product—the print. Some photographers discover that an 8 x 10 machine print can be purchased for anywhere between $2 and $5. They, rightly so, double the price of the print and sell their prints for between $4 and $10. But I feel there are other costs that must be reflected in your print prices.

You should include the cost of the film, the processing, and the proofing in your print prices, but even this adds up to more than meets the eye. For example, you might shoot six frames of the bride and groom cutting the wedding cake. Check the Repertoire chapter, but for a quick recap, the pictures would include two cake-cutting shots (looking at the cake and looking at the camera) the bride feeding the groom, the groom feeding the bride, a kiss, and possibly their hands, complete with shiny wedding rings, clasped together in front of the cake. When the couple returns the proofs, you find that they've chosen one cake-cutting picture and no amount of your cajoling or salesmanship will make them include other cake pictures in their album. In this instance, the actual cost of the one cake

print that sold is the cost of the print plus the six frames of film and their processing and proofing. Another even more horrid (from a profit standpoint) example is when you shoot 30 portraits of the bride and she narrows her selection down to her two favorite pictures, one full-length and one close-up.

After 30 years of shooting I have found that the ratio between pictures taken and pictures included in an order is between 3 and 5 to 1. While there are instances (such as a family group or the entire bridal party) where one negative will yield a six- (or more) print order, these images are few and far between. Taking all this into account I feel that the cost of five negatives (including raw film, processing, and proofing) must be included in the price of one final print. Using 220 film (24 exposures) and having a numbered proof made of each negative will result in a price of about $1 per picture. This, in itself, should be a sobering thought—every time you push the shutter button it costs you a buck!

Learn to think before you push! Let's say for argument's sake that you have shopped labs wisely, and your final 8 x 10 print costs you $3. If you add the five frames of film (plus processing and proofs) to the mix, at $1 each you will see that your final print really costs approximately $8. Some of you will argue that, because you are already figuring the cost of the film, processing, and proofing into your wedding package expenses, you shouldn't include these costs a second time when figuring out the price for a print.

Although I can understand this, it can complicate things when you are pricing other types of assignments. Imagine, for instance, you are pricing a portrait sitting instead of a wedding. In that case, you must include all the film and processing costs required to produce a print in your pricing structure. An alternative would be that you could make two print price lists (one for weddings and one for portraits), but I find that this is confusing to the customer. It seems to be easier on everyone if there is only one set price for an 8 x 10 (or any other print size). From a profit standpoint, if you can include your costs twice, so much the better for you!

Size Affects Price

While most photographers sell rectangular prints, from a profit standpoint you might look into selling square prints. Most wedding labs will make a 10 x 10-inch print for slightly more than an 8 x 10, but a photographer can sell a 10 x 10 print in an album for 50% more than an 8 x 10. While this may be only $10 to $15 more for a single print, it can really add up with 50 to 75 10 x 10 (as opposed to 8 x 10) prints in an album. If you add in the extra amount you can charge for a 10 x 10 binding (as opposed to an 8 x 10), the additional profit accumulates to a tidy sum. Square prints are also an easy upgrade to sell for parent albums. The resulting 8 x 8 (or 7 x 7) parent album is much more impressive than the traditional 5 x 7 parent album. If you decide to offer square prints and albums, you must take that into account when you compose

Carry Insurance

No matter how careful you are with equipment there is always the possibility of someone (a guest, waiter, musician, or member of the bridal party) getting hurt by something that you're responsible for. With this in mind, it is imperative that you carry liability insurance. You can not afford to be without it. Forgo a vacation, eat gruel, drive a jalopy, *but carry liability insurance*. This is true whether you set up room lights or not. It's like carrying a second camera—there are absolutely no exceptions!

the photograph. Although square prints are lucrative, in general the majority of the prints I sell are the "normal" rectangular sizes.

I deliver 3-1/2 x 5-inch proofs to my customers for one simple reason: I tend to give my proofs away as incentives. Therefore, if they were sized at 4 x 5 inches, I would lose 4 x 5-inch print sales. I consider a 4 x 5 to be a finished print. By making my proofs 3-1/2 x 5, I can sell 4 x 5s as enlargements and therefore charge more for them.

More Per-Print Costs

As a pro, you can't just hand your client a stack of loose prints. Presentation is part of the game. A folder for each 8 x 10 print can cost between $0.50 (for a simple cardboard folder) to $1.45 (for a heavy stock, lightly textured, feather deckled edge, gold-embossed, cardboard Cadillac—my studio's choice). While these folder prices come down with volume purchases, the price might go up (by about $0.10) if you

decide to have your studio name and phone number imprinted on each folder. Spend some time with an album catalog to decide in which type of folder you would like to present your prints.

You also must include any print finishing costs in your calculations. These might include spotting, slight retouching (major retouching should be offered and billed separately), lacquer spraying, and texturing of your final prints. If you budget between $1 and $2 per print for this, you won't be far off. The bottom line for an 8 x 10 (in case you haven't been keeping up) is now over $11, and that total reflects just materials, not labor. Therefore, you must consider how much time it will take you to locate the negative, order the print, drop off and pick up the print, examine the print, have the print finished, insert the print in a folder, and prepare it for delivery. Who does the above steps (whether you or a staff member) doesn't matter. Whether completing any of the steps just means delivering the negative or print to an outside supplier

doesn't matter. It still takes time, and as you know, time is money! Since you can prepare many negatives for the lab (or prints for the bindery or retoucher) at once, these procedures are not extremely labor-intensive, but all the steps together probably add up to handling each print for 5 or 10 minutes (or 1/6 hour—once again I'm overestimating in my favor). Add these labor costs to the $11+ you've already spent for materials.

Don't Forget Car Mileage

I can't even count the number of times a beginning photographer has told me that sending prints to a customer costs only the postage and the envelope. He never mentions (or even considers) that he lives five miles from the post office! It's sad but true, but every time the odometer on your car clicks over to the next mile your car is one step closer to needing a repair, one step closer to having to be replaced, and worth a few pennies less when you try to sell it. Every time the tires make one revolution they are one turn closer to needing replacement. Big companies understand this and calculate a $0.25 expense for every mile traveled by car. Why companies can understand this and photographers can't is beyond me.

Run a quick test for yourself. Pick a busy week (although a six-month trial would be better) and keep track of all the mileage you put on your car while doing photographic legwork. Remember to include trips to the camera store, the lab,

Important Hint

One way to insure success is to overestimate the amount of time involved to produce the job. That way, when something takes three hours instead of one, you already have a fudge factor built into your calculations! In fact it makes good business sense to overestimate all your production costs so you won't find yourself working for a very small profit when something unforeseen pops up.

the post office, the bindery, prospective clients, other wedding suppliers, and shooting assignments. Add up your totals and divide them by four. Your answer will be the number of dollars needed to operate your car for that time period. You'll be surprised at what your car actually costs to operate so that you can run your business. Now remember to include this figure in your expenses.

The Final Tally

With all these costs included I can't see how any studio owner would charge less than $20 to $25 for an 8 x 10 print. However there are hundreds of studios that successfully operate and sell 8 x 10 prints for between $10 and $15. These studios either do a huge volume or operate at such a small profit that driving a cab (as mentioned in this book's introduction) becomes more profitable. How much you charge for an 8 x 10 is purely up to you, but to make an educated decision, you have to be aware of the costs I've outlined.

Starting off with a high additional print price offers another advantage when you are selling your work. If your profit margin is strong enough, you can offer a slight discount if your customer is willing to guarantee a larger order at the time of booking.

Here's the scenario: You explain your prices and packages to the customer, and when the customer asks how much additional 8 x 10s are, you tell them $25 a piece. The customer goes crazy and says he or she wouldn't pay $25 to have tea with the queen! Don't get flustered, but instead say, "I can offer you a 20% discount on the price of extra prints if you will guarantee me an order of 75 prints in the bridal album right now." This sometimes works and (forgive the cliché) a bird in hand is worth two in the bush. Once you agree to a set of terms, write it up in the contract. If you've built a good profit margin into your print price, you have room to negotiate. Some customers don't really care about the price, but they do care about getting some type of discount. With proper planning on your part, you can give those customers what they want and still make the profit you need to exist.

Your time is very expensive. In fact, for a single-photographer studio, it is the most limited commodity you have to sell. If your client wants to have photographs taken at an out of the way location, you need to consider the time it takes to travel to and from the site. You must also consider that although you might come back with one or two outstanding images, the lack of variety could limit the assignment's profitability. Your time could be spent taking more lucrative types of pictures. On the other hand, one nice thing about being your own boss is that occasionally you can throw your profit and loss statement to the wind and take the photos you want to. Photo © Franklin Square Photographers, Ltd.

HAVE A CONTRACT

While some photographers consider a handshake as a way to seal a deal, I feel a written contract is a necessity. Any time you are selling services and products to a customer, it pays to have both parties' responsibilities written down and agreed upon. The contract you design should include much more than just a list of what the customer is going to receive and how much he or she is going to pay. Here are some ideas on other things that should be included in the contract.

1. Your contract should include a payment schedule.

Two thousand (or five thousand) dollars is a lot of money as one big sum. Therefore, your contract should break the total down into amounts that are manageable for the customer. A deposit should be required to reserve the date with you. This might be anywhere from 10 to 25% of the total amount. Your contract should stipulate that if the customer cancels, the reservation deposit is refundable only if you can get another assignment for that day. The second payment from the customer should be required on or before the wedding day, and it (along with the reservation deposit) should equal between 75 and 80% of the total bill. Half of the remaining balance (with any extras included) should be required when the customer returns the proofs, and the final payment, due upon album delivery, should be by cash or certified check. Be very careful about making exceptions to these rules. Once you have delivered the final album you have no leverage left to insure payment, and the last thing you want to do is chase after a customer who bounces a final payment check!

2. Your contract should include the number of hours you will be working and what you charge for extra coverage time (overtime).

Are you shooting pictures for two hours or twelve? Some customers expect you to be with them for the entire wedding day, regardless of when it starts and when it ends. Bands do not work that way. Caterers do not work that way. Why should you?

In my region, "standard coverage" (if there can be such a thing) consists of six hours of photographic time. Additional *half*-hours are billed to the customer at rates from $35 to $75 per person (remember you might have an assistant with you). When deciding upon an overtime rate, whatever you charge (if you charge...and you should) must take into account not only the labor costs involved but the film and processing costs for the materials you'll be using during the overtime period. A reasonable estimate to use in your calculations would be $24 to $36 per hour (about one picture every two minutes at about a $1 per picture).

Consider charging extra for twilight bookings during peak seasons. You could fit in two weddings on a Saturday in June if one is a morning ceremony followed by a luncheon and the second ceremony is at 4:00 PM followed by a dinner. However, a 2:00 ceremony with a 6:00 reception will eat up your entire day. Every caterer (at least in my area) understands that they must maximize their profit given the limitations of their dining room facilities, and therefore they charge a premium if one party ties up their facilities for the entire day. If you are a lone photographer, you too must maximize your profit during the busy seasons. Whether or not you decide to follow these suggestions is up to you, but to make informed choices (and more money) you should consider all these options.

3. Your contract should include the limits of your liability.

What happens if there is a power failure at the lab while your customer's film is in the processor? What happens if the leaf shutter on your lens drops a blade while the bride is walking down the aisle? What happens if the exposed film is stolen from you by a bullfrog with a machine gun? What happens?!

There may be a time, through no fault of your own, that the pictures you take at a wedding don't come out. What do you owe the bridal couple? Your contract should cover this eventuality (in the gentlest words possible), and your liability should be limited to the return of your customer's deposit(s). Professional labs understand this because every lab order form states that if there is a problem, they will give you an equal amount of unexposed film as compensation for your loss. If (or when) this type of catastrophe does occur, you should have a mechanism (your contract) that details what you are going to do about it. If you're dumb enough to get falling-down drunk at a wedding you've contracted to cover, no disclaimer on your contract will save you from a lawsuit (and you deserve it), but if there is a problem that is beyond your control and you've acted in good faith, your contract should protect you.

4. Your contract should spell out who owns the negatives and the copyright to the images you produce.

This may be self-explanatory to you, but it should be covered by your contract. As digital picture workstations become available to the public, it will be increasingly easy for a bride or groom to plop down your photographs on the bed of a scanner and run off copies for the entire family. Although this type of unauthorized use of your intellectual property (the pictures) is hard to police, your contract should state in plain terms that *the images are yours*. One photographer I worked for many years ago pointed out to customers that the piece of paper on which the photograph was printed was worth only pennies. It was what he put on the paper that was of value! What you put on the piece of photographic paper is yours, and you are selling the bride and groom only the rights to look at and enjoy the images, not the right to make and distribute copies.

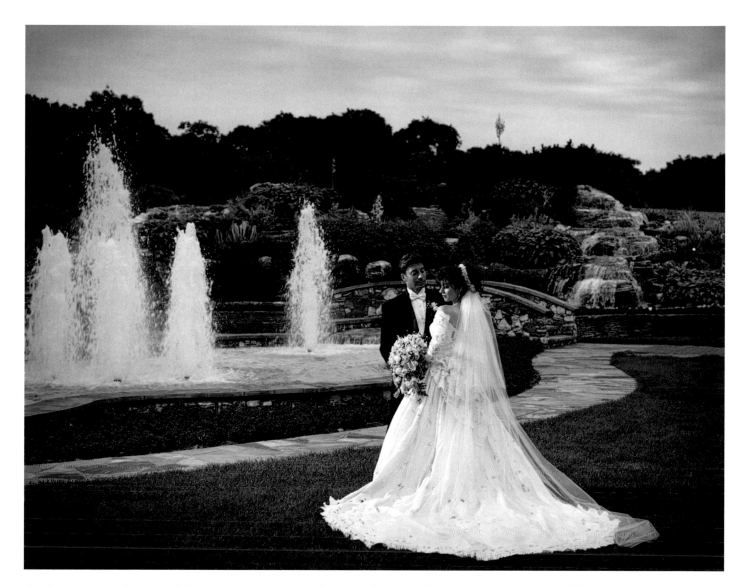

5. Your contract should include the price of additional prints and any extra charges (such as the overtime rate or the price of an additional set of proofs) the customer might face.

Most often, disagreements over wedding photography occur because something wasn't discussed beforehand, and when you bring it up later the customer is distraught because you never mentioned it during your sales pitch. Therefore, everything that might add to the price you charge should be listed in your contract. No surprises...no arguments.

All of the legalese covered by your contract might make selling your wedding photography more difficult. It would be easier to gloss over the fine points as you use words to paint a beautiful picture during your sales pitch. However, covering all these points up-front can eliminate numerous problems later.

Consider getting legal help with this document (your contract). Laws are different from state to state and, because your contract is a legal document that might someday be needed in a court to settle a dispute, it is important to dot your "i's" and cross your "t's." A local lawyer can help you with this better than I. Most importantly, the contract you design should favor *you!* It should be fair to your customer, but your goal in making a contract is to protect yourself.

The paper a photograph is printed on is of little value. It's the image that you put on it that counts. Your contract should state clearly that you own the rights to the images.
Photo © Franklin Square Photographers, Ltd.

Interesting viewpoints aren't captured only from the balcony. Sometimes shooting from a low point of view can be interesting, as this picture proves. Looking for a different perspective can give your images a unique look that sets you apart from your competition.
Photo © Phil Cantor Photography

THE WHOLE PACKAGE

Some wedding studios offer package deals that typically include a bridal album, two parent albums, a large-sized portrait, and a dozen wallet-sized prints. Other studios, usually ones that are catering to an upscale clientele, believe in an à la carte policy, which requires a minimum order (usually the bridal album) to reserve the date, and everything else from parent albums through portraits cost extra. And yet other studios, again with upscale clientele, charge a creative fee for the shoot day and everything else (including the bridal album) is à la carte.

The type of pricing structure you choose will be based on the clientele and the competition in your area. You might want to work with a creative fee and an à la carte menu, but if all the local competition offers packages that include everything for one price, you might find it hard to attract and sign up customers. On the other hand, in a small photo studio operation, selling packages means that on any given "hot" date (i.e., a Saturday afternoon in June or September), you won't be committed to fulfilling a small order (such as a minimal bridal album), because the customer has already agreed to purchase the bridal album, parent albums, portraits, et al.

Many of the non-photographic costs enumerated earlier change as you pass from one geographic area to another. While the photographic costs remain about the same, everything else (including your labor, due to the higher cost of living) is much more expensive in large metropolitan areas. Defining the prices for your area is your job, but I can give you an idea of the photographic expenses involved in producing two single album wedding orders. I have used approximate figures (always rounded up to the highest dollar value), and my figures are based on 6 hours of coverage, working with one assistant, and shooting 6 x 6cm negatives on 220 film. The examples I'm citing, which include labor costs, are based on the New York metro area. First let me describe what the client receives for their money.

A Basic Starter Package

One (1) 50-picture 8 x 10 leather-bound library album
One (1) 11 x 14 portrait
Twelve (12) wallet-sized pictures, maximum of 2 poses (6 of each)

Scenario A: Photographic and Labor Costs

1.	Twelve (12) rolls of 220 film @ $6/roll	$72
2.	Processing and numbered proofs @ $15/roll	$180
3.	Fifty (50) 8 x 10 prints @ $3/print	$150
4.	One (1) 8 x 10 leather binding @ $100	$100
5.	Lacquer spraying of album prints @ $0.73/print	$40
6.	Candidman—six hours @ $75/hour	$450
7.	Assistant—six hours @ $15/hour	$90
8.	One (1) 11 x14 print @ $8/print	$8
9.	Twelve (12) wallet photos @ $0.50/print	$6

Total Cost of Labor and Materials	**$1,096**

When laying out an album, consider using panoramics, oval mounts, and multiple-print pages such as these offered by AlbumX Corporation. Offering your customers unique presentations can often add to your profit. Album photos © G. Gregory Geiger, CR. Photog. C.P.P.

I'm certain that some reader is going to question my figures knowing that they can produce this for less. Some may feel that they can cover a wedding with six rolls of film (instead of 12), and that change alone reduces the expenses involved by $126. Others might offer a 24-print starter package (instead of my 50-print minimum—a difference of $78), or they might not lacquer spray their prints (a savings of $40), or they may provide a less-expensive, plastic, slip-in binding. These photographers might be willing to work for $50 per hour and offer only three hours of coverage. Further they may be able to find an assistant that will help out for only $25.

All of these cost-saving procedures are valid. The customers and the competition in your region may demand these more thrifty choices, but I have found that I don't enjoy the end product of my labors as much when I start to cut corners. If your geographic area demands that you cater to customers on a small budget, so be it, but I find it is much more fulfilling (and profitable) to offer the best quality I can produce, and I look for customers with the same desire. In addition, because the number of days on which you can shoot a wedding are limited (we're back to time again) choosing to shoot the low-budget wedding cuts into the time you have available for high-end assignments.

If you expect customers to hire you based solely on your rock-bottom prices, you must realize that whatever you charge, some other photographer will be willing to do the same thing for less. If you get your price down to one measly buck, some other photographer will offer the same job for 99 cents. The question becomes this: Do you even want the lowest-paying, least-profitable assignments?

Setting aside my distaste for low-budget coverage (in fact, I don't even offer it!), let's total up the minimalist approach just to see what the bottom-line expenses are:

Scenario B: Photographic and Labor Costs—Minimal Coverage

1. Six (6) rolls of 220 film
 @ $6/roll $36

2. Processing and numbered
 proofs @ $15/roll $90

3. Twenty-four (24) 8 x 10 prints
 @ $3/print $72

4. One (1) 8 x 10 plastic slip-in
 binding $50

5. Lacquer spraying—eliminated $0

6. Candidman—three hours
 @ $50/hour $150

7. Assistant—three hours, flat fee $25

8. One (1) 11 x 14 print @ $8/print $8

9. Twelve (12) wallet photos @
 $0.50/print $6

Total Cost of Labor and Materials $437

Working with High-Road Figures

As you can see, there are many ways to cut a corner, but let's return to Scenario A for a moment. Even accepting my desire to produce the best-quality product I can, some reader is going to look at the first set of figures and decide that because he (or she) is making $450 for the shooting time on this hypothetical assignment, he therefore can charge the customer $1,100 and still do just fine. In his mind, he is considering his shooting time to be profit, but it is not. In Scenarios A or B, you should never price either of these jobs at their bottom-line cost. It wouldn't make any sense. Remember, those figures represent *cost without profit*.

Keep Yourself and Your Studio Separate

A mistake many beginning photographers make is not separating themselves from their studio. The two are separate entities, and both must make a profit. You, as a candidman, work for the studio, and deserve a reasonable wage for the work you do. As a candidman you must supply camera and flash equipment (including spares and maintenance), a reliable car, insurance on equipment and car, liability insurance, a clean tuxedo, and your time to shoot a wedding. Therefore, you (wearing the candidman hat) must make a profit. The studio must book and produce the job; carry the expense of staffing and advertising; carry liability insurance; pay rent; have phone, fax, and answering systems; pay phone bills; print stationery; make samples; and so on. But the studio must also make a profit.

Let me give you an example: Imagine that you have booked two weddings for one hot Saturday in June. You hire a second photographer and assistant and pay their wage. If you use Scenario A and charge the client only your cost of $1,100, you make nothing for a lot of work! This is not success, no matter how many weddings you book!

If you are the sole owner of the wedding studio, you must make a profit as a candidman (working for your own studio) and your studio must also make a profit. This will help carry you through the winter or summer months when you have no weddings to shoot. It might be hard for a new photographer facing the pressures of competition and finding business to follow these guidelines, but wedding photography is a business. If you want to photograph for fun (a noble pastime), go shoot scenics or whatever else interests you. But when a bride is in front of your camera, you must be a businessperson, a creative one, for sure, but a businessperson nonetheless.

Let's return, for a minute, to the price you charge for an 8 x 10 print and relate that to the idea of charging $1,100 for the entire assignment. If you decide on an 8 x 10 print price of $20, and you deliver fifty 8 x 10s in an album, the price you are charging for the prints alone (50 x $20 = $1,000) would almost equal what you are charging for the entire assignment ($1,100)! If the customer takes out a calculator and does some simple math, they will realize that you are including all the rest (film, proofs, binding, and labor) for a mere $100! Anyone would agree this is not good business! Your choice is simple: Either lower your print prices or raise your package price. Without a doubt, a higher package price is the way to go! If you look at the cost figures for Scenario A and decide on a package price between $1,600 and $2,500, you are on the right track. This represents cost ($1,100) plus profit ($500 to $1,400).

Offer Incentives

Consider offering several packages with different prices, and offer your customers incentives for selecting the more expensive options. If the customer signs a contract with you for a 50-picture bridal album, you might normally charge an additional $200 to include the entire set of proofs in a slip album (your cost for the proof album might be an additional $20). However, if the customer orders two additional parent albums (24 5 x 7 pictures in a leather-bound album @ $400 each), you might offer to include the proof album for free. It's an incentive. Get the idea?

Some studios form a relationship with local videographers and offer videotaping as well as still photography services. If you can get a reduced rate from the video studio (i.e., reduced to the trade), you can sell a video service and offer your customer free photo thank-you cards if they use your videographer. Just make sure that the video profit is more than the profit on the thank-you cards and you'll be on the road to more success. Other advantages to using your videographer (from a customer's point of view) are one-stop shopping and the confidence that both the still photographer and videographer are working as a team, ensuring that things go more smoothly. Some studios even have arrangements with florists, tuxedo rental shops, invitation printers, and favor providers with further incentives to the bridal couple for using the studio's whole package.

Some of these ideas may seem like pie in the sky to the photographer begging for his or her first wedding assignment. But the idea of this chapter is to get your mind working in a business mode that can lead to the application of some of the ideas I've suggested. I cannot tell you exactly what to charge because the market and the clientele in every region are different. It never hurts to check with the local association of retired business persons in your area for more ideas on what it takes to be successful. Also, taking local college courses on small business administration might be as important as further honing your skills as a creative photographer. Investigate joining a professional photographers' organization such as PPA (Professional Photographers of America) or WPPI (Wedding and Portrait Photographers International). Your preproduction planning should also include finding an accountant and a lawyer to help you start out on the right foot.

Finally, you must realize that you are in control of your own destiny. No one can make you take an assignment that is unprofitable but yourself. Now, go find an assignment, make beautiful pictures, and...make money!

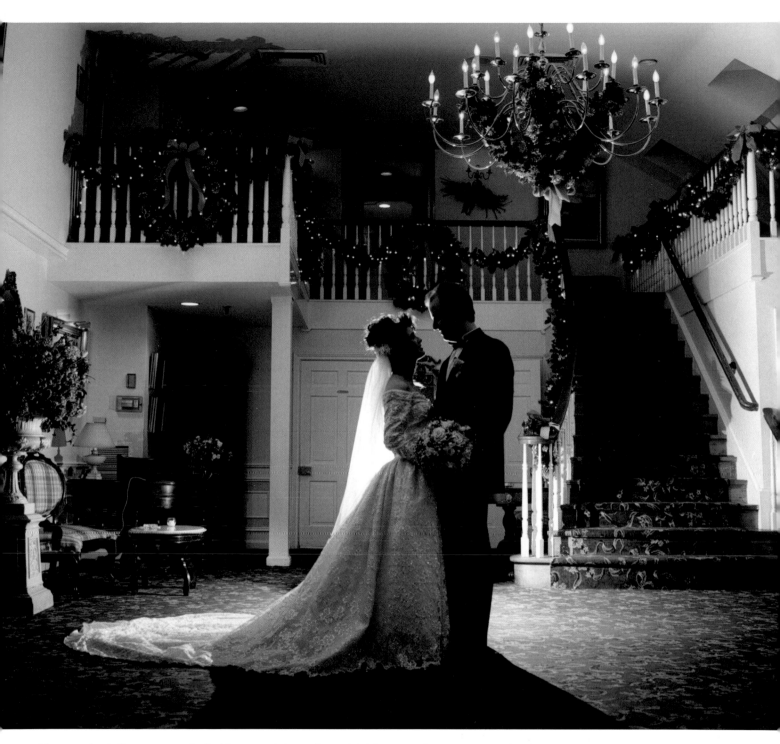

Often catering halls are accessorized with seasonal decorations—dried flowers and pumpkins in the fall, fresh flowers in the spring, and poinsettias and wreaths at Christmastime. These all help set the stage for beautiful images. While bridal couples love these images that help define the season in which they were wed, the catering halls also find such images useful in selling their services. By giving them a few 8 x 10s, they may be swayed to reciprocate with recommendations for you. Photo © Franklin Square Photographers, Ltd.

APPENDIX
A SAMPLE REPERTOIRE

What follows is a list of all the photographs described in the Repertoire chapter beginning on page 19. Feel free to make copies of this list to use on your own assignments. But don't think of this just as a checklist; it can be much more useful.

➤ Make it your own. Use this list as a framework for building your own repertoire. Add creative shot ideas, and expand the list as your photographic style changes.

➤ During a sales presentation, show this list to customers to clarify all the events you will cover and photos you will take on their wedding day. Ask your prospective clients what other types of pictures they might want and add them to the list while you are talking with them to illustrate your personalized service.

➤ Use this list to coordinate the job with your assistant. This will prepare your assistant and put his (or her) "mind in gear." Have him check off the photos as you take them. Also keep track of the photos yourself—doing the job well is ultimately your responsibility.

➤ When working with another photographer, use this list to divide the labor and designate who will take particular shots. A repertoire is like a game plan. Working off a list is almost essential when you're shooting as a team.

➤ If you hire a photographer to shoot for you, the photographs he or she takes should be in your style. Give the photographer this list annotated with your stylistic guidelines, to ensure he or she delivers the product your client was promised.

The Bride's Home

The Dressing Room

1. The Invitation and Possibly the Ring Bearer's Pillow with the Bridal Bouquet

2. Mirror Photos

 a. *Bride Using Comb and Brush*

 b. *Bride with Compact*

 c. *Bride Applying Lipstick*

 d. *Bride's Hands Holding Parents' Wedding Photo, with Her Reflection in the Mirror Behind*

 e. *Bride's Hands Holding Invitation, with Her Reflection in the Mirror Behind*

 f. *Bride's Hand Holding Engagement Ring, with Her Reflection in the Mirror Behind*

 g. *Bride and Mirror Together*

3. Mom Adjusting Bride's Veil

4. Bride and Maid of Honor

The Living Room or Yard

1. Bride and Dad: Formal

2. Bride and Dad: Kissing Him on the Cheek or Hugging Him

3. Bride and Her Parents: Two Frames

 a. *Bride and Her Parents: Selective Focus*

4. Bride's Parents Alone: Two Frames

5. Bride and Mom: Regular and Soft Focus

6. Three Generations: Bride's Side

7. Bride and Sisters (and optional, Bride with Each Sister or Bride with All Siblings)

8. Bride and Brothers (and optional, Bride with Each Brother)

9. Bride and Bridesmaids (and optional, Bride with Each Maid)

 a. *Bride and Flower Girl*

10. Bride Alone: Three to Four Close-up Poses, Two to Three Frames per Pose

 a. *By Window Light: At Least Two*

11. Bride Alone: Three to Four Full-Lengths

12. First Half of a Double Exposure

Leaving the House

1. Bride, Parents, and Bridesmaids in Front of House

2. Dad Helping Bride into Limousine

Arriving at the Church

1. Dad Helping Bride out of Limousine (or variations)

The Ceremony

Groom and Best Man: Two Frames (possibly the second as a gag shot)

The Processional

1. Mothers of Bride and Groom Being Escorted Down the Aisle

2. Each Bridesmaid Walking Down the Aisle

3. Maid of Honor Walking Down the Aisle

4. Flower Girl and Ring Bearer

5. Bride and Dad Walking Down the Aisle: At Least Two Frames

6. Dad's Kiss Good-Bye

Readings or Music

Second Half of a Double Exposure

Long Exposures from Rear

Rings Times Two

Candle Lighting

Special Traditions
1. Mass
2. Couple Kissing at the Sign of Peace
3. Bride and Groom Kissing Parents at the Sign of Peace
4. Drinking Wine and/or Receiving the Host
5. Presenting Flowers to the Church
6. Other Religious Traditions

The Recessional
1. Bride and Groom: At Least Two Frames
2. Bride and Groom: Kissing in the Aisle at Rear of Church

Receiving Line: Three to Twelve Candids

Two Quick Pictures of the Bride and Groom with Each Set of Parents
1. Possible Pictures of the Couple with Their Grandparents

Leaving the Church
1. Bride and Groom: Silhouette in Church Door
2. Bride and Groom with Bridal Party on Church Steps and the Rice Throw

Getting into the Limousine
1. Shooting through the Far Door, Looking in at the Bride and Groom
2. Bride and Groom Looking out Limousine Window

3. From Front Seat Looking into Back of Car
 a. *Bride and Groom Toasting*
 b. *Bride and Groom Facing Camera and Facing Each Other*
 c. *Bride and Groom Kissing*

Formal Portraits

Entire Bridal Party

Gag Shots of the Bridal Party

Groom and Ushers (and optional, Groom with Each Usher)

Bride and Bridesmaids

Bride, Groom, Maid of Honor, and Best Man

Bride and Maid of Honor

Groom and Best Man

Groom Alone: Four to Six Poses— Two to Three Full-Length and Two to Three Portraits

Bride and Groom: Three to Four Different Poses

Variations on the Bride and Groom Portraits
1. Close-up of Rings on Hands
2. A Scenic Image
3. Bride and Groom: Selective Focus

If There Is Time...
1. A Few Additional Full-Lengths and Close-ups of the Bride
2. Any Bridal Party Couples
3. Groom with His Siblings in the Bridal Party
4. Relaxed Group Picture of the Bridal Party around the Limos

Family Photos

Groom and His Dad

Groom and His Mom

Groom and His Parents: With or without Selective Focus

Groom's Parents Alone: Two Frames

Groom and His Siblings

Three Generations: Groom's Side

Bride and Groom with Groom's Parents: Two Frames

Bride and Groom with Groom's Family: With and without Grandparents

Bride and Groom with Groom's Siblings

Bride and Groom with Groom's Grandparents

Bride and Groom with Bride's Family

Bride's Family Miscellany

Grandparents Alone or as Couples

Extended Family

The Reception

The Entrance
1. Siblings

2. Best Man and Maid of Honor

3. Flower Girl and Ring Bearer

4. Bride and Groom: Two Frames

The First Dance
1. Bride and Groom: Two to Three Full-Lengths and Possibly a Close-up

2. Bridal Party Couples (especially married ones)

3. Parents

4. Grandparents

The Toast
1. Best Man Toasting

2. Bride and Groom with Best Man and Toasting Glasses, If Possible

3. Bride and Groom Toasting Each Other

Table Pictures
1. The Two Parents' Tables

Candids: 24 to 48 Photos of Bridal Party and Guests Dancing Fast and Slow, and Groups on the Dance Floor
1. Two-Up Dancing Photos: Faces toward the Camera

2. Three- and Four-Up Groups Dancing: Facing the Camera

3. Large, Impromptu Groups of the Couple's Friends

4. Totally Candid Tight Shots (Close-ups) of the Bride and Groom

Bride and Dad Dancing

Groom and Mom Dancing

Romantic Interlude: 10 or 12 Photos
1. Double Exposures

2. Candlelight Photos

3. Good-Bye Shots or Gag Shots

4. Available-Light Night Scenes Including Reception Hall Scenery

The Cake
1. Bride and Groom Cutting Cake: Two Frames

2. Bride Feeding Groom

3. Groom Feeding Bride

4. Bride and Groom's Hands over Cake, Showing Rings

5. Bride and Groom Kissing Each Other with Cake in Composition

Bouquet and Garter Toss
1. Tossing Bouquet

2. Removing Garter

3. Tossing Garter

4. Putting Garter on Bouquet-Catcher's Leg

APPENDIX U.S. SUPPLIERS AND PROFESSIONAL ORGANIZATIONS

Photographic Equipment

APIC
12 Lincoln Boulevard
Emerson, NJ 07630
(201) 261-2160, (800) 600-1147
PIC light stands

B + W filters
(see Schneider Optics, Inc.)

Bogen Photo Corp.
565 East Crescent Avenue
Ramsey, NJ 07446-0506
(201) 818-9500
Bogen-Manfrotto light stands, tripods
Bogen lighting accessories
Elinchrom flash equipment
Gitzo tripods
Gossen light meters
Metz flash units

'roncolor
see Sinar Bron, Inc.)

Bronica
(see Tamron Industries, Inc.)

Canon U.S.A. Inc.
1 Canon Plaza
Lake Success, NY 10042-1198
(516) 328-5000
Canon photographic equipment

Chimera Photographic Lighting Inc.
1812 Valtec Lane
Boulder, CO 80301
(888) 444-1812
Lightbank systems

Cokin Creative Filter System
(see Minolta Corporation)

Comet
(see Dyna-Lite Inc.)

Contax
Kyocera Electronics Inc.
100 Randolph Road
Somerset, NJ 08875
(732) 560-0060, (800) 526-0266
Contax photographic equipment

Cullmann
(see R.T.S. Inc.)

Denny Manufacturing Company Inc.
Box 7200
Mobile, AL 36607
(800) 844-5616
Backdrops

Domke
(see The Saunders Group)

Dyna-Lite Inc.
311-319 Long Avenue
Hillside, NJ 07205
(800) 722-6638
Comet flash equipment
Dyna-Lite flash equipment

Eastman Kodak Company
343 State Street
Rochester, NY 14650-0536
(800) 242-2424
Kodak photographic equipment and film

Elinchrom
(see Bogen Photo Corp.)

Fuji Photo Film, U.S.A. Inc.
555 Taxter Road
Elmsford, NY 10523-2314
(914) 789-8100
Fuji photographic equipment and film

Gitzo
(see Bogen Photo Corp.)

Hasselblad USA Inc.
10 Madison Road
Fairfield, NJ 07004
(973) 227-7320
Hasselblad photographic equipment

HP Marketing Corp.
16 Chapin Road
Pine Brook, NJ 07058
(201) 808-9010
Linhof cameras and accessories
Rollei and Rolleiflex cameras

Kart-A-Bag
(see Remin Laboratories, Inc.)

Leica Camera
156 Ludlow Avenue
Northvale, NJ 07647-2308
(201) 767-7500, (800) 222-0118
Leica photographic equipment

Light Impressions Corp.
439 Monroe Avenue
Rochester, NY 14607
(716) 271-8960, (800) 828-9859
Archival photographic supplies

Lindahl Specialties, Inc.
P. O. Box 1365
Elkhart, IN 46515
(800) 572-2011
Lens shades and flash brackets

Linhof
(see HP Marketing Corp.)

Lowel-Light Manufacturing Inc.
140 58th Street
Brooklyn, NY 11220-2521
(718) 921-0600, (800) 334-3426
Lighting, stands, and accessories

Lumedyne, Inc.
6010 Wall Street
Port Richey, FL 34668-6762
(813) 847-5394
Flash equipment

Lumiquest
P. O. Box 310248
New Braunfels, TX 78131
(210) 438-4646
Flash equipment

Mamiya America Corp.
8 Westchester Plaza
Elmsford, NY 10523-1605
(914) 347-3300
Mamiya cameras
Sekonic light meters

Manfrotto
(see Bogen Photo Corp.)

Metz
(see Bogen Photo Corp.)

Minolta Corporation
101 Williams Drive
Ramsey, NJ 07446-1282
(201) 825-4000
Minolta photographic equipment
Cokin Creative Filter System

Norman Enterprises Inc.
2601 W. Empire Avenue
Burbank, CA 91504-3225
(818) 843-6811
Flash equipment

Nikon Inc.
1300 Walt Whitman Road
Melville, NY 11747
(516) 547-4200
Nikon photographic equipment

Pentax Corporation
35 Inverness Drive
East Englewood, CO 80155
(800) 729-1419
Pentax photographic equipment

Photek
549 Howe Avenue
Shelton, CT 06484
(800) 648-8868
Backgrounds and umbrellas

Photoflex
333 Encinal Street
Santa Cruz, CA 95060
(408) 454-9100
Flash equipment

Photogenic Machine Company
P. O. Box 3365
Youngstown, OH 44513
(330) 758-6658, (800) 682-7668
Flash equipment

Polaris
(see The Saunders Group)

Quantum Instruments, Inc.
1075 Stewart Avenue
Garden City, NY 11530
(516) 222-0611
Flash equipment

Remin Laboratories, Inc.
510 Manhattan Road
Joliet, IL 60433
(815) 723-1940
Kart-a-Bag

Rollei
(see HP Marketing Corp.)

R.T.S. Inc.
40-11 Burt Drive
Deer Park, NY 11729
(516) 242-6801
Cullmann tripods

The Saunders Group
A Tiffen Company
21 Jet View Drive
Rochester, NY 14624
(716) 328-7800
Domke camera bags
Polaris exposure meters
Silver Pixel Press/KODAK Books
Stroboframe flash brackets
Wein remote flash control products

Schneider Optics, Inc.
285 Oser Avenue
Hauppauge, NY 11788
(516) 761-5000
B + W filters

Sekonic
(see Mamiya America Corp.)

Sinar Bron, Inc.
17 Progress Street
Edison, NJ 05820
(908) 754-5800
Broncolor lighting

Speedotron Corporation
310 S. Racine Avenue
Chicago, IL 60607-2841
(312) 421-4050
Professional lighting systems

Stroboframe
(see The Saunders Group)

Sunpak
(see ToCAD America Inc.)

Tamron Industries, Inc.
125 Schmitt Boulevard
Farmingdale, NY 11735
(516) 694-8700
Tamron lenses
Bronica cameras

Tenba
503 Broadway
New York, NY 10012
(212) 966-1013, (800) 328-3622
*Soft cases for camera and lighting
equipment*

Tiffen Manufacturing Co.
90 Oser Avenue
Hauppauge, NY 11788
(516) 273-2500
Tiffen filters
*Tiffen multiple filter kits, including
Hollywood/FX Wedding and Portrait Kit*
Davis and Sanford tripods

ToCAD America Inc.
300 Webro Road
Parsippany, NJ 07054-2825
(973) 428-9800
Sunpak flash equipment

Vivitar Corporation
1280 Rancho Conejo Boulevard
Newbury Park, CA 91320-1403
(805) 498-7008
Flash equipment
Vivitar lenses